EXPLORING ART

for children to

create,
display,
and enjoy

again and again . . .

Special thanks to:

Molly	Greg	Carin
Devon	Eric	Catherine
Carmen	Jennifer	

our young artists

EXPLORING ART

By
Liz & Dick Wilmes
Art
Jeane Healy

A **BUILDING BLOCKS** Publication

3893 Brindlewood, Elgin, Illinois 60120

ISBN 0-943452-05-8
Library of Congress Catalog No. 86-81782

RESOURCE CONSULTANT:
 Dawn Zavodsky

COVER CONSULTANTS:
 Pat and Greg Samata
 Samata Associates, Inc.
 Dundee, Illinois 60118

PUBLISHED BY:
 BUILDING BLOCKS
 3893 Brindlewood
 Elgin, Illinois 60120

DISTRIBUTED BY:
 GRYPHON HOUSE, Inc.
 P.O. Box 275
 Mt. Rainier, Maryland 20712

ISBN 0-943452-05-8
$16.95

Dedicated to:

. . . the children who do it their
way and the adults who
guide them.

Contents

August

Introduction

Exploring Art is filled with over two hundred art activities appropriate for young children. The ideas have been carefully designed so that each month contains an assortment of art media and techniques. The activities are mostly open-ended, although some require a little more direction that others.*

Using Exploring Art

Each activity in **Exploring Art** is divided into four major areas:

1. Prepare For The Activity: This section is comprised of two sub-headings. The first one, *Gather the Materials,* is a list of all of the supplies and materials you'll need to collect before the children can enjoy the activity. The second sub-heading is *Talk With The Children.* This section introduces the art activity to the children through a game, rhyme, or book as well as provides a brief explanation of the media and supplies at the art table. It is an opportunity to correlate the art with other areas of your curriculum.

2. Enjoy The Activity: The second section in each activity is a complete description of the art idea. The explanation begins with laying out the materials and supplies and continues by describing methods for presenting the activity. As you are working with the children, remember that it is their art and adult help is only needed to assist them in the process.

3. Displaying The Art: The activities in **Exploring Art** are designed to be displayed in specific areas of the room — bulletin boards, doors, walls, windows, etc. The teacher, however, needs to consider her own space and environment. For example, if you have a lot of bulletin board space, you may want to display the wall activities on your bulletin board or vice-versa.

4. Extensions: The last section of each activity suggests additional ideas which relate to the art idea. Sometimes these are variations of the art activity itself. They can also be a related book, game, fingerplay, field trip or visitor suggestion. Like the *Talk With The Children* section, these extensions help to enhance and correlate your total curriculum.

*The Appendix will give you a clearer indication of the themes, areas of display, and degree of difficulty for each activity.

Getting Parents Involved

Familiarize the parents in your center with the art activities you offer in your program. Through this ongoing parent education, they will learn more about their children's development, gain insight into your art program, and develop an appreciation for the skills their children are learning through art.

1. *Newsletter:* In the regular newsletter you distribute to your families, highlight different art activities the children have experienced. Briefly explain different media they have used as well as how they used it. If the children have used unusual media or supplies you might want to feature these. Think about adding a photograph or two showing the children using the media. Remember, *"A picture is worth a thousand words."*

2. *Ask for Volunteers:* Encourage your parents to volunteer in the center. When they are there, ask them to help the children who are enjoying the art activity. Before they go over to the area, tell them about the activity, explain the media the children are using, and give them some hints about talking with the children concerning the art they are doing.

Have parents help you frame and hang the artwork that is going to be displayed. Remember to use the display ideas suggested in each activity as well as in the *Displaying The Children's Art* section which follows.

3. *Explanation Card:* In the corner of each art activity being displayed, add a short descriptive note which explains the art media the children used and how they used it. Encourage your parents to read the notes and talk with their children about the experience.

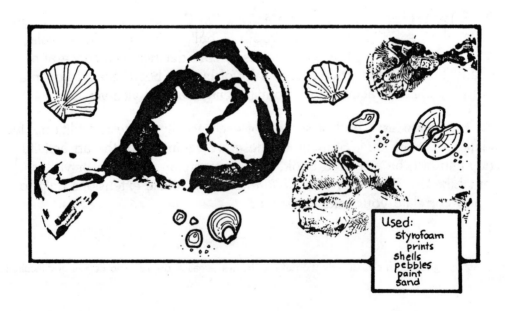

Used:
styrofoam prints
shells
pebbles
paint
sand

4. *Art Festival:* In conjunction with a regular parent meeting, display a wide variety of the art that the children have recently been enjoying. As a part of the meeting, explain the different types of art. You might include a short slide presentation showing the children in the art area. Parents will not only enjoy seeing their children but will develop a better appreciation for the art their children are enjoying.

5. *Save Materials:* At the beginning of the year give your parents a list of collage and other art materials you'll be using during the year.** Encourage them to save these items and donate them to the school. Throughout the year they will enjoy seeing the materials as their children use them for their individual and group art activities.

Displaying the Children's Art

Show an appreciation and a respect for the art the children enjoyed creating. When displaying it remember to:

- Hang all of the art at the children's eye level so they can easily see it. To help you remember, have several children assist you. They can add tape, hold art, check position, and so on.
- Hang the art straight. Use the lines in the walls, frames in the window, borders on the bulletin boards, and grain in the doors as reference points.
- Check each morning to be certain that all of the artwork is securely fastened. Rehang any that might have come loose or have fallen off.
- Use heavy-duty tape when the surface is difficult to display on. Loop the tape in circles, attach it to the back of the art, and then fasten it to the wall or door. Doing it this way, the tape does not interfere with the art. If the surface is easier to hang on, double-stick cellophane tape works well.
- Talk with the children about their art. Encourage their comments and reactions. Discuss color, lines, figures, design, etc. Ask them what they were thinking about as they were doing the art. Talk about how they liked working with the media.

See the Appendix for a detailed list of materials used in **Exploring Art.

Framing the Art

Framing the children's art helps to show it off. It sends a special message to the children that you respect their work and feel it is important. Here are several framing ideas which you, a volunteer, or the children can do:

• *Round Frames* - Smaller pieces of artwork can be glued to paper plates or pizza boards. Brush watered-down white glue on the artwork or frame and stick them together.

• *Fabric and Wrapping Paper* - Gluing larger creations to pieces of fabric or wrapping paper really helps them come alive. Water down white glue, brush it on the back of the art or on the front of the fabric or wrapping paper, and then press the artwork to the background. Trim the edges of the frame when the artwork has dried. Periodically add an extra touch to the fabric by cutting the edges with pinking shears.

• *Yarn* - The children can easily do this type of frame themselves. Have them drizzle glue around the edges of their art, give them a piece of wide yarn, and let them lay it on the glue. After the yarn has been laid down, the children should press it so it sticks firmly.

• *Paper Sacks* - Use large paper sacks like those from the grocery store. Cut openings in the bags a little smaller than the artwork you're going to frame. Brush glue around the front edges of the art, carefully slide it into the bag and line it up with the opening you cut. Press it so it adheres to the inside of the bag. You can use all sides of the bag and hang it from the ceiling or use three sides and display it on a wall or bulletin board.

• *Used Window Frames* - Gather window frames people no longer need. Be sure that all of the glass has been taken out. Securely back the frame with a piece of heavy posterboard. Hang the frame on a wall. Tape the children's art in the individual sections of the frame.

• *Used Placemats* - Encourage your parents to donate clean, useable cloth placemats which they no longer need. Use them in several different ways:

•• Put a long table in your hallway. Tape or pin the children's art to the mats. Lay the framed art on the table.

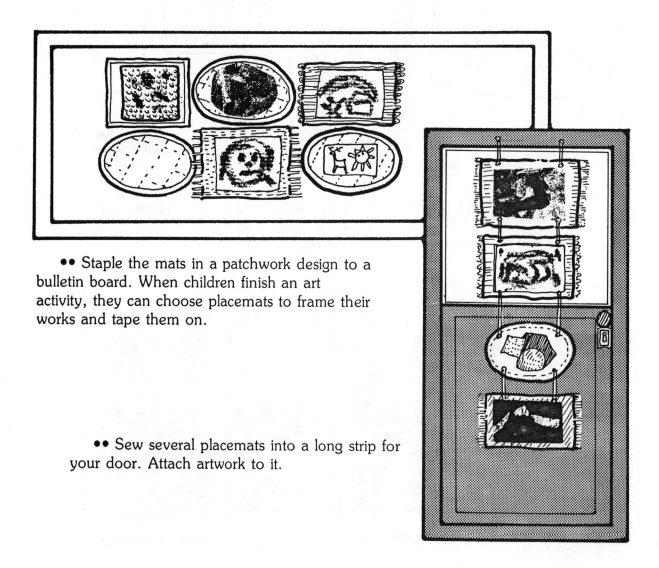

•• Staple the mats in a patchwork design to a bulletin board. When children finish an art activity, they can choose placemats to frame their works and tape them on.

•• Sew several placemats into a long strip for your door. Attach artwork to it.

• *Gift Boxes* - Collect the tops from a variety of sizes of boxes. Using a utility knife, cut openings in the top slightly smaller than the sizes of the art you're going to display. You can glue or staple the art to either side of the top. Hang the framed art on your wall or bulletin board.

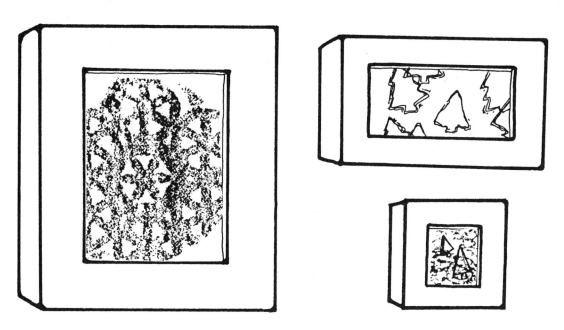

• *Facial Tissue Boxes* - If you're framing smaller pieces of art, use the tops of the tissue boxes. Brush glue on the inside of the box top and fasten the art to it so the art peeks through the openings in the boxes.

Constructing Simple Displays

Besides the display ideas suggested for each art activity, here are some additional ones you might enjoy using throughout the year.

• *Curly Ques* - The Curley Que is used when displaying small pieces of art that the children have created. Get a piece of posterboard. Draw a spiral on it as large as you can and then cut it out. Punch a hole at the top to hang it. As each child is ready to hang his artwork, help him punch a hole along the spiral and tie it on with a string or piece of yarn. When everyone has attached his art, hang the spiral low from the ceiling. When the children have finished more art, simply rotate the pieces by untying the one piece, letting the children take it home, and hanging up a new one.

• *Twine Lines* - This type of display is very easy, attractive, and versatile. You'll need a ball of heavy twine and spring-loaded clothespins. Hang varying lengths of twine from your ceiling so that you can easily reach them. Tie a clothespin to the end of each piece of twine. When the children finish their art, let them choose which piece of twine they would like to display it on. Help them clip it on.

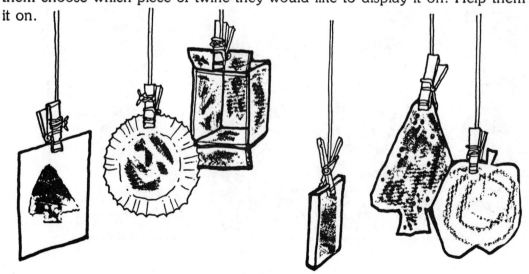

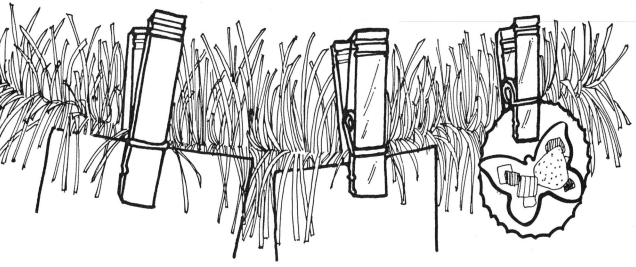

• *Holiday Hangers* - Add pizzaz to special occasions by stringing a piece of colorful garland or ribbon across your room. Hang it securely because as you add the art, it will begin to sag to an appropriate level. Use colored, plastic clothespins to attach the art.

• *Felt Banners* - Felt banners are very colorful and durable. In addition, you can make them any size you'd like depending on the space you have. You'll need a dowel rod, felt, twine, and scissors. Cut the felt the size you want. Sew a rod pocket in one end of the felt. Slip the dowel rod through the pocket. Tie a piece of twine to each end of the dowel rod and hang it at an appropriate height for the children. Fasten the children's art to the banner with straight pins.

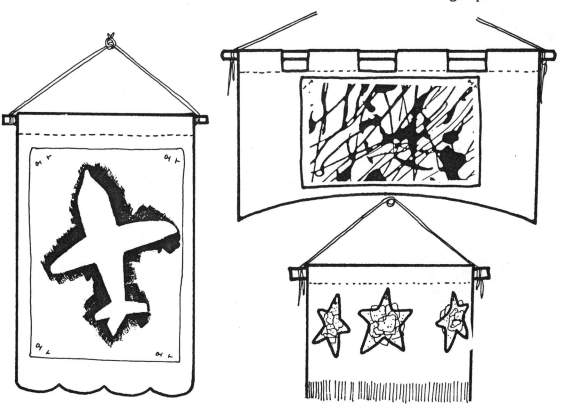

• *Paper Banners* - This type of banner is not only easy to make but very versatile since it hangs in any part of the room where there is a hook. It also easily tapes to the wall or door because the hook in the hanger lays flat against the surface. To make this banner you'll need a large sheet of construction paper, glue, and a metal hanger. Fold the corners of the construction paper over the top of the hanger and glue the flaps to the backside of the paper. Use straight pins to fasten the art to the banner.

• *Box Displays* - If you do not have much useable wall or bulletin board space, consider stacking several large cardboard boxes and putting them in or near your art area. To make your display, you'll need several large, sturdy cardboard boxes, heavy-duty tape, paint or wallpaper, and brushes. Paint or wallpaper your boxes. When they are dry, stack them with the largest one on the bottom. Neatly tape them together for safety. Use tape or thumbtacks to fasten children's art to the boxes.

● *Criss-Cross* - The criss-cross display is a type of permanent mobile. To make it you'll need two small branches, two dowel rods, or two of any other materials you want to cross. In addition you'll need heavy-duty twine, a roll of string, and spring-loaded clothespins. Cross your two branches and securely fasten them in the middle with heavy twine. Attach a piece of twine to the middle for a hanger. Cut varying lengths of string and tie them to the branches. Clip a clothespin to the end of each string. Use them for easy rotation of the children's art.

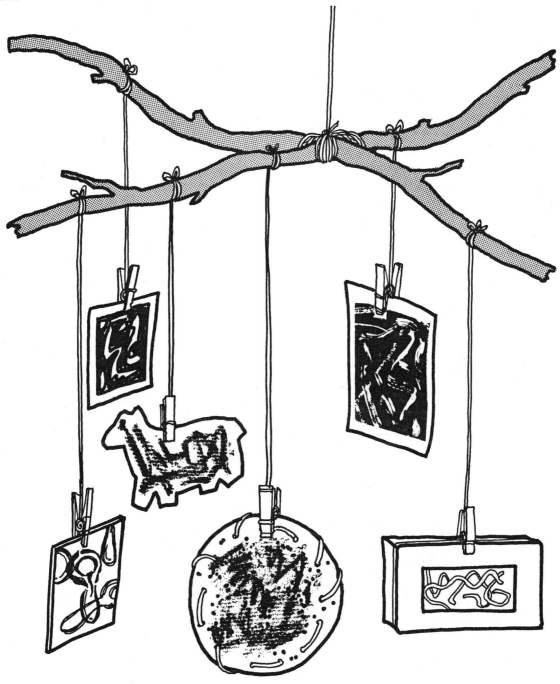

• *Fish Net* - If you have a large, empty wall get a piece of fish net and fasten it to the wall. Hang the children's art on it using clothespins. During different seasons and holidays it is easy to add specific decorations to reflect a certain spirit. Weave crepe paper, colored ribbons, streamers, or glittered garlands in and out of the holes or hang small Italian lights from the netting. (Be sure the netting is fire-proof.) Frame children's art on different seasonal or holiday symbols, such as leaves, pumpkins, stars, hearts, eggs, etc. Clip the framed art to the net.

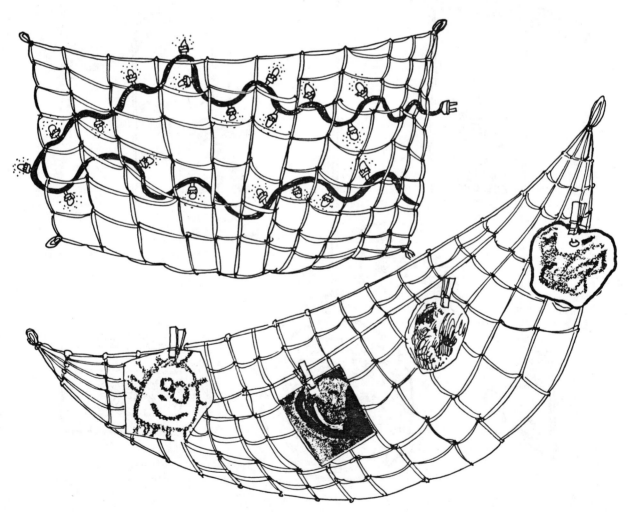

• *Rainbow Ribbons* - This is a very colorful display which you can easily use with all types of art. You'll need two half inch dowel rods and at least five different colors of wide (about three inches) sturdy ribbon or fabric. Cut the ribbons in four foot lengths. Wrap one end of each ribbon around one of the dowel rods. Securely glue the ribbon to the rod. (You can also sew a rod pocket in each ribbon and slide the dowel through the openings.) Repeat with the other dowel rod. Attach heavy-duty twine at each end of one dowel rod and hang it low over a table in your room. Display children's art on both sides of the ribbon. Straight pins work best.

You can easily make several of these and hang them in different areas of your room. They add lots of color and cheer and serve as a display and small divider at the same time.

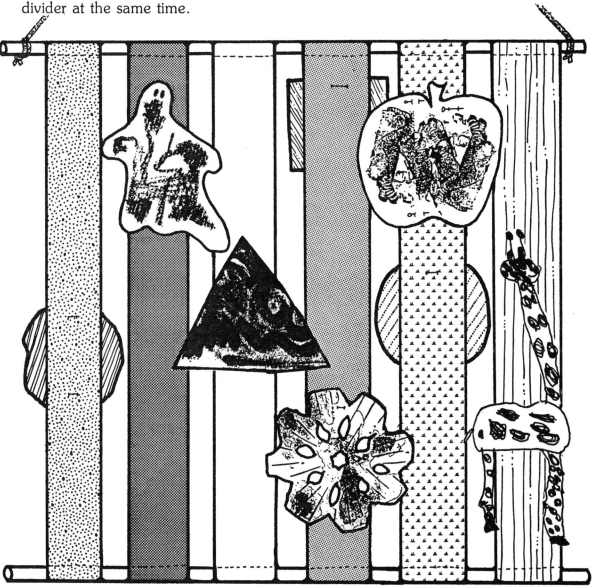

BUDDY PAINTING

┌─ PREPARE FOR THE ACTIVITY ─

Gather The Materials
- Cut butcher paper the size of your bulletin board.
- Have: wide paint brushes
 four or five colors of tempera paint

Talk With The Children: During the first several weeks of school, do as many activities as you can to help everyone get to know each other. For example, sing a Hello Song each day and allow the children to have an opportunity to say their names.

Buddy Painting is an art activity which helps everyone get acquainted. Tell the children that when they come to art they should bring another child with them so they can paint the mural with a buddy.

ENJOY THE ACTIVITY

Lay the paper on the floor in the art area. Distribute the paint and brushes around the paper. When the buddies arrive, they should sit around the edges of the paper and paint with any or all of the available colors. As they paint, encourage them to talk to each other and use each other's name.

DISPLAY THE *"BUDDY PAINTING"*

After the painting has dried, have several children help you loosely roll it up and carry it to the bulletin board. Tack one edge of the painting to the board. Begin unrolling it, tacking it as you go. After it is securely fastened, stand back and enjoy looking at all of the colors. Talk about the different colors. Find the color that was used the most frequently.

Cut out large letters which say *"HI"* and tack them in the middle of the painting. Add a list of the children's names.

EXTENSION:

Use the Buddy Painting as a background paper for the children's easel paintings this month.

APPLE TREE

Gather The Materials

- Cut butcher paper the size of your bulletin board. Draw three very simple large tree shapes on it.
- Put small chunks of wood in several containers.
- Draw simple apple shapes about six inches in diameter on white paper.
- Pour thin layers of red, yellow, green, black, and brown tempera paint into shallow pans.
- Have: blunt-tipped scissors
 tape
 construction paper

Talk With The Children: Bring several red, yellow, and green apples to show the children. Use them to fix an apple salad. Have one child give you a yellow apple. Cut it into wedges for the children and let them cut their wedges into pieces. Put the pieces in a mixing bowl. Continue with other apples. Add raisins, celery, and salad dressing and mix. Enjoy for a snack. Encourage the children to look at the apple skins as they eat their salad.

ENJOY THE ACTIVITY

Lay the butcher paper on the floor in the art area. Put the pieces of wood and the black and brown paint around the edges of the paper. Using the wood blocks, have the children print three trees. When the trees have dried, put the green paint on the floor and have the children hand print leaves on all of the branches. If they want, they can also hand print grass along the bottom edge of the paper. Let it dry and then hang it on the bulletin board.

Print the apples for the trees. Put the scissors, apple shapes, and tempera paint on the art table. When the children come to art have them cut out apples. As they are cutting, they should decide what color apples they would like to make. When they have decided, have them make a fist, dip the side of it into the appropriate color of paint, and then fist print on the apple. Repeat the fist-printing over and over until the apple is covered. Let the apple dry. If the children would like to print more apples, simply repeat the process.

DISPLAY THE "APPLES"

Each child should decide where he would like to hang his apple. If the tree is low enough, let him help you tape it onto the branch. If not, have him watch you.

If you want, weave a basket from construction paper strips and staple it near the base of one of the trees. Put all of the extra apples in·or around the basket. Throughout September let the children pick the apples and take them home.

EXTENSION:

On a warm day go outside and bob for apples. Put enough apples in a bucket of water for all of the children. Have a big spoon or ladle. Each child should catch his apple on the spoon and then eat it for snack. What color skin does each apple have?

FALL STROLL

PREPARE FOR THE ACTIVITY

Gather The Materials
- Pull the corn husks off of eight or nine ears of corn.
- Cut butcher paper the size of your bulletin board.
- Pour tempera paint into shallow pans.
- Have: thin paper, such as onion skin
 crayons with the paper peeled
 off (the children can do this)
 large plastic tub

Talk With The Children: Bring tall corn stalks to show the children. As you are discussing corn with them, let them (one at a time) have the opportunity to pull the ears of corn off of the stalks. Help them if the ear is difficult to pull. Put all of the ears in a large plastic tub. Put the ears of corn and the bare stalks in the Discovery Area for several days. While the corn is there, have the children peel it, saving the husks.

Tell the children that at art they can use the corn husks to paint a large piece of background paper. While the paper is drying, they are going to take a walk and make crayon rubbings to hang on the bulletin board.

ENJOY THE ACTIVITY

Before the children take their fall stroll, let them paint the background paper for their crayon rubbings. Spread the butcher paper on the floor and put the tempera paint and corn husks around it. Using corn husks for brushes, paint the piece of butcher paper. When it's dry, hang it on the bulletin board.

Just before their walk, give the children pieces of paper and let them choose a crayon. At the beginning of the walk have everyone kneel down and make a rubbing of the sidewalk in front of the school. Continue on, making rubbings of tree bark, leaves, the side of the street post, and whatever else attracts each child's fancy.

DISPLAY THE "CRAYON RUBBINGS"

When they return from their stroll, tack the crayon rubbings to the background paper. During the following days talk about the rubbings. Make a list of them and add it to the bulletin board.

EXTENSION:

On a rainy fall day, take an inside fall stroll and make more crayon rubbings.

FURRY SQUIRREL

PREPARE FOR THE ACTIVITY

Gather The Materials
- Cut a large squirrel shape from brown or gray mailing paper.
- Collect pieces of brown, gray, black, and white materials such as fabrics, flocked wallpaper, and cotton. Place each type of material in a different container.
- Have: glue in small containers
 heavy-duty tape

Talk With The Children: Squirrels live in cities, towns, farm country, and forests. Ask the children what they know about squirrels — what they look like, what they eat, what they do all day, etc. Show the children the squirrel shape and the samples of the different textures they are going to use at art. Talk about completely covering the backside of the textures with glue before putting them on the squirrel.

ENJOY THE ACTIVITY

Put the squirrel shape on the art table with the glue and different materials nearby. The children should glue the materials on the squirrel until he is completely covered. While they are gluing, talk about the different textures. Let him dry.

DISPLAY *"FURRY SQUIRREL"*

Hang him at children's eye level on either the inside or the outside of the classroom door. As the children come to school each day, ask them if they saw a squirrel on the way. What was he doing? Did he look like the squirrel on the door?

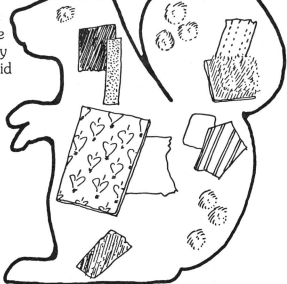

EXTENSION:

Take a walk around the neighborhood. Everytime anyone sees a squirrel, stop, be very quiet, and watch what he does. When you get back to the school, talk about all of the things you saw the squirrels doing.

WELCOME WREATH

PREPARE FOR THE ACTIVITY

Gather The Materials

- Collect toilet paper rolls so that each child has at least one or two rolls to paint.
- Lay out newspaper for the rolls to dry on.
- Have: tempera paint
 brushes
 rug yarn
 heavy-duty tape

Talk With The Children: Ask the children if they have any decorations on the doors of their homes. What kinds of decorations? Why do they have decorations? Have them make a big wreath with their arms, then look through it and say *"Hi"* to a friend sitting nearby.

Tell the children they are going to make a wreath for the classroom door. First they will paint toilet paper rolls all different colors and then string them together in a wreath shape.

ENJOY THE ACTIVITY

Put the toilet paper rolls, paint, and brushes on the art table. When each child comes to art, let him paint the roll(s) any color he chooses. When finished, he should stand it upright on a piece of newspaper to dry. After all of the rolls are dry, sit with several children and string them onto the yarn. Tie the ends together and loop a big bow. (If you have too many rolls for one wreath, make two or three so that they nest inside each other or so that you have several large ones).

DISPLAY THE *"WELCOME WREATH"*

Tape the loop of toilet paper rolls in the shape of a wreath on the classroom door low enough so that it hangs at the children's eye level. If you have several wreaths, arrange them higher on the door or hang them on another door.

You might want to draw a simple smiling face to put in the center of the wreath.

EXTENSION:

Talk about various ways people greet each other. Present different situations to the children and have them tell the others how the people in the story would say *"Hi"* to each other. For example: *Jamil is outside playing with a friend. His mom calls him inside. When Jamil comes in what will he say and/or do to his mom? Here's another: You are shopping at the grocery store with your dad. You see a friend. How will you say 'Hi' to him?*

RED APPLE

⌐ PREPARE FOR THE ACTIVITY ¬

Gather The Materials
- Cut out a large apple from posterboard.
- Have: several red textures such as fabric and yarn

 glue

 heavy-duty tape

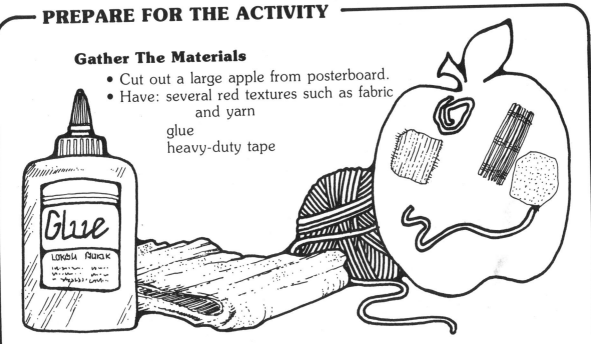

Talk With The Children: Discuss apple picking. Have the children close their eyes and try to picture a real apple tree. Ask them if they can reach any of the apples they see. Have them open their eyes and discuss how they would reach the apples that were too high in the tree.

Show the children the apple that you cut from posterboard and several of the red materials. Tell them that at art they can glue the materials onto the apple. When they finish they will hang the apple in the room. Throughout the month the children can bring more red materials from home to glue to the apple.

ENJOY THE ACTIVITY

Put the apple shape in the middle of the art table. Have the glue and red materials on each side of the apple. Let the children glue the materials to the apple.

DISPLAY THE "RED APPLE"

Tape the apple low on a wall. Through September have the children bring in more red materials that can be glued onto the apple. When they bring things in, have them immediately glue them to the apple. At the end of September begin your Wall of Colors (See October-August for ongoing ideas). Put the apple on a long wall where you'll be able to add different colored artwork each month. Maybe one of the walls in the hall would work best.

EXTENSIONS:

Take a red color walk. Stroll around the neighborhood. Look for anything that is red. If the children find red leaves, they can glue them to the apple.

If there is an orchard nearby, take the children apple picking.

BIRTHDAY TRAIN

PREPARE FOR THE ACTIVITY

Gather The Materials

- Cut an engine, caboose, and twelve other train car shapes out of a variety of colors of posterboard. Write the months and the children's birthdays on each car. Save them to use each month.
- Cut large candle shapes for each birthday child out of construction paper.
- Have: collage materials
 tempera paint
 crayons
 markers
 chalk
 glue
 heavy-duty tape

Talk With The Children: Near the beginning of September bring tape, the engine and the first train car (September) to show the children. Tell them that through the year, they are going to connect a birthday train. Talk a little about the engine. Then tape it low on a wall near the circle time area. Show them the September car and talk about the children whose names are on that car. Play a game called Pretend Birthday. Say to a child, *"How old are you?"* When he tells the group, clap that number of times, counting aloud as you clap. After clapping, the group says, *"Happy Birthday, Nicole."* Continue with several other children. Tape the September car to the wall near the engine.

ENJOY THE ACTIVITY

Give each child a candle shape on his birthday. Ask him how he would like to decorate it. Give him appropriate materials and let him enjoy adding color to the candle.

DISPLAY THE *"BIRTHDAY CANDLE"*

Have the birthday child show his candle to the other children and tell them how he decorated it. While he is holding the candle, sing Happy Birthday to him. Have him tape it in the September train car.

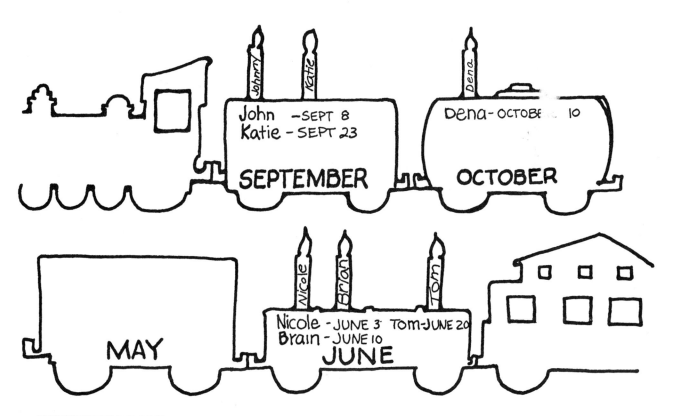

EXTENSIONS:

At the beginning of each month talk about the upcoming birthdays. You might also discuss other special events and add appropriate symbols to the train car to remind everyone what's happening.

On each child's birthday have the class make him a birthday book. Cut two birthday cake shapes out of posterboard for the front and back of the book. Cut birthday cake shape pages for the book out of regular paper. Let the children draw pictures and dictate birthday messages. (They can 'write' their own messages if they want.) When all of the pages are finished, put the book together by punching two holes on the left side of the front, back, and pages and fastening it with several loops of yarn. Read the book to all of the children and then let the birthday child take the book home.

WINDOW APPLES

PREPARE FOR THE ACTIVITY

Gather The Materials
- Draw large apple shapes on green, yellow, and red construction paper.
- Have: blunt-tipped scissors
 red, yellow, and green crayons with paper peeled off (the children can do this.)
 individual pencil sharpeners or potato peelers
 pie tin
 pieces of newsprint
 stack of newspapers
 double-sided cellophane tape
 electric iron

Talk With The Children: Bring a red, yellow, and green apple to show the children. Talk about the fact that apples are grown with three different colored skins. Carefully cut the three apples into as many pieces as you have children. Put the pieces on a plate, pass it around the group, and let the children each choose a piece. Have them look at the color of the skin on their piece of apple. Tell those who have apples with yellow skins to eat their's first, those with green skins next, and those with red skins last.

As you explain the art activity, remember to discuss the safety aspects of using potato peelers and a warm iron.

34

ENJOY THE ACTIVITY

Have the children make the crayon shavings with pencil sharpeners or potato peelers, putting each color in a separate pie tin.

Set up a place near the art table where you will iron the apples. Turn the iron on a warm setting. Put the apples, scissors, and crayon shavings on the art table. Have the children choose what color apple(s) they would like to make. First they should cut it out and then sprinkle crayon shavings on one side. After the shavings are in place, the children should carry the apple over to the iron, lay the apple on a stack of newspapers, cover it with several pieces of newsprint, and iron the apple until the shavings have melted. Take the apple out from underneath the newsprint.

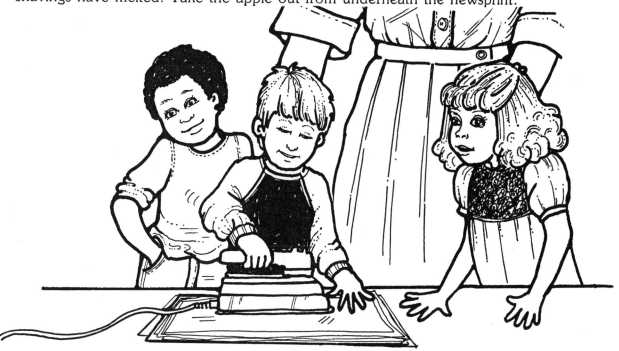

DISPLAY THE "WINDOW APPLES"

Let each child decide where on the window he would like to put his apple. Help him tape it there. Enjoy looking at all of the colors when the sun shines through the melted crayon.

EXTENSION:

Enjoy this rhyme with the children:

APPLE GREEN

Apple green, apple red,
Apple fell upon my head.
Dick Wilmes

MEET NEW FRIENDS

PREPARE FOR THE ACTIVITY

Gather The Materials

- Take each child's photo the first day of school.
- Make the frame for the mobile. Cut a piece of heavy posterboard about 30″ long and 3″ wide. Staple it into a circle. (Punch 8 equidistant holes around the top edge of the circle. Lace 8 strands of yarn through them, gather them at the top, and tie them together. Hook the knot on a paper clip or hook in the ceiling.) Punch 8 equidistant holes around the bottom edge of the circle. Cut 8 varying length pieces of yarn which will hang from the holes.
- Cut construction paper slightly larger than the developed photos.
- Have: blunt-tipped scissors
 glue
 brushes for glue
 heavy-weight yarn

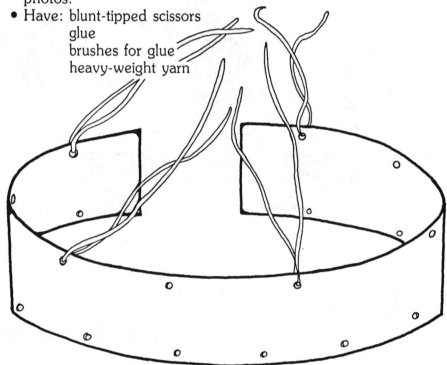

Talk With The Children: Pass the photos to the appropriate children. Have them hold the photo up and say *"I'm Nicole."* Continue with all of the children. Collect the photos, mix them up, and pass them out randomly. Have a child look at the photo he is holding, look around at the children, match the photo with the real child, and take it to him. As he hands the child the photo, the child should say his own name. Collect all of the photos.

Tell the children that you are going to bring the photos to art where they will mount them and construct a large mobile.

ENJOY THE ACTIVITY

Bring the photos and construction paper to art. When each child is ready, have him find his photo and pick the color of construction paper he would like to use to mount his photo. Have him brush glue on the back of his photo and mount it onto the construction paper. He should keep pressing until it feels firm. Let the photos dry. Ask each child if he would like you to write his name below his photograph. If so, do it with him.

Lay the eight pieces of yarn on the table. Have the children brush glue down the middle of the construction paper and then press it along one of the pieces of yarn.

DISPLAY THE "NEW FRIENDS"

When all of the photos have dried on the yarn, tie the strands through the eight holes along the bottom of the frame. Arrange them so they balance. Hang the mobile fairly low near the door so the children see the photos as they come to school each day.

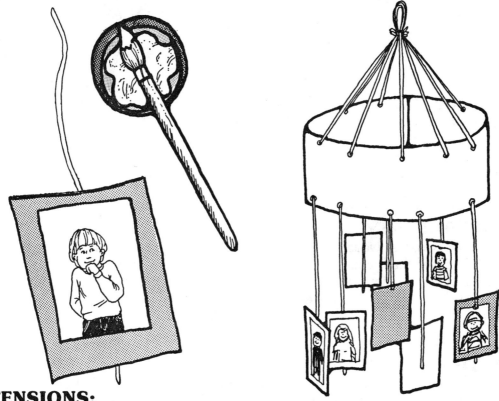

EXTENSIONS:

Encourage the children to look at the photos and try to remember their new friends' names.

Take a class photo and mount it near the mobile. Have fun finding individual children within the class photo.

LEAF PAINTING

PREPARE FOR THE ACTIVITY

Gather The Materials

- Draw large, simple leaf shapes on a variety of fall colored construction paper.
- Gather a variety of weeds from outside. Try to pick weeds with stems so the children have a handle to hold onto.
- Pour thin layers of fall colored paint into shallow dishes.
- Have: blunt-tipped scissors
 paper punch
 light-weight yarn

Talk With The Children: Show the children a variety of real colored leaves. Talk about the colors in each leaf.

Let the children see some of the weeds you collected. Tell them that at art they will be using the weeds to paint construction paper leaves. Ask them what colors of paint they might use.

ENJOY THE ACTIVITY

Put the leaves, scissors, weeds, and paints on the table. The children should choose the color of leaf they would like to paint and cut it out. Using the weeds, brush the leaves with the paints. (Remember to give children the option of painting both sides of their leaf.) When the leaves have dried, each child can punch a hole near the top and then loop a piece of yarn through the hole.

DISPLAY THE *"LEAF PAINTING"*

Once the leaf has a loop, let each child decide where on the ceiling he would like to hang it. Attach it high enough so it will not interfere with people who are walking around.

EXTENSIONS:

As children find real leaves, have them bring them into the classroom and see if any of them look like the painted leaves. Have a basket on the Discovery Table for the real leaves. Encourage the children to examine the various leaves during free play.

Enjoy this poem with the children:

FALL LEAVES

Leaf of red, leaf of green
Prettiest leaf I've ever seen.
Leaf of brown, leaf of gold,
Sometimes flat, sometimes rolled.

Falling from the trees so high,
Blowing in the autumn sky.
Soon the snow will begin to blow
Then in Spring new leaves will grow.

Dick Wilmes

SEWN APPLES

┌─ PREPARE FOR THE ACTIVITY ─

Gather The Materials

- Draw a thin outline of an apple on at least one styrofoam meat tray for each child. A ballpoint pen works best.
- Punch holes around the apple outline about 1/2" apart — use the yarn needle.
- Have: yellow, red, and green rug yarn
 blunt-tipped yarn needles
 permanent black markers
 string

Talk With The Children: After talking about all of the different types of apples, enjoy this rhyme:

APPLES

Way up high in the apple tree,
Two little apples smiled at me.
I shook that tree as hard as I could,
Down came the apples,
Um, um, good!

Show the children the apple shape you outlined on one of the meat trays. Point out the little holes you punched. Tell them that at art they will be using rug yarn to sew in and out of the holes all around the apple.

ENJOY THE ACTIVITY

Have the trays, yarn, and needles on the art table. When the children come to art they should decide what color yarn they would like to use to sew their apples. Help them thread their needles and tie a knot at the first stitch. Encourage them to quietly chant *"Up and down"* as they poke the needle through the holes in the meat tray. After they have sewn around the apple, let them decide if they would like to make another row around the apple or if they are ready to tie off. Let them choose whether to use a marker to add any detail such as a stem or leaves.

DISPLAY THE "SEWN APPLES"

As each child finishes, let him punch a hole in the top of the meat tray, loop a piece of string through it, and hang it from the ceiling.

EXTENSION:

If possible, take a trip to an apple orchard and pick a variety of apples. (If not, buy a variety of apples from the market.) Taste test the different apples and then make applesauce with the remaining ones. Remember to add cinnamon. It smells so good.

GAME TREE

── PREPARE FOR THE ACTIVITY ──

Gather The Materials

- Put a large tree branch in a bucket of plaster of paris. Let it harden.
- Have: fifty or more spring-type wooden clothespins
 eight colors of tempera paint
 brushes
 piece of rope

Talk With The Children: After the children have been in the classroom for several weeks, talk about different things they enjoy doing. What puzzle is their favorite? Do they like building with the blocks? Which books do they like to look at? Now introduce the Game Tree. Tell the children that during the year you and/or they are going to make different games which they can play on the tree. Tell them that at art they are going to make the first game by painting clothespins different colors.

ENJOY THE ACTIVITY

Have the clothespins and paint on the art table. Hang the rope near the table. Let the children paint the clothespins all of the different colors. As each clothespin is finished, have the child who painted it carefully clip it to the piece of rope to dry. Continue until all of the clothespins have been painted.

DISPLAY THE "GAME TREE"

When all of the clothespins have dried, have the children clip them to the tree. In the next weeks, challenge the children to sort the clothespins by color, to arrange the dark colored clothespins on the top of the tree and the light ones on the bottom, or to alternate colors in designated patterns.

EXTENSION:

Cut out construction paper leaves and clip them to the tree using clothespins that are the same color as the leaves. Continue the tree activities throughout the year. During December let the children match different colored Christmas tree balls. In the winter make duplicate snowflakes the children can match. Come springtime make a variety of colored birds and butterflies which match the clothespins.

BOX SCULPTURE

PREPARE FOR THE ACTIVITY

Gather The Materials

- Collect a variety of different size boxes — cereal, cracker, gift, tissue, and toy boxes.
- Get a large corrugated cardboard base, such as one side of a big packing box.
- Have: glue
 tempera paint
 brushes

Talk With The Children: Several days before the activity, bring in a variety of boxes ranging in size from medium to small. Put them in the block area and encourage the children to build with them. In addition, have a small table with sandpaper nearby. Have the children sand all of the boxes which have a glossy finish. Tell them that in a few days they will be gluing the boxes together and that glue does not adhere to the glossy finish.

ENJOY THE ACTIVITY

Have the children help you bring all of the boxes from the block area to the art area. Explain to them that in the block area they built and rebuilt with the boxes. Show them the large piece of corrugated cardboard you brought for the base. Now they are going to glue all of the boxes together, starting with the largest box being glued to the base. Once they have done that, the children can continue to build and glue all of the boxes. If children bring more boxes from home, let them add the boxes to the sculpture.

When the sculpture is completed and all of the glue has dried, paint it with the fall colors.

DISPLAY THE *"BOX SCULPTURE"*

Slide the sculpture to a place in the room where everyone will enjoy seeing it. Have fun looking at all of the ways the boxes have been arranged.

EXTENSION:

Put a box of plastic or wooden animals on the base. Pretend the sculpture is a mountain with the animals climbing up and down and all over it.

SEPTEMBER MATS

ENJOY THE ACTIVITY

Display all of the leaves and set the paint, brushes, and brayer on the table. When the children come to art, they should choose several leaves and take a piece of construction paper. Have them paint one side of a leaf and then carefully flip it paint-side down on their white paper. Holding it steady with one hand, they should roll a brayer over the leaf or press it gently with their other hand. When the child has pressed all over his leaf, he should gently lift it up. Now he can paint the leaf again or use another leaf and print in another area of the construction paper. Continue printing. When finished, add each child's name.

Let the placemats dry thoroughly. When dry, laminate the placemats or cover them on both sides with clear adhesive paper. When trimming, leave a half inch edge around each placemat.

DISPLAY THE "PLACEMATS"

Put the placemats near the area where you eat. Before eating, have one or two children distribute the placemats around the table. After eating, wipe each mat and put it away.

EXTENSION:

Using larger pieces of construction paper, print more mats. Put these mats in the manipulative area. The children can put their puzzles, games, and small buildings on them when playing in that area.

FALL MURAL

PREPARE FOR THE ACTIVITY

Gather The Materials
- Cut a piece of butcher paper about five or six feet long.
- Have: lunch bags for each child
 crayons
 buttermilk
 chalk
 large paint brushes
 glue
 meat trays for the children's collections

Talk With The Children: Get fall study prints from your library and discuss the different signs of fall with the children. Then play Clap For Fall. Slowly say a series of words such as *"pumpkin, cereal, hand, colored leaf"*, etc. When the children hear a word associated with fall, they should clap. When the word is not related, they should keep their hands quiet. After the game, tell the children that at art they can chalk a large sheet of paper. Later in the week they are going to take a walk and collect different signs of fall to glue onto the chalked background.

ENJOY THE ACTIVITY

Let the children create the background for their mural. Spread the butcher paper on the floor and have the buttermilk, brushes, and chalk available. Have the children paint the butcher paper with buttermilk and then chalk it. Let it dry.

On a warm fall day have the children decorate bags with crayons and then go for a slow walk around the school. Encourage the children to collect items they see and put them in their bags.

When the children return from the walk, have them help you bring the chalked butcher paper outside and lay it on the ground or a table. Put the glue around the paper. Have the children pour their goodies onto meat trays so they can easily see their entire collections. As they want to take a break from playing on the outside equipment, have them sit around the paper and glue their collections to it. Let the mural dry.

DISPLAY THE *"MURAL"*

Secure the mural to an outside fence. As the children are playing, encourage them to ride their bikes over to it and look at all of the items everyone collected.

EXTENSION:

When you are ready to take the outside mural down, lay it on the ground once again. Have the children sprinkle bird seed all over the paper. Leave the paper on the ground overnight. When you return the next day, look at the mural. Is there any bird seed left? If it is gone, ask the children what could have happened to it? If it is still there, think about why no animals (birds) ate it.

PUMPKIN PATCH

PREPARE FOR THE ACTIVITY

Gather The Materials

- Cut brown butcher or mailing paper the size of your bulletin board.
- Have: orange, brown, and green fingerpaint
 brown, black, gray, or green crepe paper streamers
 glue
 heavy-duty tape

Talk With The Children: Before the children create their own pumpkin patch, take a field trip to a pumpkin farm. Let the children enjoy strolling through the fields. Look at all of the sizes and shapes of the pumpkins. Examine how pumpkins grow. What colors are the vines?

When you return, show the children the long strip of brown paper. Tell them that at art they are going to create a Pumpkin Patch by fingerpainting a field full of pumpkins connected with crepe paper streamers.

ENJOY THE ACTIVITY

Lay the brown paper on the floor in the art area. Have the orange fingerpaint ready to use. Let each child fingerpaint pumpkins on the brown paper for the patch. When each child is finished fingerpainting his pumpkins, talk to him about adding a stem and/or leaves. If he wants, let him add the details using other colors of fingerpaint.

When all of the pumpkins have dried, cut strips of colored streamers. Have the children work together to gently twist the streamers and then glue them as vines connecting all of the pumpkins.

DISPLAY THE *"PUMPKIN PATCH"*

Hang the Pumpkin Patch on the bulletin board. Enjoy looking at all of the different pumpkins. Find the largest, fattest, tallest, smallest, shortest, skinniest pumpkins. Great activity for increasing vocabulary!

EXTENSION:

Make a Pumpkin Patch board game. Cut seven or eight pairs of pumpkins out of orange construction paper. Glue one set of pumpkins on posterboard. Cover the game with clear adhesive paper. Put the loose pumpkins in a plastic bag. To play, have the children match the pumpkins.

WHOOO! BOO!

PREPARE FOR THE ACTIVITY

Gather The Materials
- Cut butcher paper the size of your bulletin board.
- Pour thin layers of black and orange tempera paint into shallow pans.
- Have: Halloween cookie cutters
 construction paper
 tissue paper
 ink pads
 marbles
 markers

Talk With The Children: Before Halloween discuss different holiday figures and symbols with the children. As they talk, make a list of the various characters they mention. Use their ideas to help create the Halloween bulletin board. Tell the children that they will be printing the background for the bulletin board with Halloween cookie cutters and then adding the spooks and other Halloween characters they had thought of.

ENJOY THE ACTIVITY

Lay the piece of butcher paper on the floor with the cookie cutters and the pans of tempera paint around the edges. Using the cookie cutters, have the children print Halloween characters all over the paper. As they are printing, enjoy talking with them about the characters, masks, and other traditions of the holiday. Let the background dry thoroughly and then fasten it to the bulletin board.

For the next several days, add to the bulletin board. Depending on what was on their list, they might stuff tissue paper ghosts, make thumbprint cats using black ink pads, marble paint witches, and decorate funny faced jack-o-lanterns with markers.

DISPLAY THE "HALLOWEEN CHARACTERS"

Let the children add their Halloween figures as they create them. Encourage the children to look at the bulletin board each day and watch it develop. The children might want to make chains to border the bulletin board.

EXTENSION:

Read the story *CLIFFORD'S HALLOWEEN,* by Norman Bridwell.

HIDDEN COLORS

PREPARE FOR THE ACTIVITY

Gather The Materials

- Cut butcher paper the size of your door.
- Have: all colors of crayons
 black tempera paint in shallow dishes
 wide brushes
 heavy-duty tape

Talk With The Children: Cut large felt circles to match each of your crayon colors. Pass the crayons to the children, let them hold their crayons and name the colors. Put one felt circle on the felt board. Ask the group what color it is. After they have named the color, take the felt piece off the board, put it on the floor, and have the children with the matching crayons put them on top of the felt circle. Continue matching the crayons and felt circles.

Tell the children that at art they are going to color a large piece of paper with all of the crayons. After the paper is full of color, they will cover the colors up with black paint. When the paint has dried, they can use their fingernails to scratch designs in the paint.

ENJOY THE ACTIVITY

Lay the piece of butcher paper on the floor in the art area. Distribute the crayons around the edges of the paper. When the children come to art, encourage them to use a variety of colors as they scribble the entire piece of paper. Talk about the colors as they crayon. Also discuss the different ways children are using their crayons — long strokes, short ones, soft and hard ones, curved lines and straight ones, and so on. Let them continue until the paper is as full of color as possible. When finished, have the children paint the entire piece of paper with black paint — be sure to cover all of the crayon color. When it is thoroughly dry, the children can use their fingernails to scratch designs and pictures in the black paint. What happens as the children scratch the paint?

DISPLAY THE *"HIDDEN COLORS"*

After all of the children have scratched designs in the paper, have several of them help you carry it over to the door and hang it up. Each day look carefully at the designs — find specific colors, look for shapes, maybe scratch additional designs, and so on.

EXTENSION:

Have a crayon treasure hunt. After you have hidden all of the crayons, tell each child a specific color of crayon to look for. When you say "Go" have everyone begin hunting. As they find their specific color, have them pick the crayon up, bring it to you, and put it into a crayon box.

NEWSPAPER GHOSTS

PREPARE FOR THE ACTIVITY

Gather The Materials

- Cut large ghost shapes out of newspaper OR draw very simple ghost shapes on newspaper.
- Have: a warming tray
 crayons with paper taken off
 (let the children do that)
 several potholders
 blunt-tipped scissors
 cellophane tape

Talk With The Children: As Halloween approaches, talk with the children about the different characters they could dress-up to be — some children like to pretend to be funny figures, some like to be animals, some like to dress-up as ghosts and other scary things. Pick several characters such as ghosts, witches, and queens and encourage the children to move and talk like these characters.

Tell the children that at art they can color ghosts to hang in the window. Show them the warming tray. Discuss how to use it as well as safety precautions they need to follow.

ENJOY THE ACTIVITY

Put the warming tray in a safe, fairly inactive corner of the art area. Turn it on a low setting. Put the crayons and potholders near the warming tray. Have the ghosts and scissors on the art table. First let the children cut out as many ghost shapes as they would like. When they have finished cutting, they should bring the ghosts to the warming tray. Put a ghost on the tray, hold it in place with the potholder, and slowly color.it with a variety of crayons. As the children move the crayons on the shape, the warmth from the tray will melt them.

DISPLAY THE *"GHOSTS"*

As the Ghosts are finished, have the children tape them to the window. Continue until all of the Ghosts are flying in the sunshine.

EXTENSIONS:

Enjoy the rhyme with the children:
BOO!
I'm a friendly ghost you know, (Have the children kneel)
But I can scare you too. (Point to each other)
I'll put on my scary face, (Have the children bend over)
And then I'll call out "Boo!" (Pop up when they say "Boo")
Read *GEORGIE* by Robert Bright to the children.

NATURE WEAVING

Gather The Materials
- Get two sturdy sticks that are approximately two feet long.
- Cut four or five long pieces of heavy twine.
- Gather long natural items which grow in your locale — willow branches, corn stalks, cattails, etc.

Talk With The Children: Show the children the sticks and twine you are going to use to build the loom for the nature weaving. Tell them that after the loom is built, they will be able to weave willow branches, corn stalks, etc. in and out of the heavy twine. Show the children some of these materials and talk about them. Are any of them taller than the children? Which ones?

ENJOY THE ACTIVITY

Have the children lay the two sticks in the art area. Let them help you tie strands of twine between the sticks, leaving about six inches between each strand. Hold the loom up to make sure that the twine is securely fastened to the sticks.

Bring in the materials the children will weave through the loom. Because the materials are long, it may take several children weaving together to complete one row. Continue until all of the items have been woven and the loom is full.

DISPLAY THE "NATURE WEAVING"

Hang the Weaving on the wall. Remember to hang it low enough so the children can easily see it.

EXTENSION:

Encourage the children to bring in smaller pieces of nature such as peach stones, nuts, and pinecones. Let them find little nitches in the weaving for their item. If necessary, glue the item to the weaving.

ME

PREPARE FOR THE ACTIVITY

Gather The Materials
- Have: roll of butcher paper
 tempera paint
 brushes
 heavy marker
 full-length mirror
 heavy-duty tape

Talk With The Children: Enjoy the rhyme:
HEAD, SHOULDERS, KNEES, AND TOES
Head, shoulders, knees, and toes,
Knees and toes.
Head, shoulders, knees and toes,
Knees and toes.
Eyes and ears and mouth and nose.
Head and shoulders,
Knees and toes, knees and toes!

Tell the children that you are going to trace their bodies on long sheets of paper and then they can dress themselves with paint. You would like them to think about how they are going to lie on the paper. Have them lie down on the floor and practice lying in different positions.

ENJOY THE ACTIVITY

Put the paint and brushes in the area on the floor where the children will paint. Set up a full-length mirror nearby. Roll the butcher paper out on the floor. Have a child lie down. Trace around his body with a heavy marker. Identify the major body parts as you draw. When finished, have the child carry his tracing over to the painting area and dress himself with tempera paint. Encourage him to use the full length mirror to look at his eyes, hair, clothes, etc.

DISPLAY THE *"ME TRACINGS"*

After each child's tracing has dried, have him choose a spot on the wall where he would like to hang it. Help him tape it securely. As you are fastening it, discuss what he is wearing in the tracing, the color of his eyes, and so on.

EXTENSION:

Put a growth chart on the wall and record the children's heights and weights each time they make a Me hanging. (See February, April, and July for additional Me activities.)

ORANGE PUMPKIN

PREPARE FOR THE ACTIVITY

Gather The Materials
- Cut a large posterboard pumpkin out of posterboard.
- Have: several different types of orange papers
 glue
 heavy-duty tape

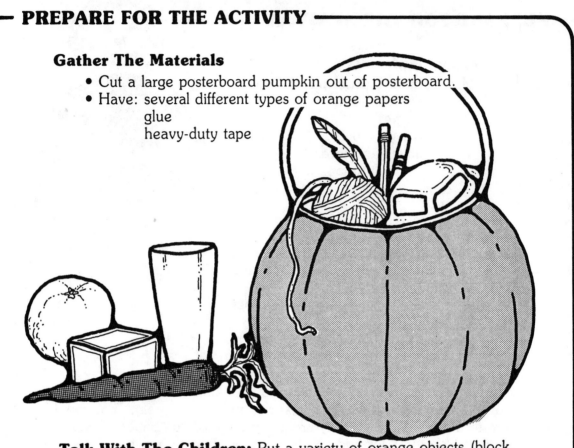

Talk With The Children: Put a variety of orange objects (block, orange, car, yarn, etc.) in a plastic pumpkin. Bring it to show the children. Talk about the color orange as you pull the different items out of the pumpkin. Now show the children the large posterboard pumpkin. Tell them they are going to glue all types of orange scraps on it at art.

ENJOY THE ACTIVITY
Put the pumpkin shape in the middle of the art table with the orange paper scraps and glue on the sides. The children can glue the materials to the pumpkin.

DISPLAY THE *"ORANGE PUMPKIN"*
Tape the Orange Pumpkin low on a wall. Throughout October encourage the children to bring in more orange materials that can be glued to the pumpkin. Glue them each day during free play. At the end of October, move the pumpkin to the Wall of Colors (see September, Red Apple).

EXTENSION:
Have the children paint a dozen or so orange spring-loaded clothespins. Put them in a bucket. As children see orange things in the classroom, have them get an orange clothespin and clip it to the object.

FALLING LEAVES

— PREPARE FOR THE ACTIVITY —

Gather The Materials

- Collect lots of brown leaves.
- Outline very simple leaf shapes onto fall colored construction paper.
- Get a fallen branch.
- Have: slightly watered down white glue
 brushes for the glue
 blunt-tipped scissors
 several small plastic tubs
 paper punch
 narrow ribbon

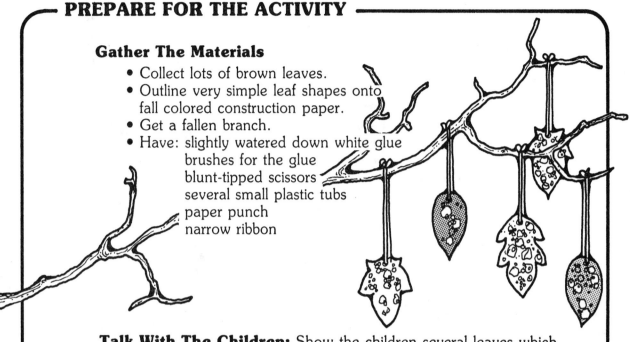

Talk With The Children: Show the children several leaves which have stayed green, some which still have their fall colors, and others which have dried and turned brown. Talk about this sequence.

Pass the tub of brown leaves around. Let the children feel them — crunch them — smell them. Tell the children that you are going to put the leaves on the Discovery Table along with a tray and rolling pin. You would like them to crush the leaves during free play. Tell the children that at art they are going to glue the crushed leaves onto construction paper leaves.

ENJOY THE ACTIVITY

Have the construction paper leaves, crushed leaves, scissors, and glue at the art table. When the children are ready to enjoy the activity, have them first choose a colored paper leaf, cut it out, and brush one side with glue. When the glue has been spread over the leaf, have the children sprinkle the crushed brown leaves over the colored leaf. If the children would like, add crushed leaves to the other side. Let the leaves dry. Punch a hole in each leaf, cut a short strip of ribbon, and loop it through.

DISPLAY THE *"LEAVES"*

Bring the branch into the art area and let the children hang their Leaves on it. When all of the Leaves are attached, hang the branch from the ceiling or stand it in a bucket of sand.

EXTENSION:

Next time you walk outside, take a rake with you. Let the children rake up the fallen leaves into a pile and then enjoy jumping and romping in them.

SILLY SPOOKS

PREPARE FOR THE ACTIVITY

Gather The Materials
- Have: bulk cotton
 sheets of construction paper
 scraps of construction paper
 blunt-tipped scissors
 glue in shallow containers
 narrow elastic
 cellophane tape

Talk With The Children: Use a ghost puppet while talking to the children. After a friendly discussion, have him teach the children several rhymes about what spooks do on Halloween night.

FIVE LITTLE SPOOKS
Five little spooks on Halloween night.
Made a very, very spooky sight.
The first one danced on his tippy-tip-toes.
The next one tumbled and bumped his nose.
The next one jumped high up in the air.
The next one walked like a fuzzy bear.
The next one sang a Halloween song.
Five little spooks played the whole night long!

FIVE LITTLE WITCHES
Five little witches sitting on a gate;
The first one said, "My it's getting late!"
The second one said, "There are goblins
* in the air!"*
The third one said, "But we don't care."
The fourth one said, "Let's run, let's run."
The fifth one said, "It's Halloween fun."
"Wooooooooo" went the wind.
And out went the lights.
Those five little witches ran fast
* out of sight.*

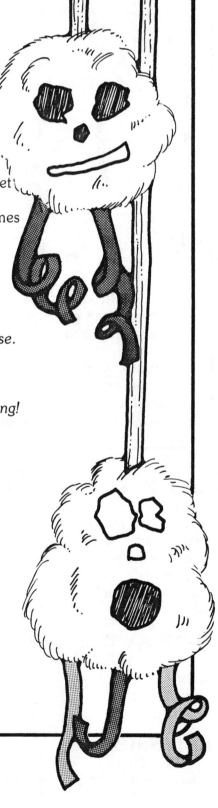

ENJOY THE ACTIVITY

Have the cotton, construction paper, scissors, glue, and paper scraps on the art table. When the children come to art, help them tear a wad of cotton off of the big piece and fluff it into a ball. First the children can add legs to their spooks by cutting narrow strips of construction paper, dipping the ends in glue, and sticking them around the bottom of their cotton wads. (If the children would like, they can curl the legs by wrapping the strips around their fingers or pencils before gluing them.) After gluing as many legs on the Silly Spooks as they'd like, have them use the paper scraps for a face.

DISPLAY THE *"SILLY SPOOKS"*

When each child is finished, have him cut a piece of elastic and tape it to the head of his Silly Spook. Hang the spooks from the ceiling. Watch them dangle as the elastic moves.

EXTENSION:

Play a group game called *Spook-E-Do.* Tell the children that each of them is going to have the opportunity to show the others a trick or lead them in an exercise. Give them a minute to think about their trick or exercise. Call on a child. Have him stand where everyone can see him. The group chants:

> *Hello Shelley, Spook-E-Do.*
> *What is the trick you're going to do?*
> *Will you hop or bend or spin around?*
> *Stretch or wiggle or touch the ground?*

Let the child do his stunt or lead his exercise. Continue with all of the Silly Spooks in the group.

HARVEST CHARACTER

Gather The Materials
- Collect samples of all types of fall harvest — pumpkins, a variety of gourds, corn shucks, etc.
- Gather clothes to dress the Harvest Character — a pair of coveralls, boots, a hat, etc.
- Have: lots of newspaper
 old broom
 chair
 knife
 small nails
 hammer

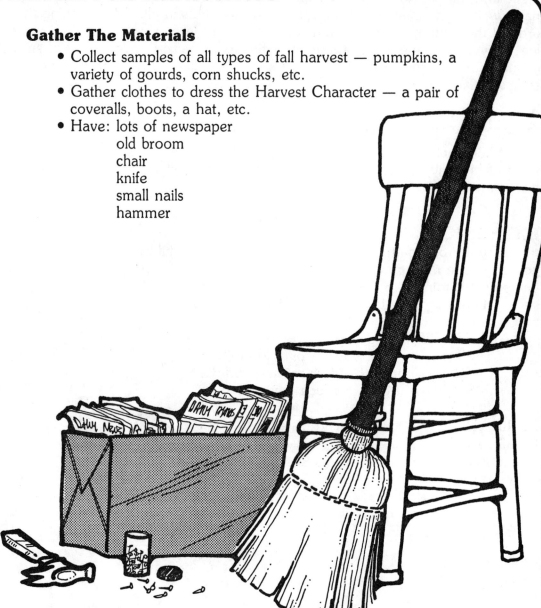

Talk With The Children: Fall is a time of leaves, pumpkins, gourds, harvest, and so on. Put a variety of gourds and vegetables on the Discovery Table for the children to examine. You might add a magnifying glass, a scale, and baskets for sorting.

Many people make Harvest Characters to celebrate this season. Bring the pair of coveralls to show the children. Tell them that at art they are going to construct a Harvest Character. First they will wad the newspaper and stuff it in the coveralls. Next they will create his head using a pumpkin, the gourds and vegetables.

ENJOY THE ACTIVITY

First create the body of your Harvest Character. Bring the coveralls and newspaper to the art table. Have the children wad-up pieces of newspaper and stuff them into the coveralls. Put the legs into the boots. When the character is stuffed full, poke the broom (brush down) through his coveralls to his waist, and then prop him onto a chair. (If your broom is too long, tie it to the back of the chair rather than poking it through his coveralls.)

Create his head, using a pumpkin. Have the variety of fall harvest on the table. First cut one hole in the bottom of the pumpkin for the broom handle to fit through. Now cut holes and slits in the pumpkin for different size gourds and vegetables. (Use small nails if you need to tack any of them more securely.) Add corn husk or corn silk hair and finish him off with a sloppy hat.

DISPLAY THE *"HARVEST CHARACTER"*

When he's all ready, let him sit outside the classroom door to greet everyone who comes in and goes out.

EXTENSION:

Continue to talk about the different vegetables harvested this time of year. Use some of them to make vegetable soup with the children. Let them clean and prepare the vegetables (remember safety). As you are all working, talk about each vegetable. Talk about them again while you are enjoying the warm soup you cooked.

PUMPKIN STACK

PREPARE FOR THE ACTIVITY

Gather The Materials
- Get five or six pumpkins ranging in size from large to small.
- Have: a sharp knife
 scoops
 permanent markers
 newspaper
 plastic tub

Talk With The Children: Bring the five or six different sized pumpkins for the children to see. Talk about which one is the largest and which one is the smallest. Line them up from largest to smallest. Count them. Mix them up. Now arrange them from smallest to largest. Tell the children that at art they are going to clean out the pumpkins, draw faces on them with markers, and then build a totem pole.

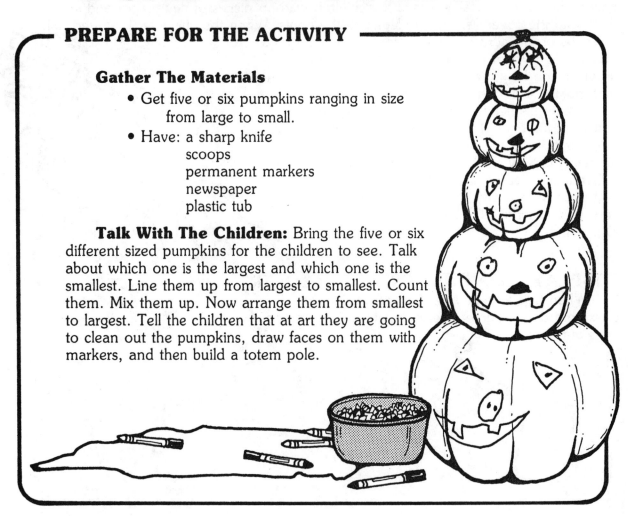

ENJOY THE ACTIVITY

Spread a thick layer of newspaper on the art table. Put the two largest pumpkins on the table. Cut the tops off and let the children scoop out the insides. Save the insides in a plastic tub. Let the children clean the other pumpkins on the next day.

When the pumpkins are all cleaned out, wipe the outside skins dry. Put a variety of markers on the table and let the children decorate the pumpkins.

DISPLAY THE *"PUMPKINS"*

Put all of the pumpkin tops, except the smallest one, off to the side. Beginning with the largest pumpkin on the bottom, stack the pumpkins into a totem pole. (You may have to trim the opening to get them to fit securely.) Place the top on the smallest pumpkin.

EXTENSIONS:

Clean some of the pumpkin seeds and bake them for a snack.

Put a pumpkin and several washable markers on the Discovery Table. Encourage the children to draw faces on the pumpkins, wash them off, and make some more.

YARN TOSS

PREPARE FOR THE ACTIVITY

Gather The Materials

- Have: large box with a lid from grocery store
 all colors of tempera paint
 brushes
 7-8 skeins of different colored medium-weight yarn
 utility knife

Talk With The Children: Pass beanbags to each child. Put a plastic tub on the rug in the middle of the group. Have the children count backwards from ten to zero. When they say "Zero" have them toss their beanbags into the tub. Gather up the beanbags, pass them out again, count, and toss.

Show the children the skeins of yarn. As you hold up each one, have them call out its color. Tell the children that at art they are going to make a tossing game for the classroom by winding yarn balls and painting a large box.

ENJOY THE ACTIVITY

Place the box, paints, and brushes at one end of the art table. Have the children paint all sides of the box. Let it dry. When dry, cut a large shape in each of the four sides.

At the other end of the art table drape several skeins of yarn over chairs. Start several yarn balls for the children and let them continue to wind the yarn around and around. The children can continue to wind as long as they want. Another child can pick up the ball and continue. When each ball is large enough, cut the skein and tuck the end of the yarn securely into the yarn ball.

DISPLAY THE "YARN TOSS GAME"

Put the box in an open area of the room. Add the yarn balls and begin tossing.

EXTENSION:

Use the yarn balls for a variety of other games.
- Roll yarn balls to each other.
- Play a musical record. Pass a ball around the circle. Stop the music. Who has the ball? Start the music and continue.
- Make a large target. Tape it to the wall and let the children throw the yarn balls at it.
- Hang a small basketball hoop. Toss the ball through the hoop.

PUMPKIN FACES

PREPARE FOR THE ACTIVITY

Gather The Materials

- Have: large grocery bag
 scraps of orange and assorted
 other colors of construction paper
 glue
 stack of newspapers
 heavy-duty tape

Talk With The Children: Make a pumpkin spinner game and play it with the children. Cut a large circle out of a piece of posterboard. Divide the circle into eight equal sections. Draw one part of a jack-o-lantern face in each section — eye, nose, mouth, ear, eyebrow, tooth, stem, and free space. Cover it with clear adhesive paper and attach a spinner. Cut a large orange pumpkin. Cut the appropriate number of individual features to match the ones on the spinner board. Put the pumpkin and spinner board on the floor so all of the children can see them. Pass out the individual features to the children. Have one child flick the spinner and call out what feature it stops at. A child who has that feature should put it on the pumpkin. If it stops on the free space, have one child add his feature. (If there are more than one of a certain feature, only one should be placed per spin.) Continue until the pumpkin has his entire face. Talk about all of the features.

Tell the children that at art they can create a different kind of Pumpkin Face by gluing scraps of paper to a large paper bag.

ENJOY THE ACTIVITY

Put the grocery bag, glue, and orange construction paper pieces on the art table. Have the children turn the bag into a pumpkin by gluing the orange pieces onto the bag until it is covered. Put the other colors of paper pieces on the art table and let the children glue a face on each side of the bag. After the face has been created, wad up pieces of newspaper and stuff the bag until it is round and full. Shape your pumpkin a little and tape it closed. Make several Pumpkin Faces if the children would like.

DISPLAY THE *"PUMPKIN FACES"*

Put the Pumpkin Faces on a table or shelf in the classroom. At snack time, put them on the snack table and enjoy talking about times when the children have carved pumpkins.

EXTENSION:

Expand the spinner game. Make several pumpkins and sets of features. Give each child playing the game a pumpkin and a set of features. Have the children take turns flicking the spinner and making faces on their pumpkins.

HALLOWEEN PARTY

PREPARE FOR THE ACTIVITY

Gather The Materials
- Cut butcher paper the size of the table where you will eat.
- Cut sponges in the shapes of different Halloween figures.
- Have: tempera paint in shallow pans
 a roll of heavy-duty paper towels

Talk With The Children: Let the children help you plan and prepare for the classroom party. Discuss snacks, special activities, and decorations. As you talk about each phase of the party, make a list of their suggestions. Use their ideas. One thing you can suggest is that they decorate the tablecloth for the party. Show them the Halloween figures you cut out of sponges. Tell them that at art they can sponge paint the tablecloth.

ENJOY THE ACTIVITY

Several days before the party, decorate the tablecloth. Spread the butcher paper on the floor with the paint and sponge shapes around it. Let the children sponge paint their tablecloth with all of the Halloween figures. Let it dry. If the children would also like to decorate their napkins, have them choose one of their favorite shapes and make a print on heavy-duty paper towels.

DISPLAY THE *"TABLECLOTH"*

When the children set the table for the party, have them begin with their own Tablecloth. As they eat, have them identify the different shapes they sponge painted.

EXTENSIONS:

The children can also make the snack for their party. Using Halloween cookie cutters, have them cut bread into Halloween shapes. Spread the shapes with a variety of soft cheeses. Arrange the snack on a tray and enjoy eating.

Enjoy this game at your party. Let the children make paint stick pumpkin puppets. Each child should cut out two pumpkins. He should decorate one and leave the other one plain. Glue the jack-o-lantern and the plain pumpkin back to back on a paint stick. Using the puppets, say this rhyme:

PUMPKIN TWIST

Pumpkin, pumpkin round and fat, (Have the plain side facing out)
Become a Jack-O-Lantern
Twist like that! (Twist the puppet to the jack-o-lantern side)

RIBBON SCULPTURE

Gather The Materials
- Have: variety of colors of ribbon
 blunt-tipped scissors
 sturdy stools

Talk With The Children: Once most of the leaves have fallen off of the trees, bring a large empty branch to show the children. Ask them, *"Why is this branch empty?"* Discuss what happened to the leaves. After discussing the whole process of the leaves turning colors and falling off of the trees, ask the children if they like trees better with the colored leaves hanging on them or with no leaves.

Show the children the different spools of ribbon you brought. Tell them that when they go outside, they can add color to the trees by cutting pieces of ribbon and draping them over, under, around, and through all of the branches they can reach.

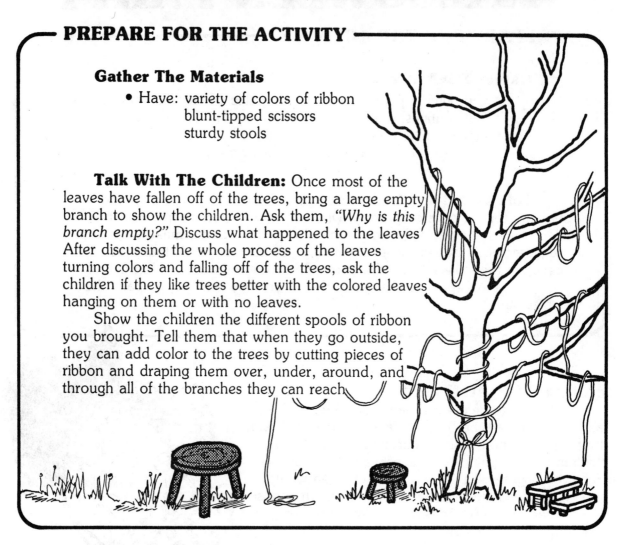

ENJOY THE ACTIVITY

Bring the stools, scissors, and ribbon outside. Look at the different available trees. Decide which ones to sculpture with colored ribbons. As the children want to take a break from their large muscle play, they can choose a ribbon, cut off a piece, and wind it around the tree branches. Continue, using as many pieces of ribbon as they want.

DISPLAY THE "SCULPTURED TREE"

After the tree has been sculptured, have the children enjoy it. Talk about what colors they used, how long their pieces were, any special designs they see, and so on.

EXTENSION:

Put the large branch you originally showed the children on the Discovery Table. Add the ribbons and scissors. Let them ribbon sculpture an inside branch. When finished, plant it in a large bucket of sand.

GOBBLE, GOBBLE

PREPARE FOR THE ACTIVITY

Gather The Materials
- Cut butcher paper the size of your bulletin board.
- Pour tempera paint into shallow pans.
- Draw very simple turkey shapes on construction paper.
- Have: Indian corn
 corn cobs
 blunt-tipped scissors

Talk With The Children: Turkey is one food that the Pilgrims and Indians ate on Thanksgiving. Enjoy this rhyme about the turkey.

THE TURKEY

The turkey is a funny bird.
His head goes wobble, wobble.
And all he says is just one word,
"Gobble, gobble, gobble."

Tell the children that they are going to make a field full of turkeys for the bulletin board. First they will paint the background using Indian corn and then print turkeys with corn cobs.

ENJOY THE ACTIVITY

Spread the butcher paper on the floor and put the pans of light-colored tempera paint and pieces of Indian corn around it. When the first children come to art, have them take pieces of corn and roll them around in the tempera paints. As each ear is covered, let a child paint the paper by rolling the corn on it. When finished with an ear, put it back into the paint pan. Continue painting with the same piece of corn or with another piece covered with a different color. Watch the design develop. When it has dried, hang it on the bulletin board.

Put the turkeys, corn cobs, and pans of dark-colored tempera paint on the table. Let each child choose a turkey shape and cut it out. Have him roll a corn cob in the paint and then roll it over the turkey. Continue printing until the turkeys are covered.

DISPLAY THE "TURKEYS"

After the turkeys have dried, let the children tack them to the bulletin board. You might want to add bunches of clean Indian corn and corn cobs to the bulletin board.

EXTENSION:

When you and the children greet each other, say *"Gobble, gobble, Eric"* instead of *"Hello, Eric."* They can respond *"Gobble, gobble, Mrs. Burt."*

PATCHWORK QUILT

PREPARE FOR THE ACTIVITY

Gather The Materials
- Cut light-weight posterboard into twelve inch squares. These will be hung on your bulletin board, so check the dimensions and make adjustments in the size of the squares to fit the board.
- Have: crayons
 paper punches
 marker
 medium-weight yarn
 blunt-tipped yarn needles

Talk With The Children: Show the children a quilt. Tell them that people used to (and some still do) make all of their own blankets. People made many different kinds, some were warm and fluffy, others were lightweight; some were plain, and others had designs. Some of the blankets that had designs in them were called patchwork quilts. In these, people sewed designs in squares of fabric and then sewed all of the decorated squares together.

Show the children the posterboard squares. Tell them that at art they are going to pretend that these squares are fabric and they can crayon designs on them just like people sew designs on fabric squares.

ENJOY THE ACTIVITY

Put the squares, crayons, and paper punches on the art table. Encourage each child to color a design on at least one square. After each child is finished, make dots about two inches apart around the edges of the square. Have the child punch holes through the marks on his square. When all of the squares have been colored and punched, put the needles and yarn on the art table. Help the children arrange the squares and sew them together. Finish by sewing a border around the outside edges of the quilt.

DISPLAY THE *"QUILT"*

Hang the Quilt on your bulletin board. If you have a real patchwork quilt, put it on a table near the bulletin board for the children to look at.

EXTENSION:

Secure pieces of burlap into embroidery hoops. Using yarn and yarn needles, let the children sew designs on the fabric.

THANKSGIVING MURAL

⎯ PREPARE FOR THE ACTIVITY ⎯

Gather The Materials

- Cut butcher paper the size of your bulletin board.
- Cut large (6"- 8") T-H-A-N-K-S-G-I-V-I-N-G letters out of flat pieces of styrofoam. Make a handle by gluing a 2 inch piece of dowel rod into each letter.
- Pour thin layers of tempera paint into shallow containers.

Talk With The Children: Cut the letters THANKSGIVING out of felt. Put them on the felt board and read the word to the children. Talk about the fact that during Thanksgiving many people think about people they love. At the top of a piece of chart paper write *"People I Love."* Have the children slowly and quietly call out different people they love. As they do, write down the names — remember there will be duplicates. Talk a little about how they show love to each other.

After talking about the people they love, show the children the styrofoam letters you cut out. Tell them that at art they are going to use these letters to print a Thanksgiving Mural.

ENJOY THE ACTIVITY

Lay the butcher paper on the floor in the art area. Put several letters in each paint container and distribute them around the paper. When the children come to the art area, let them print as many letters as they wish. As they are printing, talk about Thanksgiving, the colors of the paint, letters, etc.

DISPLAY THE *"THANKSGIVING MURAL"*

When the paint has dried, hang the mural on your bulletin board. Tack the list of people whom the children love onto the mural.

EXTENSION:

Write several lists with the children of different things for which they are thankful such as favorite foods, toys, and animals. Add these to the bulletin board.

MR. TURKEY

Gather The Materials
- Cut a large turkey shape out of tagboard.
- Have: popsicle sticks/tongue depressors

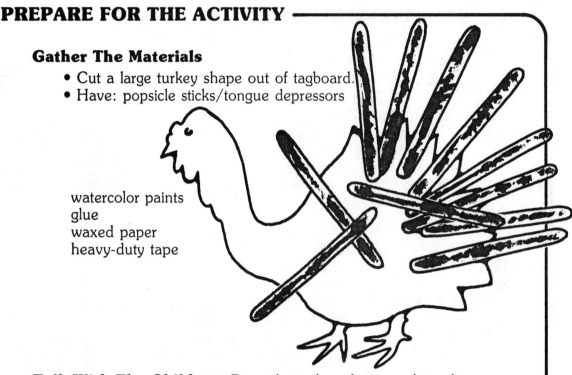

watercolor paints
glue
waxed paper
heavy-duty tape

Talk With The Children: Bring the turkey shape to show the children. Pretend he has feathers. If he had feathers, what color would they be? How would the feathers feel? Why do turkeys grow feathers? Do people grow feathers? Why or why not? Tell the children that at art they can add feathers to the turkey by watercoloring the popsicle sticks/tongue depressors and gluing them onto Mr. Turkey.

ENJOY THE ACTIVITY

Put the watercolors and popsicle sticks/tongue depressors on the table. Have the children paint the sticks and lay them on a piece of waxed paper to dry. Put Mr. Turkey and the glue on the table. Pretend the sticks are turkey feathers and glue them onto his body. As the children are gluing, talk about all of the colors Mr. Turkey is wearing.

DISPLAY "MR. TURKEY"

Let Mr. Turkey dry overnight. When the children come to school, have them check to see if all of the feathers are firmly attached. Hang him low on the door with heavy-duty tape.

EXTENSION:

Play *"Duck, Duck, Turkey"*, a simple variation of the game *"Duck, Duck, Goose"*.

NUT WREATH

⌐PREPARE FOR THE ACTIVITY⌐

Gather The Materials
- Cut a sixteen inch circle from corrugated cardboard. A large pizza board is perfect. Cut a hole in the center.
- Collect a variety of nuts and pinecones. Separate each material onto a separate tray.
- Have: glue
 heavy-duty tape
 bow

Talk With The Children: Bring the base and one or two of each type of nut and pinecone to show the children. Let them feel the textures. Are some bumpy, smooth, prickly, and other textures? Talk a little about their shape.

Tell the children that at art they will be gluing the nuts and pinecones to the base. Because most of the materials have curves, they will be a little more difficult to glue and the children should hold them to the base a little longer than if they were flat.

ENJOY THE ACTIVITY

Place the glue and the corrugated base in the middle of the art table. Put the containers of nuts and pinecones at the ends of the table. The children should pick several materials, glue them to the base, and then choose several more. Continue until the base is full.

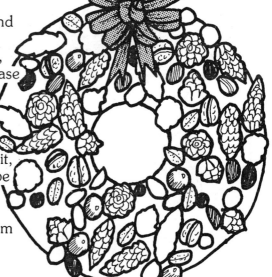

DISPLAY THE "NUT WREATH"

Let the wreath dry thoroughly. Before hanging it, have the children check the nuts and pinecones to be sure they are securely glued on. When everyone is sure the wreath is ready, add a bow for color, and hang it at children's eye-level on one of the classroom doors or maybe the front door of the school.

EXTENSIONS:

Have a bowl of nuts in the shell. Crack the nuts with the children and enjoy them along with a glass of apple juice for snack.

Put a bowl of different nuts and a muffin tin on the Discovery Table. Encourage the children to sort the nuts into the muffin cups.

TURKEY SUNCATCHER

PREPARE FOR THE ACTIVITY

Gather The Materials

- Fold a piece of construction paper in half. In the center, cut a simple turkey silhouette through both halves of the paper.
- Have: crayons with the paper peeled off (the children can peel them)

 individual pencil sharpeners or potato peelers
 meat trays
 roll of waxed paper
 electric iron
 blunt-tipped scissors
 stack of newspapers
 thin ribbon
 glue
 cellophane tape
 paper punch

Talk With The Children: Enjoy this art activity on a sunny day. Talk about the sun and the different things it does for us. Let the children walk over to the windows and stand there. Can they feel the warmth of the sun?

Show the children the turkey frames you cut out. Tell them that at art they are going to be making Turkey Suncatchers by melting crayon shavings between waxed paper and putting them in the turkey frames. Remember to discuss safety while using the sharpeners and iron.

ENJOY THE ACTIVITY

On the day the children are making the turkeys have them shave the crayons onto several meat trays. Designate a special place to do the ironing. (Take extra caution with the warm iron.)

Have the waxed paper and shaved crayons on the table. When each child comes to art, help him tear off a piece of waxed paper. He can sprinkle crayon shavings onto the paper, carry it over to where the iron is, and lay it on the stack of newspapers. Have the child tear off another piece of waxed paper and lay it over the crayon shavings. Together cover the waxed paper with several pieces of newsprint and iron it until the shavings have melted.

After melting the shavings, let each child pick a turkey frame. He should open it up and drizzle glue along the entire inside edge. Now lay the waxed paper on one side of the frame and close it, pressing down firmly around the edges so the glue seals the waxed paper to the frame. Hold it up to the sun. Can the child see the brightly colored turkey? When the turkey has dried, the child can trim off any excess waxed paper that is sticking out of the frame.

DISPLAY THE *"SUNCATCHERS"*

The children should punch holes in the top of their Suncatchers and loop pieces of ribbon through them. Hang each turkey in the window as the children finish.

EXTENSION:

Take a field trip to a nearby turkey farm or zoo which features turkeys in the fall.

JACK FROST DESIGNS

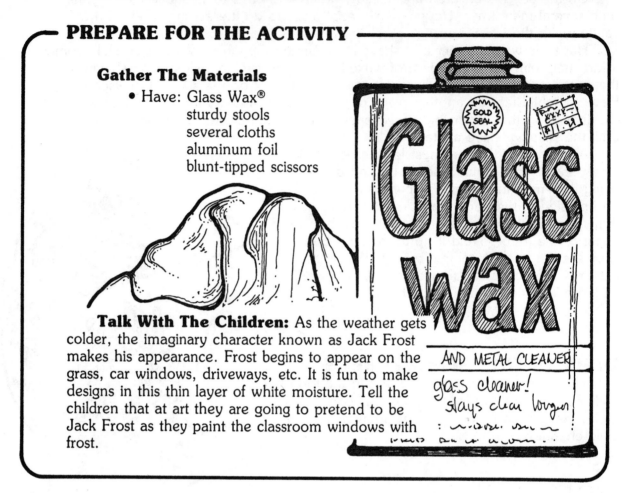

PREPARE FOR THE ACTIVITY

Gather The Materials
- Have: Glass Wax®
 sturdy stools
 several cloths
 aluminum foil
 blunt-tipped scissors

Talk With The Children: As the weather gets colder, the imaginary character known as Jack Frost makes his appearance. Frost begins to appear on the grass, car windows, driveways, etc. It is fun to make designs in this thin layer of white moisture. Tell the children that at art they are going to pretend to be Jack Frost as they paint the classroom windows with frost.

ENJOY THE ACTIVITY

Bring the Glass Wax®, cloths, and stools over to the windows. Let the children pretend to be Jack Frost as they spread Glass Wax® on the windows. Using their fingers, fingernails, hands, knuckles, and fists, encourage them to create all types of designs on the windows. As they are making their designs, have them periodically stand back and look at their creations.

DISPLAY THE *"JACK FROST DESIGNS"*

The designs are on the windows. Add a border of fringed aluminum foil. Tear pieces of aluminum foil to fit around your windows. Lay the foil the long way on the table. Fold the top side of the foil halfway down to strengthen the edge. Now let the children snip the bottom half of the aluminum foil, stopping when they get to the fold. When all of the foil has been fringed, frame the Jack Frost Designs.

EXTENSION:

Encourage the children to look for frost each morning when they awake. If they have a little extra time before going off to school, suggest they dress warmly, go outside and make designs in the real frost.

BLUE STAR

PREPARE FOR THE ACTIVITY

Gather The Materials
- Cut a large star shape from posterboard.
- Have: variety of blue papers
 meat trays
 watered-down glue
 brushes for the glue
 heavy-duty tape

Talk With The Children: Show the children the large star. Have them lie down on the floor and close their eyes. Pretend it is night and all of the stars are glowing in the sky. As they are lying there picturing the stars, have them sing *"Twinkle, Twinkle, Little Star"*. When they open their eyes, tell them that at art they are going to glue different types and shades of blue paper onto the star.

ENJOY THE ACTIVITY
Before the art activity, have the children tear the blue papers into small pieces and put them on meat trays. Put the star in the middle of the table, arranging the containers of glue and blue papers around it. Begin by brushing glue on a section of the star and layering pieces of the blue paper on top. Continue until the star is complete.

DISPLAY THE *"BLUE STAR"*
Hang the star low on a wall. During November encourage the children to look for more blue materials they can add to the star. Glue them as they bring them in. At the end of November, add the Blue Star to the array of other colors being displayed on the Wall of Colors.

EXTENSIONS:
Tell the children to look at the stars in the sky. Talk about the stars and moon they might have seen. Did they see a lot of stars or just a few? How many?
Enjoy this rhyme with the children:

THE STARS
I watch the stars come out at night.
I wonder where they get their light.
I don't think they will ever fall,
So I'll reach up and pick them all.

THE TURKEY FAMILY

PREPARE FOR THE ACTIVITY

Gather The Materials
- Cut from tagboard five or six turkey shapes ranging in size from quite large to small.
- Pour different colors of fingerpaint into large trays.
- Have: heavy-duty tape
 brown and green crepe paper streamers

Talk With The Children: Thanksgiving is a holiday when many families get together and enjoy being with one another. Discuss all of the foods the children would like to have at their Thanksgiving Day meal. How many children would like to have turkey?

Show them the turkeys you cut out. Tell the children that at art they are going to give the turkeys their feathers by handprinting different colors of fingerpaint on the shapes.

ENJOY THE ACTIVITY

Put two of the larger turkey shapes on the art table with containers of paint placed around them. When the children decide to do art, have them handprint turkey feathers all over each of the turkeys. Encourage them to try different types of handprints such as with their fingers spread far apart and close together. Continue with the other turkey shapes.

DISPLAY THE *"TURKEY FAMILY"*

When all of the feathers have dried, bring the entire turkey family over to the wall. Let the children help you tape them up at their eye-level. You might want to add brown or green streamers under the turkeys to create a ground effect. Ask the children what they think.

EXTENSION:

Out of felt cut different size turkey shapes and colored feathers for each size turkey. Put the turkeys on the felt board and pass the feathers to the children, keeping one of each size for yourself. Point to the largest turkey. Hold up the largest feather. Ask, *"Who thinks he has this size feather to dress the largest turkey?"* Have children put the feathers on the turkey. Talk about the colors. Point to another turkey, hold up another feather, and dress him with feathers. Continue until all of the turkeys are covered with feathers.

THANKSGIVING WORDS

PREPARE FOR THE ACTIVITY

Gather The Materials

- Cut a piece of posterboard about 3″ by 24″.
- Cut 3″ by 8″ pieces of white posterboard.
- Draw large, simple feather shapes on different colors of construction paper.
- Have: markers
 blunt-tipped scissors
 glue
 paper punch
 yarn

Talk With The Children: Tell the children the story of the first Thanksgiving. If you have pictures of the Mayflower, log cabins, foods, canoes, or other related things, show them to the children as you relate the story.

When you finish telling the story, ask the children, *"What words do you remember me using when I told you about Thanksgiving?"* As they tell you the words they remember, write them on the posterboard cards. Tell the children that at art they are going to construct a mobile using all of their Thanksgiving words.

ENJOY THE ACTIVITY

Lay the long, narrow piece of posterboard, along with the feathers, scissors, markers, and glue on the art table. When the children come to art, have them cut out the feathers, add detail with the markers if they want, and then glue them to the base. When all of the feathers are glued, make the posterboard into a circle and staple it closed.

Let the children punch a hole through each of the Thanksgiving Words and loop various lengths of yarn through them. Suspend the cards from the headband by taping or tying the yarn to it.

DISPLAY THE *"THANKSGIVING WORDS"*

After the mobile has been made, punch eight holes on the top of the headband — one on each side of the circle. Loop eight pieces of yarn through these holes and hang from the ceiling.

EXTENSIONS:

When adults come to the center, encourage them to read the Thanksgiving Words to the children.

Add matching stickers to the words to help the children *"read"* them.

BEAN SCULPTURE

PREPARE FOR THE ACTIVITY

Gather The Materials
- Get a variety of large dried beans.
- Put plastic and wooden toothpicks on meat trays.

Talk With The Children: Bring the variety of dried beans to show the children. Pass them around. Name each kind, talk about its color, size, shape, and texture. Have the children help you pour the beans into a large pot of water or if you want to keep the types of beans separate, put each kind in a smaller pot. Soak them overnight.

The next day show the children the soaked beans. Talk about what happened to them. Tell the children that you are going to put the beans on the art table along with different types of toothpicks so they can build a bean sculpture.

ENJOY THE ACTIVITY

Put the materials on the art table. When children come to art, have them put the toothpicks and beans together in various ways. They can all work together to build one giant sculpture or work in small groups or individually. Continue adding beans and toothpicks until the sculpture is finished. Let it dry. When the beans harden, the sculpture will be very sturdy.

DISPLAY THE *"BEAN SCULPTURE"*

Carry the sculpture to the Discovery Table. Have magnifying glasses available. Encourage the children to look at all of the different types of beans through the magnifying glasses.

EXTENSION:

Let the children sort different beans. (Remember safety when using small objects.) Put four or five of each type of bean in a small plastic tub. Have a muffin tin available. Have the children look at each bean and put similar ones together in the individual muffin cups.

LOG CABIN

PREPARE FOR THE ACTIVITY

Gather The Materials
- Get a large appliance box.
- Have: brown tempera paint
 wide paint brushes
 utility knife for adult use only
 heavy-duty tape

Talk With The Children: Discuss the children's homes with them. Find out whose homes are built with wood, brick, or other materials. Then talk about the different rooms in the houses. After a short discussion, begin telling them about the Pilgrims' homes, how they were made with logs and usually had only one room.

Show the children the large box you brought. Tell them that they are going to paint it and pretend it is a log cabin.

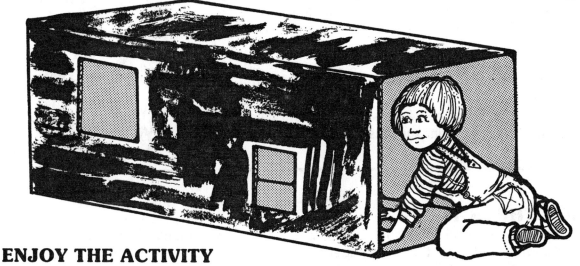

ENJOY THE ACTIVITY

Put the box in the art area and have the children paint it. Let it dry overnight. When completely dry, let the children decide where they would like their windows. Carefully cut the windows. Tape the edges so the cardboard will not fray.

DISPLAY THE *"LOG CABIN"*

Slide the Log Cabin into an open area where the children can pretend they are Pilgrims and Indians. Add appropriate accessories, such as dolls, cooking utensils, and a few pillows.

EXTENSION:

Take a walk around the neighborhood. Notice the different types of houses. Look carefully at what materials are used in their construction.

TOTEM POLES

Gather The Materials

- Have: paper towel rolls
 lots of bottle caps in several containers
 tempera paint (add a little liquid
 detergent so the paint adheres better)
 glue
 brushes
 newspaper

Talk With The Children: One thing the Indians of the Pacific Northwest used their tall timbers for was totem poles. They carved and painted images of animals, friends, and family on them. Have the children pretend that their family is going to create a totem pole. Ask them to name favorite animals which they would like to put on the totem pole. What else would they like to carve into the tall timber?

Tell the children that at art they are going to use paper towel rolls and bottle caps to create totem poles for the classroom. As you are explaining the art activity, remember to talk about the fact that the paper towel rolls have curved surfaces, thus the children will need to press the bottle caps to the rolls a little longer than if they were flat surfaces.

ENJOY THE ACTIVITY

Put the paper towel rolls, bottle caps, and glue on the art table. When the children come to art have them get paper towel rolls and glue as many bottle caps onto them as they want. Let the totem poles dry thoroughly and then let the children decorate them with various colors of tempera paint. Put the totem poles on a sheet of newspaper while the paint dries.

DISPLAY THE "TOTEM POLES"

Let the children group the totem poles on tables, shelves, and cupboards throughout the classroom. Several would look nice as a centerpiece on the housekeeping table.

EXTENSION:

Get a tall stump. Let the children paint it. Put it in the hall right outside your door.

THANKSGIVING TABLECLOTH

PREPARE FOR THE ACTIVITY

Gather The Materials
- Cut butcher paper the size of the table you eat at.
- Pour thin layers of tempera paint into shallow dishes.
- Collect Thanksgiving cookie cutters.

Talk With The Children: Enjoy planning the classroom Thanksgiving feast with the children. It may be as small as a special snack or as large as an all-family gathering. Let the children help decide about food, decorations, games, and activities.

One thing the children can do is decorate the tablecloth. Show them the different Thanksgiving cutters. Name each one and talk about it. Tell them that at art they can print a tablecloth for the party using these cookie cutters and different colors of paint.

ENJOY THE ACTIVITY

Spread the butcher paper on the floor. Place the dishes of paint and the cookie cutters around the paper. Let the children sit around the paper and print all of the Thanksgiving symbols on their tablecloth. As they are printing, talk about Thanksgiving.

DISPLAY THE *"THANKSGIVING TABLECLOTH"*

On the day of your celebration, spread the Tablecloth over the table. What colors did the children use to print their symbols?

EXTENSION:

Use the cookie cutters again to make a Thanksgiving snack. Cut slices of cheese into Thanksgiving shapes. Serve the cheese with crackers.

ANIMAL FOOD

Gather The Materials

- Have: oranges
 bread slices
 blunt-tipped needles
 heavy-gauge thread

Talk With The Children: Begin discussing how people and animals prepare for the cold weather. Talk about animals who migrate south to warmer weather, those who hibernate, and then about animals who remain in the cold weather. Animals who stay in cold weather oftentimes need help to survive. One thing they need is food. People need to remember that once they begin to feed the animals they must continue throughout the winter months.

Show the children the oranges and bread. Tell them that at art they are going to string a garland of food for the animals.

ENJOY THE ACTIVITY

First have the children break each of the slices of bread into four or five pieces. Put the pieces into dishes. Cut the oranges into small wedges. Have the dishes of bread and oranges on the table. Help the children thread their needles and begin to string the food. Each child can string the bread and oranges for as long as he wants. When he is done, he can leave his thread on the table and another child can start from there.

DISPLAY THE "ANIMAL FOOD"

After several garlands of Animal Food have been completed, let the children put on their outer wear and hang the strands on a nearby tree or bush.

EXTENSIONS:

Make a large simple chart about the birds who eat at your feeder. (You will use it for four months.) Have the numbers 1-31 across the top of the chart and swatches of the basic colors down the left side. Cover with clear adhesive. Each day when you see a specific color bird, mark it in the appropriate box with a washable marker. (Wipe clean at the end of each month.)

Read.*MOUSEKIN'S WOODLAND SLEEPERS* by Edna Miller.

HOLIDAY COLOR

PREPARE FOR THE ACTIVITY

Gather The Materials

- Cut butcher paper the size of your bulletin board
- Use pinking shears to cut several medium to large Christmas tree shapes out of easel paper.
- Pour green tempera paint in shallow dishes.
- Have: all colors of tempera paint
 medium width brushes
 glitter
 tinsel
 evergreen sprigs
 plastic medicine droppers

Talk With The Children: Color and sparkle make the holiday season come alive. Bring small containers of each color of paint to show the children. Pass them around, name the colors, and talk about them. Tell the children that they are going to paint a long background sheet of paper using all of the colors and then sprinkle glitter and drape tinsel on the wet paint. After the paper is dry they will add Christmas trees.

ENJOY THE ACTIVITY

Spread the butcher paper on the floor with the brushes and paint around the edges. Paint the entire sheet. While the paint is wet, sprinkle glitter and drape strands of tinsel on it. When dry, carefully shake the excess glitter and tinsel off of the paper. Hang the paper on the bulletin board.

Lay the Christmas tree shapes on the art table. Using evergreen sprigs as brushes, let the children paint the trees. If the children would like to add lights, let them use medicine droppers and drop dots of color on the trees.

DISPLAY THE *"TREES"*

When the Trees have dried, let the children help you hang them on the bulletin board. Admire your art. What colors do you see?

EXTENSION:

Talk about decorating a real Christmas tree. What types of things do the children hang on it — lights, ornaments, garlands? What else? Cut a large felt evergreen tree and a variety of felt ornaments. Let the children help you decorate the tree.

TREE FARM

Gather The Materials

- Cut butcher paper the size of your bulletin board.
- Draw four or five large, different-sized Christmas tree shapes on freezer wrap paper.
- Mix light blue liquid tempera paint with salt.
- Have: wide brushes
 - blunt-tipped scissors
 - shades of green fingerpaints
 - cotton batting

Talk With The Children: Encourage the children to talk about farms. What grows on farms? What animals live on farms? Discuss a special type of farm — a tree farm. Some tree farms are called orchards and groves. They have fruit trees growing on them. Maybe the children have visited an apple orchard or a citrus grove. Another type of tree farm grows tall evergreen trees. People use certain types of evergreen trees at Christmas and call them Christmas trees.

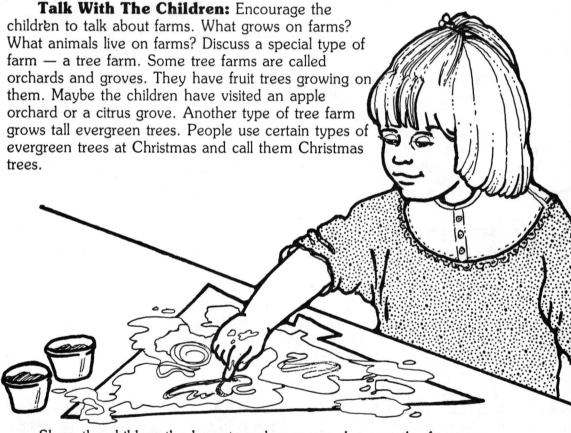

Show the children the large tree shapes you drew on the freezer wrap. Tell them that they are going to fingerpaint a Tree Farm for the classroom.

ENJOY THE ACTIVITY

Lay the butcher paper on the floor in the art area. Put the blue tempera paint and brushes around the edges. Have the children paint the background for the tree farm. Let it dry and then hang it on the bulletin board.

Lay several of the trees (glossy side up) on the art table. Let the children cut them out. Spread the fingerpaint containers around the trees. Have the children fingerpaint the trees. When finished with each tree, the children should put it in a special place to dry. Continue until all of the trees are painted.

DISPLAY THE "TREE FARM"

Have the children carry the Trees over to the bulletin board and hang each one. Using cotton batting, the children might want to add snow under the Trees.

EXTENSIONS:

Add a variety of forest animals to the bulletin board. Let the children cut out shapes of squirrels, raccoons, birds, deer, etc. and then paint, collage, or chalk them. When dry, put them in the trees, flying through the air, peeking out from behind the tree trunks, and so on.

Bring in different types of evergreen branches to show the children. Put them on the Discovery Table.

HAPPY HANUKKAH

PREPARE FOR THE ACTIVITY

Gather The Materials

- Cut butcher paper the size of your bulletin board.
- Cut sponges in star shapes.
- Pour thin layers of blue tempera paint into shallow containers.
- Draw sixteen simple candle shapes on construction paper — about 4″ wide by 10″ high.
- Draw two larger candle shapes to make the Shammash.
- Cut out a Menorah from textured wallpaper about four feet wide.
- Have: tissue paper
 blunt-tipped scissors
 blunt-tipped needles
 medium-ply yarn
 paper punches
 staplers
 heavy-gauge thread

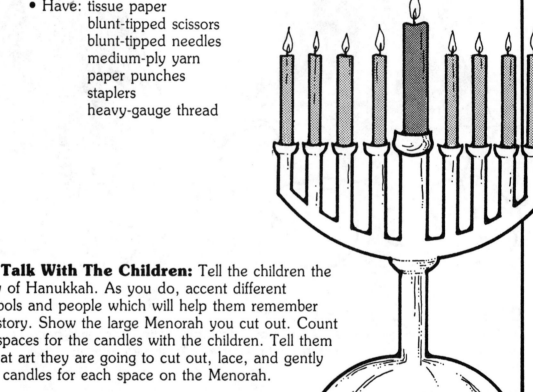

Talk With The Children: Tell the children the story of Hanukkah. As you do, accent different symbols and people which will help them remember the story. Show the large Menorah you cut out. Count the spaces for the candles with the children. Tell them that at art they are going to cut out, lace, and gently stuff candles for each space on the Menorah.

ENJOY THE ACTIVITY

Before the first day of Hanukkah have the children begin to create their bulletin board. First have them print the background. Lay the piece of butcher paper on the floor in the art area. Put the star shapes and tempera paint around the edges. When the children come to art have them sponge paint stars on the entire paper. Let the paint dry and then hang the background paper on the bulletin board. Tack the Menorah to the bulletin board.

Now have the children make the candles. Put the candles, scissors, yarn, needles, and tissue paper on the art table. Having the children work in pairs, they should first cut out two candle shapes. Then one child in the pair holds the two candle patterns together, while his partner punches holes around all of the edges of the candles. After the holes have been punched, the children should sew the two candles together. Help the child who begins sewing the candles to thread his needle and tie on the first stitch. Again one child should hold the candles while the other child sews. Continue sewing around the candles, leaving the bottom edge open. Tie off the last stitch. Tear the tissue paper in pieces and stuff the candle. Sew the bottom of the candle closed. Repeat this process to make the other candles.

DISPLAY THE "MENORAH"

On the first day of Hanukkah, staple the Shammash and one candle to the Menorah. Each of the following days add another candle to the Menorah.

EXTENSION:

Make felt board pieces of the Hanukkah symbols. Pass them out to the children. As you tell the story of Hanukkah, have the children who are holding the appropriate pieces bring them to the felt board.

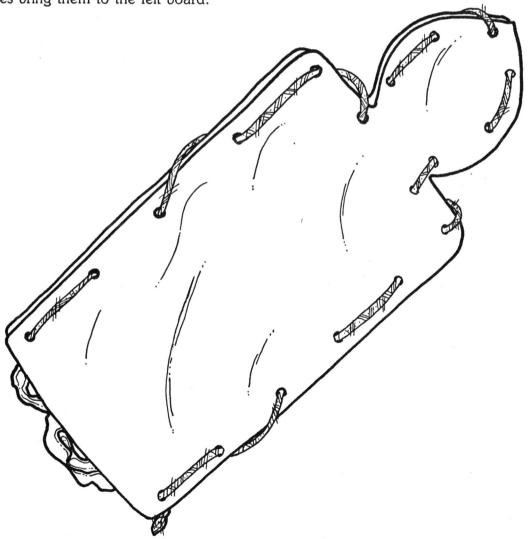

GINGERBREAD KIDS

Gather The Materials

- Cut butcher paper the size of your bulletin board.
- Cut two large gingerbread shapes out of brown mailing paper.
- Collect all types of brown materials such as fabrics, wrapping paper, shopping bags, posterboard scraps, sandpaper pieces, and so on. Separate each material onto a different tray.
- Mix glitter with ground coffee and/or ground tea leaves. Pour the mixture into salt shakers with large holes.
- Have: blunt-tipped scissors
 glue
 brushes for glue
 paint
 paint brushes

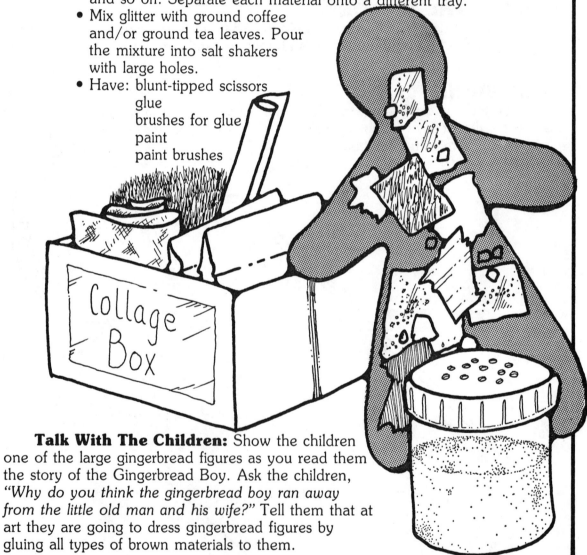

Talk With The Children: Show the children one of the large gingerbread figures as you read them the story of the Gingerbread Boy. Ask the children, *"Why do you think the gingerbread boy ran away from the little old man and his wife?"* Tell them that at art they are going to dress gingerbread figures by gluing all types of brown materials to them.

ENJOY THE ACTIVITY

Lay the butcher paper on the floor in the art area. Put the glue, brushes, and salt shakers around the edges. Let the children create the background for the Gingerbread Kids by brushing glue on the paper and shaking the brown mixture on it. Let the background dry and then hang it on the bulletin board.

Lay the gingerbread shapes, brown materials, and glue on the art table. Let the children glue the materials onto the shapes. When dry, they may want to add features to their Gingerbread Kids using other colors of collage materials or paint.

DISPLAY THE *"KIDS"*

Hang the Gingerbread Kids on the bulletin board. Maybe your kids would like to name the Gingerbread Kids.

EXTENSIONS:

When the children are outside, encourage them to be the Gingerbread Kids and run away from each other. As they do, they can chant the gingerbread boy's rhyme:

> *Run, run as fast as you can,*
> *You can't catch me,*
> *I'm the gingerbread man!*

Using your favorite recipe, bake gingerbread cookies with the children.

GREETINGS

Gather The Materials
- Save the greeting cards that come into the school.
- Have: rug yarn
 blunt-tipped yarn needles
 paper punches

Talk With The Children: Ask the children, *"Why do you say 'Hello' to people when you see them?"* After discussing this, talk about greeting cards. They are a special way of saying *"Hi"* to friends during this time of year. Show the children some of the cards that people have sent to the center. Read the messages on them.

Tell the children that they are going to punch holes along the top and bottom of every card and then sew them together to make a banner for the school door.

ENJOY THE ACTIVITY

Place the cards, punches, needles, and yarn on the art table. Have the children first punch holes across the top and bottom of each card, leaving a half an inch between holes. Help the children thread the needles and tie the first stitch to a card. In the beginning, the children should sew the bottom of one card to the top of a second card. Soon they will have pairs of cards sewn together. Now they can begin to sew the pairs together so they will eventually have a banner of greeting cards. After they have sewn enough cards for one banner, they can begin to sew another one. Continue as you receive cards each day.

DISPLAY THE *"BANNER OF GREETING CARDS"*

Weave yarn through the top of the banner and tie it into a bow. Hang the banner on the front door of the school where everyone can enjoy all of the special greetings each day of the holiday. It is fun to watch the banner grow.

EXTENSION:

Have the children make and send greeting cards to several special people they know. (Get the addresses from the parents.)

POPCORN WREATH

PREPARE FOR THE ACTIVITY

Gather The Materials
- Cut a large corrugated cardboard base with a small hole in the center.
- Pop a big batch of popcorn.
- Pour thin layers of glue in meat trays.
- Have: fingerpaint
 heavy-duty tape

Talk With The Children: Popcorn is a delicious, favorite snack. Talk about how to pop popcorn and then make a batch for everyone to eat.

Show the children the base for the wreath. Tell them that at art they are going to glue popcorn to the base to make a wreath for the door.

ENJOY THE ACTIVITY

Put the base in the middle of the table. Fingerpaint it and let it dry. Spread the glue and several bowls of popcorn around the base. (Some popcorn to eat and some to glue.) The children can lightly dip pieces of popcorn into the glue and then hold them to the base until they feel firm. Continue until the wreath is full of popcorn.

DISPLAY THE *"POPCORN WREATH"*

Using the heavy-duty tape, secure the Wreath on the door at the children's eye level. Add a big red bow for color.

EXTENSION:

Enjoy this popcorn rhyme with the children:

THE POPCORN KERNEL

I am a popcorn kernel,
On the electric range,
With oil to my ankles,
Waiting for the change.

Pop, pop, it's started happening.
The noise has just begun.
Pop, pop, there it goes again.
It sounds like lots of fun.

Explosions to the left of me.
Explosions to the right.
I'm just about to blow my top,
I really think I might.
 BANG!!!

Dick Wilmes

TWINKLING TREES

Gather The Materials

- Draw simple Christmas tree shapes on construction paper.
- Cut pieces of colored cellophane slightly larger than the trees.
- Have: paper punches
 blunt-tipped scissors
 glue
 colored string

Talk With The Children: Bring a strand of Christmas tree lights to show the children. Plug it in so all of the colors glow. Talk about the different colors on the strand. Let each child say which is his favorite color. Ask the children if they have seen lights on Christmas trees. What did those lights look like? Do the children like the trees better when the lights are turned on or off?

Tell the children that at art they are going to cut out Christmas trees and add lights to them.

ENJOY THE ACTIVITY

Put the trees, scissors, and punches on the table along with the glue and stack of colored cellophane. When the children come to the art area, have them choose a tree and cut it out. Now let them punch holes in the tree for the lights. (If the tree is too large to punch holes in the middle, the children can fold the tree in half and continue punching.)

Once the holes have been punched, the tree is ready to light. Drizzle a thin line of glue around the edges of the tree. Press the piece of cellophane to the glue. When the glue has dried, let the children decide if they would like to trim the excess cellophane paper away from the tree shape.

DISPLAY THE "TWINKLING TREES"

Punch a hole in the top of each Tree and loop a piece of colored string through it. Hang all of the Trees in a sunny window. Continue watching the Trees. When do they twinkle the most? The least?

EXTENSION:

Read *A CHRISTMAS PARTY* by Cyndy Szekeres to the children.

STOCKING STUFFERS

PREPARE FOR THE ACTIVITY

Gather The Materials
- Draw a large stocking shape on butcher paper.
- Have: toy catalogues and magazines
 blunt-tipped scissors
 paste
 heavy-duty tape

Talk With The Children: During the holidays, families and friends give each other gifts. Let the children talk about different things that they would like to give and to receive. Show them a stocking. Ask if any of them hang a stocking for Santa Claus to fill. Where do they hang it? Now show them the large stocking you have drawn. Tell them that at art they are going to cut out the stocking and glue pictures on it of things they would like to receive.

ENJOY THE ACTIVITY

First have the children cut out the large stocking. Lay it at one end of the art table along with containers of paste. At the other end of the table have four or five toy catalogues and magazines. Have the children look through the pages and tear out pictures of the things they would like to receive. They should spread paste on the back of the pictures and put them on the stocking. Have fun filling the stocking with wishes.

DISPLAY THE *"STOCKING"*

When the paste has dried, hang the Stocking on the wall just outside your classroom door. As the children come to school each day, they can enjoy the pictures of the toys and other things they and their friends would like to receive.

EXTENSION:

Talk about all of their wishes. As children mention different things, write them down on a long strip of shelf paper. Tape the list to the wall near the stocking.

PURPLE CRAYON

⌐PREPARE FOR THE ACTIVITY⌐

Gather The Materials
- Cut a very large crayon shape out of white posterboard.
- Gather different shades of purple crayons.

Talk With The Children: Bring a variety of crayons to show the children. Pass them out. Talk about each one and let the children who have purple ones put them in a special box.

Tell the children that at art they are going to use the purple crayons to color a giant crayon shape different shades of purple.

ENJOY THE ACTIVITY

Put the crayon shape and purple crayons on the art table. When children come to art, have them color the entire crayon. As they are coloring, talk about the shades of purple. Look at each other's clothes. Is anyone wearing something that is purple?

DISPLAY THE "CRAYON"

Tape the crayon low on a wall in your classroom. Encourage the children to bring in purple items to glue to the Purple Crayon. At the end of December, move the Purple Crayon to the Wall of Colors.

EXTENSION:

Read *HAROLD AND THE PURPLE CRAYON* by Crockett Johnson to the children.

TREE MOBILE

PREPARE FOR THE ACTIVITY

Gather The Materials
- Draw 12″ high triangles on green construction paper.
- Have: blunt-tipped scissors
 glue
 wide ribbon

Talk With The Children: Cut one triangle into four to six horizontal strips. Lay them on the floor in the shape of a tree. Have the children find which strip is the longest and shortest. Count all of the strips. Now have the children cover their eyes. Mix the strips up. Open their eyes. Beginning with the shortest one, put the tree back together.

Tell the children that at art they are going to construct Tree Mobiles by gluing the strips onto pieces of wide ribbon.

ENJOY THE ACTIVITY

Have each child cut out a triangle and then cut the triangle into strips. When he has all of the strips cut out, have him lay them in order on the table. Cut a piece of ribbon about twenty inches long. Glue the strips to the ribbon and loop a hook at the top. Let the children construct as many as they would like.

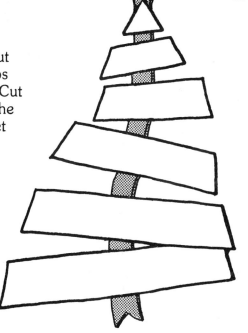

DISPLAY THE "MOBILE"

Cluster the mobiles at different heights over one of the learning centers. Encourage the children to be the winter wind and blow their Trees.

EXTENSIONS:

Make several more sets of trees. Cover the strips with clear adhesive paper. Place them in a box and put the box on the shelf near the other puzzles. Let the children enjoy their new puzzle.

Read *MR. WILLOWBY'S CHRISTMAS TREE* by Robert Barry to the children.

SILENT NIGHT

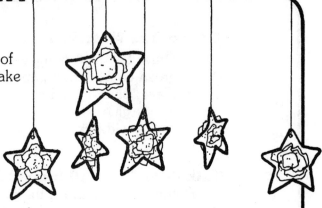

PREPARE FOR THE ACTIVITY

Gather The Materials
- Cut several large stars out of lightweight posterboard. Make one slightly larger.
- Have: aluminum foil
 glue
 meat trays
 brushes for the glue
 glitter

Talk With The Children: Tell the children the story of the birth of Jesus, including the journey of the Wisemen who followed the special star to the stable. Show the children the stars. Tell them they are going to glue pieces of aluminum foil to the stars so they glimmer for the holiday. The largest star represents the one that the Wisemen followed. The children can add glitter to that one.

ENJOY THE ACTIVITY

Have the children tear the aluminum foil into small pieces. Put the pieces on several meat trays. Lay the stars on the art table, brush them with glue, and layer the aluminum foil pieces on top. Continue layering until all of the stars glimmer. When dry, turn the stars over and glue aluminum foil on the other side. Let this side dry.

If the children would like, have them brush a thin layer of glue over the aluminum foil on the largest star and then shake the glitter on. When it's dry, shake off the excess. Do the same on the other side.

DISPLAY THE "STARS"

Hang the Stars from the ceiling over the dramatic play area.

EXTENSIONS:

Add props and clothes to the dramatic play area to make it like a stable.

Add books about the Christmas story to the book shelf such as *THE LITTLE DRUMMER BOY* by Ezra Jack Keats.

SANTA PINATA

PREPARE FOR THE ACTIVITY

Gather The Materials

- Mix flour and water to make a thin paste. Put it in several containers.
- Tear strips of newspaper and put them on plates. (Let the children do it.)
- Blow up a rubber punch ball or large balloon.
- Have: tempera paint
 brushes
 cotton batting
 glue
 heavy-duty cord

Talk With The Children: Show the children a large picture of Santa Claus. Discuss what he looks like. Then talk about the gifts that your children would like Santa to bring them. Ask the children where Santa puts their presents and if they leave a gift or snack for Santa.

Explain what a pinata is to the children. Show them the large punch ball. Tell them that over the next several days they are going to paper-mache a Santa Claus Pinata. They will cover the entire ball with glued strips, let it dry, and then paint the face.

ENJOY THE ACTIVITY

Put the ball, newspaper strips, and paste on the art table. Have the children work in small groups, one child holding the ball steady and several others dipping the strips in the paste, removing the excess, and laying them on the ball. Cover the entire ball with newspaper, making sure that the rubber band is hanging out. Let the newspaper dry thoroughly. Cover the ball with another layer of newspaper and let it dry thoroughly.

When it is dry, let the children paint it one color. Let the paint dry and then add all of the facial features. Remember to use the cotton batting for Santa's hair and beard.

DISPLAY "SANTA"

When the Pinata has dried hang it from the ceiling.

EXTENSION:

Make a pinata for your holiday party. When it has dried, pop the punch ball. Fill the pinata with a variety of goodies. Hang it low from the ceiling. At the party use a plastic bat and have the children take turns hitting the pinata until it breaks open. (Remember safety!) Enjoy all of the goodies.

PINECONE CENTERPIECE

PREPARE FOR THE ACTIVITY

Gather The Materials
- Cut several circles about twelve inches in diameter out of corrugated cardboard. Draw a four inch circle in the middle of each base.
- Have: all types of pinecones
 meat trays
 glue
 plants in small pots

Talk With The Children: Show the children all of the pinecones they are going to use to make the centerpieces. Pass them out. As they explore the pinecones, have the children separate them into the different sizes and put each size on a separate meat tray. When they understand how to sort the pinecones, let them finish the activity on their own in the Discovery Area.

After the pinecones have been sorted, tell the children that they are going to glue them to bases to make centerpieces for the classroom. Show the children one of the bases. Note the circle in the middle. Tell them that after they have glued the pinecones to the base, you are going to put a plant in the middle.

ENJOY THE ACTIVITY

Put the bases and glue at each end of the art table and the containers of pinecones in the middle. When the children come to art, have them choose pinecones, dip them in the glue, and put them on a base. (The children should leave the inner four inch circle empty.) Because the cones are curved, the children will have to hold them onto the base until they feel firm. Continue adding cones until the centerpiece is full. Let it dry. Check to be sure that all of the cones are tightly glued.

DISPLAY THE "PINECONE CENTERPIECES"

Look carefully around the classroom and decide where the Centerpieces would look nice. Put them in the appropriate places. Add a plant to the center of each one. Remember to use one on the food table at your holiday party.

EXTENSION:

Use the extra pinecones to make feeders for the birds. Mix peanut butter, cornmeal, and bird seed. Spread it on the larger pinecones. Loop pieces of string around them for hangers and hook them over branches near the school. Enjoy watching the different birds eat at the feeders.

HAPPY HOLIDAYS

PREPARE FOR THE ACTIVITY

Gather The Materials

- Cut butcher paper the size of the table where you will eat.
- Use a utility knife to cut holiday designs in large rubber erasers.
- Pour thin layers of various colors of tempera paint into shallow dishes.

Talk With The Children: One of the best parts of the holidays is getting together with friends and family. Plan a holiday celebration with the children. Maybe you can have several simple snacks and juice. Enjoy some holiday activities and songs.

Pass out the erasers to the children. Discuss the different designs carved in them. Tell the children that at art they are going to use the erasers to print the Tablecloth for their party.

ENJOY THE ACTIVITY

Spread the butcher paper on the floor in the art area. Put the erasers and paint around the edges of the paper. Have the children print their holiday tablecloth. As they are printing, talk about the different decorations the children have in their homes.

DISPLAY THE *"TABLECLOTH"*

Have the children use their own Tablecloth for the holiday party celebration. As everyone is enjoying the food, discuss the different designs.

EXTENSION:

Have the children make holiday placemats for members of their family. Print the designs on light colored construction paper. When the designs have dried, cover both sides of each mat with clear adhesive. Trim the adhesive leaving a half inch border.

ANIMAL FOOD

PREPARE FOR THE ACTIVITY

Gather The Materials
- Get suet from your local butcher.
- Have: bird seed in flat shallow containers
 mesh bags like onion bags
 dowel rods or sticks

Talk With The Children: In November the children began feeding the animals. Remember, it is important to continue the process. The animals will begin to rely on the children's help.

Walking on tiptoes, have the children sneak over to a window where they can see if any animals are eating the food that is out for them. If any animals are there, watch them for awhile. Quietly walk away from the window and discuss what the animals were doing.

Tell the children they are going to mix a special bird food at art and then hang it outside for the birds who fly near the school to eat.

ENJOY THE ACTIVITY
Put the suet and containers of bird seed on the table. Mix the suet and seed together and shape the mixture into balls. Roll the balls in more bird seed. Put the balls in mesh bags. Tie the top of the bags closed and add a loop. Push a dowel rod or stick through the bottom of the bags so that the birds can perch.

DISPLAY THE "ANIMAL FOOD"
Hang the mesh bags filled with Animal Food on a nearby tree. Enjoy watching as the birds feed there.

EXTENSION:
Using the chart you made in November, keep track of the colors of birds who eat the suet during the month of December.

PEACE BANNER

PREPARE FOR THE ACTIVITY

Gather The Materials

- Cut butcher paper the size of your bulletin board. Write "Peace" in large letters across it.
- Color rice using food coloring. Put the different colors of rice in shakers with very large holes.
- Have: white glue in small containers
 brushes for glue

Talk With The Children: Tell the children about the life of Martin Luther King, Jr. Explain to them that one of King's main goals was to help everyone learn to live in peace with each other. He worked so hard that he received a special award called the Nobel Peace Prize.

Tell the children that at art they are going to glue colored rice on letters which read "Peace"

ENJOY THE ACTIVITY

Lay the butcher paper on the floor in the art area. Put the colored rice, glue, and brushes around the edges of the paper. When the children come to art have them brush glue over the letters and then sprinkle rice on them. Continue until the letters have been covered. Let the letters dry thoroughly and then shake off the excess rice.

DISPLAY THE *"PEACE BANNER"*

Hang the Banner on the bulletin board.

EXTENSION:

Use the bulletin board as a diary of how everyone in the class is showing peace and love for each other. Cut twenty or more 3" by 12" strips of construction paper. When a child helps another child, go over to the helping child and bring him to the bulletin board. Let him pick out a strip of paper and give it to you. Have him tell you how he showed peace to someone else. Write down what he says on his strip. Let him tape it to the Peace Banner. Continue throughout the month adding examples of how the children are trying to be peaceful and loving. In the next parent newsletter, make a list of everyone's peaceful examples.

INDOOR SNOWMAN

PREPARE FOR THE ACTIVITY

Gather The Materials

- Cut butcher paper the size of your bulletin board.
- Put different colors of powdered tempera paint in salt shakers.
- Make several extra trays of ice cubes or gather icicles.
- Have: several extra pairs of mittens
 pieces of white construction paper
 different colors of tissue paper
 strips of colored construction paper

Talk With The Children: Icicles are part of the winter magic. Are there any icicles hanging from the roof of the school? If so, break one off and bring it inside. (Remember safety.) Put it in a bucket. Let the children examine it. How does it look? Feel? Smell?

Tell the children that at art they are going to create a large snowman. First they are going to paint the background by sprinkling dry tempera paint onto the paper and then smearing it around with ice. Once the background is dry they can build their Indoor Snowman.

ENJOY THE ACTIVITY

Lay the butcher paper on the floor in the art area. Put the salt shakers and small tubs of ice cubes (icicles) around the edges of the paper. The children should bring their mittens to art. First have them sprinkle several colors of dry paint on the butcher paper, then get an ice cube (wearing mittens) and smear it through the tempera paint The water and dry paint will mix as the children glide the ice over the paper. Encourage them to continue painting until the paper is completely colored. Let it dry.

Now create your snowman. Draw the outline of a large snowman on the background paper. Have the children tear the white construction paper into small pieces and glue them to his body. Add features such as face, buttons, scarf, broom, and hat using wadded up pieces of colored tissue paper.

DISPLAY THE
"INDOOR SNOWMAN"

When the Snowman is finished, have the children help you hang it. If they would like, make a long paper chain border out of colored construction paper.

EXTENSIONS:

Make colored ice cubes for water play by adding a little food coloring to the water before you freeze it.

Next time it snows, go outside and make a real snowman with the children.

FROSTY FOOTPRINTS

Gather The Materials

- Cut butcher paper the size of your bulletin board.
- Have the children wear boots the day of this activity. (Have several extra pairs.)
- Pour thin layers of different colors of tempera paint in long shallow containers, such as brownie pans.
- Have: Frosty hat
 heavy-duty tape
 "Frosty the Snowman" record
 record player
 large bucket of water
 several scrub brushes
 towels

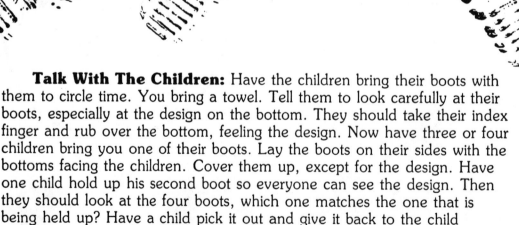

Talk With The Children: Have the children bring their boots with them to circle time. You bring a towel. Tell them to look carefully at their boots, especially at the design on the bottom. They should take their index finger and rub over the bottom, feeling the design. Now have three or four children bring you one of their boots. Lay the boots on their sides with the bottoms facing the children. Cover them up, except for the design. Have one child hold up his second boot so everyone can see the design. Then they should look at the four boots, which one matches the one that is being held up? Have a child pick it out and give it back to the child holding his boot. Continue by matching all of the children's boots.

Tell the children that at art they can pretend to be Frosty the Snowman and make footprints with their boots.

ENJOY THE ACTIVITY

Lay the butcher paper on the floor in the art area and tape it down. Have the containers of paint at one end of the paper and the bucket of water, towels, and scrub brushes at the other end. Set the record and record player up near the art activity. When each child wants to be Frosty, have him bring his boots to the art area. First have him look at the design on the bottom of his boots and then put them on. As soon as he is ready have him choose what color paint he wants to step in. Start playing the Frosty record, and let the child put the Frosty hat on his head. While the song is playing the child should step into the paint and then onto the butcher paper. Encourage him to dance just as Frosty might have and then run away on the melting snow.

When he comes to the end of the snow, he should pass the Frosty hat to another child, take off his boots and wash them. Continue until all of the children have had an opportunity to be Frosty. Let the butcher paper dry.

DISPLAY THE "FROSTY FOOTPRINTS"

Hang the Frosty Footprints on your bulletin board. As the children pass by, see if they can find the Frosty prints they made.

EXTENSION:

The children might want to build snowmen from different size paper plates and add features to them with collage materials. Hang these on the bulletin board with some puffy white cotton snow.

GIANT MITTENS

PREPARE FOR THE ACTIVITY

Gather The Materials

- Cut gray or brown mailing paper the size of your classroom door.
- Cut pieces of sponge. Clip a clothespin to each piece for a handle.
- Pour thin layers of white tempera paint into shallow dishes.
- Draw the shape of four large mittens on wide shelf paper — two left and two right.
- Have: blunt-tipped scissors
 tempera paint
 brushes
 staplers
 newspaper
 heavy yarn
 construction paper
 heavy-duty tape

Talk With The Children: On a snowy day, have the children take a piece of dark construction paper outside and catch snowflakes. Encourage them to look closely at the flakes. When they return to the classroom, talk about the flakes they caught. Tell them that at art they are going to create a door decoration by sponge painting flakes on a large piece of paper and then constructing a giant pair of mittens by stuffing mitten shapes with newspaper.

ENJOY THE ACTIVITY

Lay the paper on the floor in the art area. Spread the containers of paint and the sponges around the paper. When the children come to the activity, have them print snowflakes by sponge painting all over the paper. Let it dry and then hang the paper on the inside or outside of the classroom door.

Put the mittens, tempera paint, brushes, scissors, stapler, newspaper, and yarn on the art table. Have the children cut out and paint the four large mittens. Pair them so that the left and right ones are facing each other. Have a child hold one set of mittens together while another child staples around all of the edges except the bottom one. Repeat for the other set.

The children should loosely wad-up newspaper and gently stuff the mittens. When they are full, staple the bottom edge and loop them together with the heavy yarn.

DISPLAY THE *"GIANT MITTENS"*

Hang the Mittens on the snowy paper. If the children would like to add a border around the door, use small pairs of mittens the children have cut out.

EXTENSION:

Get five or six pairs of real mittens and a dozen clothespins. Put the mittens and clothespins in a box. Hang a short clothesline in the room. Have the children clip the mittens to the clothesline in a specific order, such as in pairs or all mittens having some red on them at one end and the rest on the other end.

WINDOW GARLANDS

PREPARE FOR THE ACTIVITY

Gather The Materials
- Cut several pieces of string as long as your classroom windows.
- Have: different colors of cellophane
 glue
 cotton swabs

Talk With The Children: Show the children a variety of garlands that might have been used to decorate a Christmas tree. Pass them around. Talk about how the garlands are similiar and different. Which garlands do the children like best? Why?

Tell the children that at art they are going to use cellophane and thin string to make garlands to hang in the classroom windows.

ENJOY THE ACTIVITY

Put the cellophane, cotton swabs, and glue on the table. Lay one or two strings out straight. Have the children tear pieces of cellophane, using swabs dot the pieces with glue and stick them to the string. Continue adding the cellophane pieces to the strings until each is full. Let them dry. Turn the garland over and add cellophane to that side. Let it dry. Continue, gluing as many garlands as the children would like.

DISPLAY THE *"WINDOW GARLANDS"*

Have the children bring the Garlands over to the window. Spacing them evenly along the window, tack one end of each Garland to the top of the window and the other end to the bottom.

EXTENSION:

Put several kaleidoscopes on the window ledge. Encourage the children to look through them. What colors do they see? Now look at the garlands. Which colors in the garlands are similar to the ones in the kaleidoscopes?

102

DIP AND DYE SNOWFLAKES

PREPARE FOR THE ACTIVITY

Gather The Materials

- Have: coffee filters
 food coloring in separate bowls
 blunt-tipped scissors
 cellophane tape

Talk With The Children: A day or so before the art activity, take magnifying glasses outside and encourage the children to look at the snow. If it is snowing, have them catch snowflakes on their mittens and then use the magnifying glasses to look at the flakes very closely.

Show the children a coffee filter. Tell them that at art they are going to color the filters by dipping them in and out of food coloring and then they will cut them into snowflakes.

ENJOY THE ACTIVITY

Dilute the food coloring with water. Cluster the bowls of coloring in several spots on the art table. When the children come to art, have them get a coffee filter. They should gather a small section of the filter and dip the point quickly in and out of the food coloring. Pinch another section of the filter and quickly dip it again. Continue until the coffee filter is full of color. Let it dry.

When the filters have dried, cut them into snowflakes. Fold the filters in half or quarters and cut squiggles and swirls on the edges. Open up the filters.

DISPLAY THE "SNOWFLAKES"

Let the children tape their Flakes on the classroom windows. How do the Flakes look on a sunny day?

EXTENSIONS:

Once again, take magnifying glasses outside. This time encourage them to look at small patches of snow that might be clumped on a bush or the seat of a swing. How do they look?

Bring some snow inside and put it in the water table. Let the children enjoy packing and building with it while wearing mittens.

WHITE CLOUDS

PREPARE FOR THE ACTIVITY

Gather The Materials
- Cut a large, fluffy cloud shape out of white posterboard.
- Pour a thin layer of glue in several shallow dishes.
- Have several boxes of white facial tissue.

Talk With The Children: Read the book *It Looked Like Spilt Milk* by George Shaw to the children. As the children look at each picture talk about what the shape looks like. Also, let the children talk about times when they have spilled their milk. Can they remember what the puddle of milk looked like? How did they clean it up?

Show the children the cloud you cut out. Ask them what this shape reminds them of. Tell them that at art they can make the cloud light and fluffy by gluing tissues to it.

ENJOY THE ACTIVITY
Put the cloud, glue, and tissues on the art table. Have the children wad-up a piece of tissue, dip it into the glue, and place it on the cloud shape. The children should continue adding tissue until the entire cloud is filled.

DISPLAY THE *"CLOUD"*
Tape the cloud to a wall. During January encourage the children to bring in other white materials to add to the cloud. Glue them around the tissues. At the end of the month, move the White Cloud to the Wall of Colors.

EXTENSIONS:
Each time you go outside, encourage the children to notice the clouds. See any distinct shapes?

Be aware of the color white in the environment — in foods, in clothes, in toys, and so on.

WIRE SCULPTURE

PREPARE FOR THE ACTIVITY

Gather The Materials
- Have: variety of different colored, pliable wires, such as wire used by telephone companies, floral or craft shops spool of heavy-duty thread

Talk With The Children: Show the children some of the wires you gathered. Pass them around so each child has several. Let each child hold up his wires and tell the others what colors he has. Have the children bend and twist their wires together. Look at what each child did. Now have them pair off and link their wires. Look again at all of the small sculptures. Have one child in each pair put their sculpture on the art table. Tell the children that you are going to link all of the sculptures together and put more wires on the table so they can add them to the sculpture.

ENJOY THE ACTIVITY

Put the wires on the art table. When the first several children come to art have them help you link their small sculptures together. After these are connected, let the children continue to add onto the sculpture. Encourage them to bend, twist, loop, and turn the wires in all directions. Watch it get higher and wider as the children build.

DISPLAY THE "WIRE SCULPTURE"

After the children have finished the Sculpture, tie long pieces of thread from different parts of it and hang it from the ceiling. Encourage the children to look at it. Find different colors and shapes. Look at it from a different angle. Now what can they find?

EXTENSION:

Create another sculpture, only this time use different colored pipe cleaners. As the children are constructing, talk about how the pipe cleaners are the same as and different than the telephone wires. Place the new sculpture on a shelf in the language area.

SNOWBALL FUN

PREPARE FOR THE ACTIVITY

Gather The Materials
- Have: white tissue paper
 glue in shallow dishes
 plastic containers
 yarn

Talk With The Children: Children play many games in the snow. They enjoy making snow angels, throwing snowballs at trees, and sledding down hills. Talk about winter safety as the children discuss their favorite games.

Tell the children that at art they are going to shape some inside snowballs by gluing wads of white tissue paper together.

ENJOY THE ACTIVITY

When the children come to the art table, have them tear the tissue into smaller pieces and wad it up. Put the tissue wads in large plastic containers. Bring the shallow dishes of glue to the table. The children should start shaping the snowballs by slightly dipping a wad of tissue onto the glue and sticking it to another one. Add more and more wads to the original pair. Continue gluing wads of tissue paper together until a snowball forms. Shape lots of them.

DISPLAY THE "SNOWBALLS"

Cut pieces of yarn in varying lengths. Glue them to the Snowballs and hang them in a cluster over one of the centers.

EXTENSION:

Read *THE SNOWY DAY* by Ezra Jack Keats. Before finishing the story, discuss what might happen to the snowball Peter put in his pocket.

PUNCHING BAG

— PREPARE FOR THE ACTIVITY —

Gather The Materials

- Have: large grocery bag/s
 newspaper
 iridescent crayons
 heavy twine

Talk With The Children: Bring a puppet to talk with the children. Tell them that you have brought a friend with you today. This friend has two questions to ask them. He wants to know what makes them angry and who makes them angry. Talk about these for awhile. Then let the puppet ask the children, *"What do you do when you get angry?"* Give the children a chance to tell what they do. Ask them if they ever fight or hit people when they get angry. Discuss this.

Tell the children that at art they can stuff a Punching Bag for the classroom.

ENJOY THE ACTIVITY

Put the bag, crayons, and newspaper on the art table. Have the children color the bag on all sides. After it is full of color, wad pieces of newspaper and stuff the bag. Let the children continue to add paper until the bag is round and plump. Tie it shut with a piece of heavy twine. Holding the punching bag by the twine, have several children give the bag a punch.

DISPLAY THE *"PUNCHING BAG"*

Let the children help you choose where to hang it. Once you have decided, tie it so it hangs just above the children's heads.

EXTENSION:

Make five or six feeling puppets. Cut six-inch circles out of construction paper. Draw different faces on each one or find pictures in magazines. Attach each face to a paint stirrer and stick them in a thick piece of styrofoam. Put the puppets in the language center.

PAPER BAG SNOWMEN

PREPARE FOR THE ACTIVITY

Gather The Materials
- Have: lunch size paper bags — two bags for each snowman
 newspaper
 heavy yarn
 white tempera paint plus other colors or use paper scraps
 blunt-tipped scissors

Talk With The Children: Bring a stuffed toy such as a teddy bear to show to the children. What do the children think the toy is stuffed with? Ask them if they ever talk with their stuffed toys. What do they talk about? Do their stuffed friends talk back to them? Tell the children that at art they are going to make some stuffed snowmen for the classroom. They are going to stuff the snowmen with newspaper.

ENJOY THE ACTIVITY

Put the newspaper, lunch bags, and yarn at one end of the art table. Put the paint and brushes at the other end. Have the children tear up the newspaper, wad it into loose balls, and stuff it into paper bags. When a bag is full, take an empty bag and pull it over the stuffed bag. Squish the bags down a little. Cut pieces of yarn and wrap them tightly around the middle of the bags to form the top and bottom sections of the snowmen.

Paint the snowmen. Let them dry and then add details.

DISPLAY THE *"PAPER BAG SNOWMEN"*

Use some of the snowmen for centerpieces on tables and shelves. Let the children use the snowmen as stuffed toys in the dramatic play area, language area, or other appropriate areas. Maybe they would like to take naps with them.

EXTENSION:

Have the children bring stuffed toys to school. Talk about the different toys. Play, eat, and rest with them.

THE SNOW FAMILY

PREPARE FOR THE ACTIVITY

Gather The Materials
- Collect varying sizes of large boxes and some cardboard or plastic tubes.
- Have: glue
 heavy duty tape
 all colors of tempera paint
 including lots of white
 wide paint brushes
 easel paint brushes
 sandpaper

Talk With the Children: Discuss the similarities and differences between the children's families and snow families. Where do the children think snow families might live? What types of clothes do they wear? What do snow families eat? What games do they play?

Show the children the large boxes. Tell them that the boxes are going to be in the art area. When they come to art they are going to construct members of a snow family by stacking the boxes together and then gluing and painting them.

ENJOY THE ACTIVITY

When the children come to the art area, have them sand any shiny surfaces on the boxes. Using the various boxes and tubes, build members of a snow family. After the children have stacked the boxes for the different members, have them glue the boxes together. Let them dry. Use heavy-duty tape to secure the arms. Paint the family white. Add detail with other colors of paint. Let them dry.

DISPLAY THE "SNOW FAMILY"

Slide the Snow Family over to the dramatic play area. Pretend this area is their home.

EXTENSION:

Be sure there are scarves, hats, brooms, jackets, and other accessories in the dramatic play area that the children can use with the members of their Snow Family

WINTER PLACEMATS

PREPARE FOR THE ACTIVITY

Gather The Materials
- Pour thin layers of white and other colors of tempera paint into shallow containers.
- Have: dark pieces of construction paper
 - spoons
 - tennis balls
 - cake pans or sturdy
 - dress boxes
 - snowman cookie cutters
 - clear adhesive paper
 - blunt-tipped scissors

Talk With The Children: Go outside make several snowballs. Put them in a plastic container and bring them inside. Show the children the snowballs and tennis balls. How are they the same? How are they different?

Tell the children that at art they are going to the tennis balls to paint placemats for snacktime.

ENJOY THE ACTIVITY

When the children come to art, have them pick the color of construction paper they would like for their placemats. They should lay the paper in a cake pan. Using a spoon, have them dip a tennis ball into the white paint and then lay it in the cake pan. Roll the tennis ball around the pan, leaving snow all over the paper. If the children need more snow, they can re-dip their tennis balls and roll more snow on their mats. Let them dry.

Using the cookie cutters and colored paint, let the children print snowmen on their mats. When dry, cover both sides with clear adhesive. Trim the edges leaving a half inch border.

DISPLAY THE *"PLACEMATS"*

When the placemats have been completed, put them near the table where the children eat. Use them each day for snacks and lunch.

EXTENSION:

Leave the real snowballs you made in the plastic bucket. Have the children watch them. What happens to them? What color is the liquid? Compare it to your tap water.

COLORFUL SNOW

PREPARE FOR THE ACTIVITY

Gather The Materials
- Collect pieces of colored chalk.

Talk With The Children: When the children are outside, talk with them about the different textures of snow. Sometimes it is light and fluffy, other times it is good for packing, still other times it is hard and crusty. What activities do they play in the different kinds of snow? Tell them that sometimes when they come outside they are going to have the chance to decorate the snow with chalk and paints.

ENJOY THE ACTIVITY

One day when the snow is hard and crusty, take chalk outside. Let the children brighten up the snow by chalking with all of the colors. Chalk another day when the snow is light and fluffy. Try it on a day when the snow is very wet. Discuss the similarities and differences.

DISPLAY THE *"COLORFUL SNOW"*

After the children have finished chalking the snow, encourage them to climb up the slide or jungle gym and look at their colorful outside creation. As adults pick up the children, have them show off their Colorful Snow.

EXTENSIONS:

Use other media to color the snow. Try tempera paint or watercolors. Paint the snow which is on the ground, on the pieces of equipment, and on the bushes.

Use food coloring to paint patches of ice, icicles which have fallen off the roof, or mounds of ice which have formed in other areas. Do the children like the bright colors?

ANIMAL FOOD

PREPARE FOR THE ACTIVITY

Gather The Materials
- Pop popcorn with the children several days before stringing — stale popcorn strings easier. You may want to substitute Cheerios® for the popcorn.
- Have: apples
 thread
 smaller type sewing needles
 several small containers

Talk With The Children: Enjoy popping two batches of popcorn with the children. Save one batch to sew garlands for the birds and animals and eat the rest for snack. Try the popcorn with and without salt. Which do the children like better?

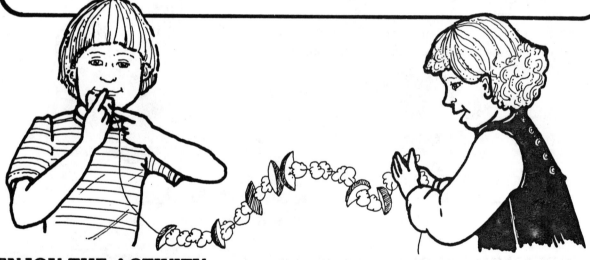

ENJOY THE ACTIVITY

Put several containers of popcorn on the table. Cut the apples into wedges. When the first several children come to string the apples and popcorn, help them thread their needles and begin. They can string the apples and popcorn for as long as they would like and then leave the garland on the table for others to continue.

DISPLAY THE *"ANIMAL FOOD"*

After the children have strung several garlands, go outside and drape them over a tree or bush.

EXTENSION:

Keep track of the birds who are eating the popcorn by letting the children mark the chart they began in November.

HEART TO HEART

┌─ PREPARE FOR THE ACTIVITY ─

Gather The Materials
- Cut butcher paper the size of your bulletin board.
- Cut large heart shapes out of fingerpaint paper.
- Pour red and pink tempera paint into shallow containers.
- Have: heart-shaped cookie cutters
 red fingerpaint

Talk With The Children: Take this opportunity to discuss a real heart with the children. Tell them that a heart is a muscle used to pump blood through a person's body. Have them put their hands on their hearts. Can they feel their hearts pumping? Now have them stand up and run in place. Stop. Put their hands over their hearts again. Can they feel their hearts pumping faster? That's because the muscles are working harder.

Tell the children that at art they will print hearts in two different ways. First they can print hearts on a large sheet of paper using cookie cutters. They are going to then fingerpaint designs on the art table and print them on heart-shaped paper.

ENJOY THE ACTIVITY

First create the background design on the butcher paper. Lay the paper on the floor in the art area and spread the cookie cutters and the tempera paint around it. Let the children print pink and red hearts on the paper. Let it dry and hang it on the bulletin board.

Put the dishes of red fingerpaint on the table. Have the heart-shaped paper nearby. When the children come to art, put a spoonful of fingerpaint on the table in front of where they are sitting. Let them fingerpaint right on the table. When each child has finished, carefully lay a heart-shaped piece of fingerpaint paper over the design. Have him firmly rub the entire backside of the paper. Gently lift the paper and look at the design or monoprint. What happened? What does the child see? Let the paint dry.

DISPLAY THE *"HEARTS"*

Let each child hang his monoprint on the bulletin board.

EXTENSION:

Put a stethoscope on the Discovery Table for the children to use when listening to their hearts.

VALENTINE FARM

Gather The Materials

- Cut butcher paper the size of your bulletin board.
- Draw simple shapes of different farm animals on construction paper.
- Draw various size construction paper hearts which will fit on the animals.
- Have: roller-type deodorant bottles
 filled with red and pink paint
 blunt-tipped scissors
 glue
 brushes for glue
 variety of collage scraps
 straw or hay
 black construction paper

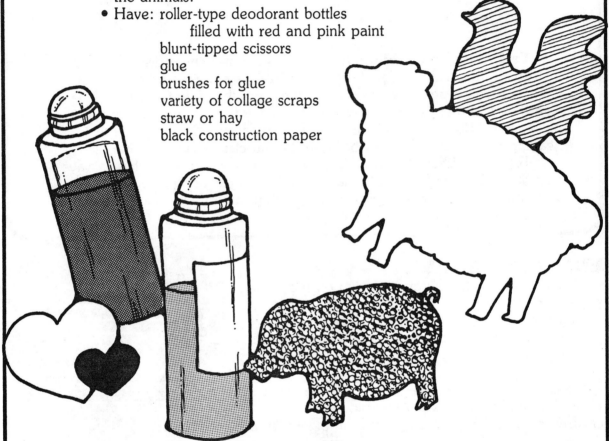

Talk With The Children: Using animal study prints or a book with realistic animal pictures, talk about different farm animals. Notice each animal's distinguishing characteristics such as a large head, lots of fur, special marks, length of tail, size, and so on.

Tell the children that at art they are going to begin their Valentine Farm by painting the background with roller bottles filled with paint. Once the background is dry, they will add all of the farm animals. Of course all of the animals will need big hearts for Valentines Day.

ENJOY THE ACTIVITY

Begin the farm by painting the background paper. Lay the butcher paper on the floor in the art area. Distribute the roller bottles around the edges of the paper. Have the children create designs by slowly moving their roller bottles in big swooping motions over the paper. When the background is dry, hang it up.

Put the animal shapes, collage materials, and glue on the art table. Each child should choose an animal he would like to put on the farm and cut it out. Using the various materials, the children can add fur and features to the animals. Have the children cut out a heart for their animal and glue it onto the body.

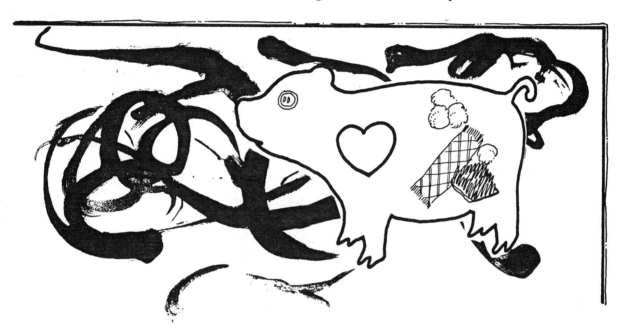

DISPLAY THE "ANIMALS"

When finished, brush glue over the backside of the animals, take them over to the bulletin board, and glue them on. Press all over the animals to be sure they are sticking. Add a little straw under each animal. Have the children cut several long, narrow strips of black construction paper. Tack them over the animals to form a simple barn roof. Continue adding more detail if you and the children want — a hay mound, fence, farmer, etc.

EXTENSION:

After all of the animals have been added, sit down with the children near the bulletin board. Have them quietly call out the names of the different farm animals. On a sheet of shelf paper, write down all of the animal names. Tack the list to the Valentine Farm.

HEART WREATH

⌐PREPARE FOR THE ACTIVITY¬

Gather The Materials
- Draw a huge heart outline on a piece of white posterboard.
- Draw many different size heart shapes on red, pink, and white construction paper.
- Have: wide marker
 blunt-tipped scissors
 paste
 double-stick cellophane tape

Talk With The Children: Cut out a large heart from a piece of red posterboard. Bring the heart and a pair of scissors to circle time. Show the children the large heart. Then cut it into a puzzle with at least one piece for each child. Pass out the pieces. Working together, put the heart back together. When finished, place the pieces in a box and put it near the other puzzles for the children to use during free play.

Tell the children that at art they are going to put together another type of heart — a heart wreath for the door.

ENJOY THE ACTIVITY
Put the posterboard, construction paper, scissors, and paste on the art table. When the children come to art, have them choose a heart, cut it out, put paste on one side, and then put it on the huge heart outline. Encourage the children to continue this process as they layer the different size construction paper hearts around the edge of the heart shape.

DISPLAY THE *"HEART WREATH"*
When the Wreath is dry, trim the posterboard away from the outside edge of the heart. Talk with the children about what message they would like you write inside the wreath. Write whatever they decide. Hang the Wreath on the door.

EXTENSION:
Make a Valentine board game. Get a piece of posterboard. Cut four or five of each size and color of heart. Glue one of each type on the board. To play, pass all of the remaining hearts out to the players. Taking turns, let each child match one of his hearts to one on the board. Continue until all of the hearts are matched. When the game is over, keep the hearts in a plastic bag so they are ready for the next children who want to play.

116

LOVE BUG

PREPARE FOR THE ACTIVITY

Gather The Materials

- Take the children's photographs at the beginning of February.
- Cut a giant Love Bug out of white butcher paper.
- Gather kitchen utensils appropriate for printing such as potato masher, funnel, etc.
- Pour red and pink tempera paint into shallow containers.
- Have: blunt-tipped scissors
 red construction paper
 glue
 brushes for glue
 heavy-duty tape

Talk With The Children: Show the children their photos. Put them on the floor so all of the children can see them. Call on a child, have him come over to the display of photos, pick one up, and give it to the child in the picture. As the child gives the photo to his friend, have him say, *"Happy Valentine's Day, Greg."* After the photos have been distributed, have the children march over to the art area and lay them down at one end of the art table. Have the Love Bug on the table. Show it to the children. Tell them that at art they are going to print the Love Bug and then frame their photos and glue them to the bug's arms.

ENJOY THE ACTIVITY

Lay the Love Bug in the middle of the table with the kitchen utensils, red and pink paint around him. When the children come to art have them dip the utensils in the paint and print designs all over his body.

While the Love Bug is drying, have the children frame their photos by cutting a piece of construction paper bigger than their photograph and gluing the photo to the paper. When the photos have dried, let each child choose one of the Love Bug's arms and glue his photo on it. Let it dry.

DISPLAY THE *"LOVE BUG"*

Hang the Love Bug securely on the door, low enough so the children can easily look at all of their school friends.

EXTENSION:

Set up a photography studio. Cut a large heart-shaped frame out of posterboard. Hang the frame from the ceiling, low enough so that the children can easily hold it and put their head through it. Have an old camera available and encourage the children to be Valentine photographers.

TEXTURE BOARD

PREPARE FOR THE ACTIVITY

Gather The Materials

- Gather a variety of textures — sandpaper, corduroy, cotton balls, burlap, fur, aluminum foil, corrugated cardboard, etc. Cut them in small pieces and put them onto separate trays.
- Have: a large piece of lightweight posterboard
 glue
 double-stick cellophane tape

Talk With The Children: Put a sample of each texture on a large tray. Place the tray on the floor for all of the children to see. Say a word such as *"bumpy."* Have the children look at all of the textures. Let a child go to the tray and pick up a texture/s he thinks is bumpy. Have him pass it to each child to touch. What do the others think? Say other words such as *"rough, soft and smooth"* and let the children find a texture/s that has that feel and pass it around.

Tell the children that at art they are going to glue a large texture board for the door.

ENJOY THE ACTIVITY

Lay the piece of posterboard in the middle of the art table with the glue and trays of textures on both sides of it. When the children come to art have them glue the different textures to the board. Encourage them to put the pieces close together. Let it dry.

DISPLAY THE *"TEXTURE BOARD"*

Tape the Texture Board low to the inside of the classroom door. Encourage the children to touch the variety of textures and think of other things that might feel similiar, such as a kitten and a cotton ball.

EXTENSIONS:

Put a copy of the book *PAT THE BUNNY* on the shelf.

Let the children make a texture book. Cut small pieces of cardboard for the pages. Have the children glue textures to each page. Punch a hole in the top of each page and fasten together with a metal ring. Add this book to your book shelf.

JACK FROST

PREPARE FOR THE ACTIVITY

Gather The Materials
- Have: large bowl
 Ivory Snow®
 egg beaters or large spoons
 several small containers
 safe stools

Talk With The Children: Ask the children if they remember Jack Frost coming in the beginning of the winter. With cold weather still here, Jack Frost continues to visit most days. Oftentimes he leaves a thick layer of frost on the windows. Ask the children if they have ever tried to scratch a design in the frost with their fingernails.

Tell the children that at art they can pretend to be Jack Frost and paint on the school windows with Ivory Snow®.

ENJOY THE ACTIVITY
When the children are ready to play Jack Frost have them put the dry soap in a bowl and slowly add water. Using the beaters or spoons, whip the soap until it reaches a mashed potato consistency. Have them scoop some of the mixture into a smaller container and carry it over to the window. They can smear the soap onto the window pane and then create designs. (Have several safe stools if the children need help reaching the window.)

DISPLAY THE *"JACK FROST DESIGNS"*
Let the frost dry. Have the children carefully look at their windows. Did Jack Frost bring them any special designs? What do they see?

EXTENSION:
Have the children be alert to designs that Jack Frost left on other windows. Encourage them to look at the frost on the windows in their homes, on their cars, on store windows, and so on. Talk about the designs the children have seen.

HAVE A HEART

Gather The Materials

- Have: waxed paper
 - crayons with the paper peeled off — can be Valentine colors or a larger variety
 - potato peelers or individual pencil sharpeners
 - containers for the shaved crayons
 - electric iron
 - stack of newspapers
 - marker
 - blunt-tipped scissors
 - paper punches
 - thin ribbon
 - cellophane tape

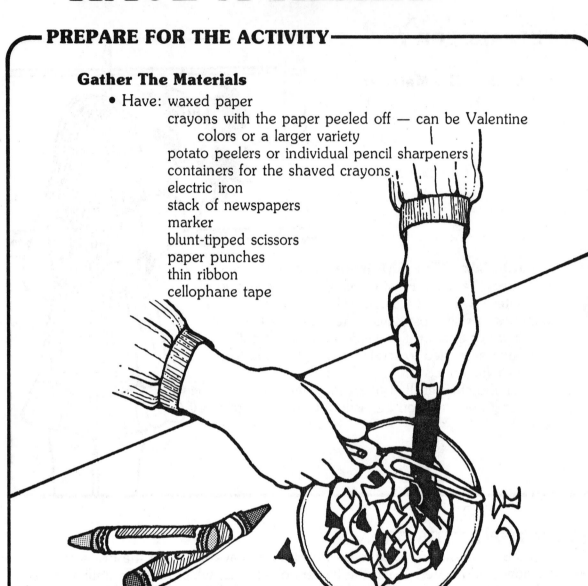

Talk With The Children: Tell the children they are going to melt crayon shavings between waxed paper for Valentine suncatchers. Have them help you decide what colors they would like to use in their suncatchers. Bring a variety of crayons to show them. Hold up a red crayon and ask, *"Would anyone like to use red?"* If a lot of children say *"Yes"* put four or five red crayons on the tray to be shaved. If only one or two say *"Yes"* put one crayon on the tray. (Remember the children can always shave more if they run out of shavings.) Continue with the other colors of crayons.

ENJOY THE ACTIVITY

First have the children shave the crayons, separating the colors into different containers. Spread the various trays of colored shavings on the art table. Establish a quiet place to press the waxed paper and turn the iron on a low setting.

When the children come to art, have them each tear off a piece of waxed paper and then sprinkle shavings on it. Cover it with another piece of waxed paper and carry it over to the ironing spot. Lay the waxed paper on a stack of newspaper and cover it with several more pieces of newspaper. Carefully iron the two pieces of waxed paper together until the crayon is melted.

Ask the child what size heart he would like to cut out. Draw an outline of a heart on the waxed paper and let the child cut it out, punch a hole in the top, and loop a piece of ribbon through it.

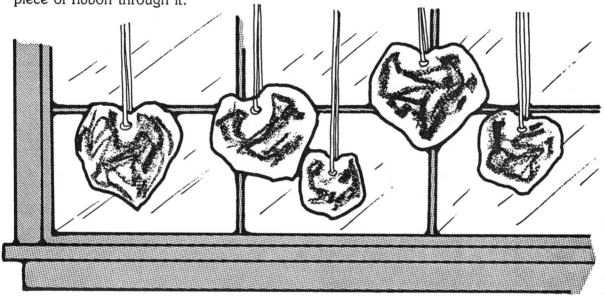

DISPLAY THE *"HEARTS"*

Hang the Hearts in a sunny window. Pretend they are bringing love to the classroom.

EXTENSION:

Let the children make more suncatchers and give them as Valentine surprises to their families.

FABRIC WEAVING

PREPARE FOR THE ACTIVITY

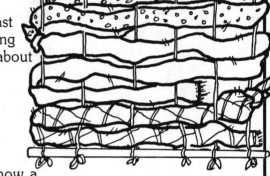

Gather The Materials

- Have: remnants of fabric, at least
 8″ wide and 18″ long
 2 half-inch dowel rods, about
 one foot each
 brown twine
 sharp scissors
 (adult use only)

Talk With The Children: If you know a person who does any type of weaving, invite him/her to talk with the children.

Before weaving, the children must build their frame. Have them cut six strips of twine about two feet long. Tie one end of each piece of twine to one dowel rod and the other ends of the twine to the other dowel rod. Hang the frame from a hook on a wall. Tell the children that at art they are going to tear strips of fabric and then weave the fabric in and out of the twine.

ENJOY THE ACTIVITY

Put the fabric remnants on the art table. When a child comes to art, have him choose a piece of fabric. Snip one end of it in several places so he can tear his strips for weaving.

When the strips have been torn, tie the first one onto the far left string at the bottom of the frame. Now he is ready to begin weaving. Have him say *"over-under"* to himself as he loops the fabric in and out of the pieces of twine. When he gets to the end of a row he should weave in the opposite direction, going right to left. When a child gets to the end of a fabric strip he (with help) should tie on another strip. When he is finished weaving he can leave the frame for another child to continue. Periodically push the rows of fabric tightly together. Continue weaving until the frame is full.

DISPLAY THE *"WEAVING"*

Ask the children where they would like to hang their Weaving. Hang it for everyone to enjoy.

EXTENSIONS:

Make another hanging using a different twine for the frame such as macrame rope or clothesline. The children could also make individual ones.

Read *CHARLIE NEEDS A CLOAK* by Tomie de Paola.

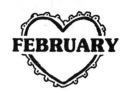
ME AGAIN

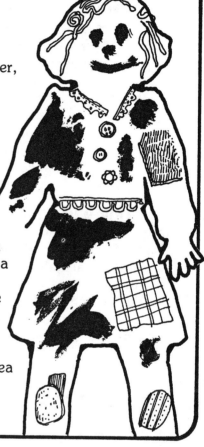

PREPARE FOR THE ACTIVITY

Gather The Materials

- Have: a roll of butcher paper
 a wide variety of collage materials
 such as different types of paper,
 fabric, ribbon, etc.
 glue
 tempera paint
 brushes
 heavy-duty tape

Talk With The Children: When the children first came to school (see October, ME) they painted a large tracing of themselves. Ask the children if they can remember making their first tracing. Let them lie down and position themselves. While they are lying down, have them try new positions and decide how they want to lie for their new tracing. Tell them that they are going to decorate new tracings in the art area with paint and a variety of collage materials.

ENJOY THE ACTIVITY

When each child is ready, have him lie down on the butcher paper and then trace around him. As you are tracing, have him name the body parts you are drawing around. Cut each tracing off of the big roll and give it to the child. Have him carry it to a place in the art area where he can dress his tracing. First each child can paint himself and let his tracing dry. When dry, he can add detail by gluing collage scraps over the paint.

DISPLAY THE *"ME"* TRACINGS

When finished, have the children help you hang the Tracings on the wall — perhaps in your hallway. As you are hanging each one, have the child tell you one or two things he thinks he does well.

EXTENSIONS:

Have a full length mirror available. Encourage the children to twist their bodies and faces into all sorts of funny positions.

Update the growth chart you began in October.

Make a full-size people puzzle.

PINK HEART

PREPARE FOR THE ACTIVITY

Gather The Materials
- Cut a large heart shape from white posterboard.
- Have: red and white tempera paint
 - large bowl
 - small pitcher
 - paint stirrers
 - small containers
 - brushes
 - heavy-duty tape

Talk With The Children: Take the children for a walk to the Wall of Colors. Talk about each color. Name the colors and take another good look at the variety of materials which have been glued up. What are they?

Show the children the heart. Tell them that they are going to paint the heart pink and glue pink materials to it during February.

ENJOY THE ACTIVITY

Put the large bowl of white paint and a small pitcher of red paint on the art table. Have a child slowly pour the red paint into the white paint. As he is pouring, have other children hold the bowl and stir the paints. Watch what is happening to the white paint as the red is being added.

Bring the big heart and brushes to the table. Pour the pink paint into several smaller containers. Let the children paint the entire heart. Let it dry.

DISPLAY THE *"PINK HEART"*

Tape the heart low on a wall in the classroom. Encourage the children to bring pink materials to glue onto the heart. Each day let children add anything they have brought. At the end of February, hang the Pink Heart on the Wall of Colors.

EXTENSION:

Show the children different Valentine cards. Look at all of the colors, but especially pink. Discuss what is pink in each card. Have some duplicate cards so the children can match them during free play.

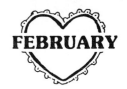

HEART MOBILE

PREPARE FOR THE ACTIVITY

Gather The Materials
- Draw hearts on red, pink, or white construction paper in four different sizes.
- Have: blunt-tipped scissors
 strips of wide ribbon
 glue

Talk With The Children: Using only one color, cut out a set of four hearts for yourself and one or two hearts for each child. Show them to the children. Lay one of each size on the floor. Pass the rest of the hearts to the children. Have them match the hearts they have to the ones on the floor.

Tell them that at art they are going to glue the different size hearts to a ribbon for Valentine mobiles.

ENJOY THE ACTIVITY

Put the scissors, hearts, and ribbons on the art table. Have the children cut the hearts out. Glue the largest hearts to the top of their ribbons. Continue gluing the hearts down the ribbons ending with the smallest ones. If the children would like to glue hearts on the other side of their ribbons they can turn them over and repeat. Loop hooks at the top of the ribbons. Make as many mobiles as the children would like.

DISPLAY THE *"HEART MOBILE"*

Hang the Mobiles from the ceiling. As the children go by them, encourage them to count the hearts.

EXTENSION:

Make several extra sets of hearts. Put them in a box. Store the box on the shelf with the puzzles. Encourage the children to sort the hearts with a friend.

OUR TOWN

Gather The Materials

- Have: large piece of heavy corrugated cardboard for the base — about three feet square

 variety of different size smaller boxes, such as toothpaste, pasta, medicine, etc.

 different colors of tempera paint — add a little liquid detergent so the paint adheres better to the boxes

 brushes

 large piece of cardboard

 magazines

 blunt-tipped scissors

Talk With The Children: Show the children the large base and all of the boxes you have collected. Bring a wide black marker with you. Tell the children they are going to build a city. Lay the base in the middle of the floor. Using your wide marker, outline several streets on the large base. Have a Main Street where the shopping district is located and several side streets for the houses and apartments. Pass a variety of the smaller boxes to the children. Let them pretend their box is a certain type of building in the shopping district. Have them name their building — fire station, police station, gas station, bakery, grocery store, laundromat, restaurant, etc. — and then put it along Main Street. Show the children the other boxes that can be houses and apartments. You put them along the side streets. Now the city has begun. What else does it need?

Tell the children that you are going to put the base and boxes in the art area. At art they are going to paint the buildings for their town.

126

ENJOY THE ACTIVITY

Have the boxes and base on the art table along with the tempera paint and brushes. Lay the cardboard near the art table. When the first children come to art, have them paint the streets you had outlined. While the streets are drying, let the children paint the boxes and put them on the cardboard to dry. If the children would like, have them look through magazines and find pictures of things which are appropriate to the different buildings such as food for the grocery store, hammer for the hardware store, clothes for the department store, and so on. Have them cut the pictures out and glue them to the buildings. Label the different buildings.

DISPLAY *"OUR TOWN"*

Put all of the boxes in a large plastic tub. Lay the base of the town on a table or on the floor and let the children enjoy moving the buildings around. Over the next several weeks, add accessories to the town such as cars, trucks, buses, people, trees, and signs.

EXTENSION:

Take a walk down to the shopping area of your town. Look around at the various buildings. Talk about what people are doing inside the buildings.

LACY TABLECLOTH

PREPARE FOR THE ACTIVITY

Gather The Materials
- Cut newsprint the size of the table where you will be eating.
- Have: different sizes and shapes of paper doilies
 red crayons with the paper peeled off
 double-sided tape

Talk With The Children: Bring some of the paper doilies to show the children. Have them rub their hands over the surface, hold the doilies up to their faces and peek through the holes, feel the edges, and so on. Talk about how doilies feel and look. If you have a real lace tablecloth or doily bring it to show the children. Tell the children that they are going to use the paper doilies and crayons at art to print a Lacy Tablecloth.

ENJOY THE ACTIVITY

When the children come to art, have them help you place the doilies on top of the art table. Secure each one with a short piece of tape. Carefully lay the piece of newsprint on the table over the doilies. The children should gently feel the paper for one of the doilies. When they find one, have them use the side of their crayon and make a rubbing of it. When all of the prints have been made, the children will have a Lacy Tablecloth for Valentines Day.

DISPLAY THE "LACY TABLECLOTH"

Use the tablecloth at lunch or during the Valentine party. Enjoy looking at the variety of lacy shapes and sizes. It might be fun to use small doilies under each person's drink.

EXTENSION:

Have red snacks for your Valentine party. How about a tangy shake? Mix 16 oz. of orange juice, 1 banana, and 2 cups of frozen strawberries in a blender. (If it is too tart, add cold water or several ice cubes.) Serve cold.

SNACK TRAYS

PREPARE FOR THE ACTIVITY

Gather The Materials
- Use a yarn needle to poke holes about 1/2 inch apart around the edges of the meat trays.
- Have: small to medium size meat trays
 pink and any other color of heavy yarn you might have
 blunt-tipped yarn needles

Talk With The Children: Discuss the children's favorite snacks with them. Ask the children what snacks they can make all by themselves. What snacks do they need help in making? Talk about snacks they have at school. Which ones do they like best? Tell them that at art they are going to decorate snack trays by sewing yarn around the edges of meat trays.

ENJOY THE ACTIVITY

Put the meat trays, yarn, and needles on the art table. When the children are ready to sew around the trays, have them choose the color of yarn they want. Then help them thread their needles and get started by tying on the first stitch. Have them chant *"Up and down"* as they sew from hole to hole. Help them tie-off at the end.

DISPLAY THE *"SNACK TRAYS"*

Use the Snack Trays for snack times during February.

EXTENSION:

Sew several additional trays and let the children use them in the Housekeeping Area.

ANIMAL FOOD

PREPARE FOR THE ACTIVITY

Gather The Materials
- Pour several varieties of birdseed in small pitchers.
- Collect small margarine tubs.

Talk With The Children: February can be one of the coldest months of the winter season. It is very important to keep feeding the animals. Each day have a child check the food supply. Replenish it when necessary.

Bring the chart to show the children. Discuss the different colors of birds who have been eating the food the children put out. What colors of birds come most frequently? Least? Never? Tell the children they are going to feed the birds another type of food — birdseed.

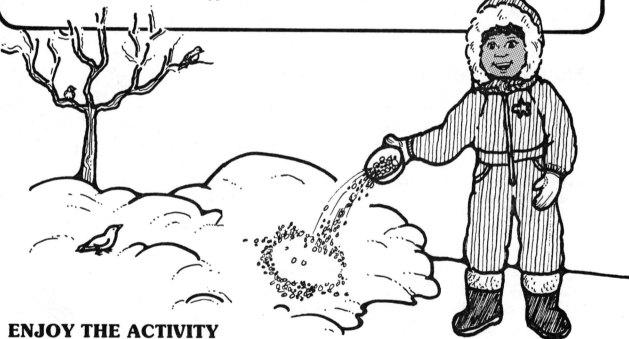

ENJOY THE ACTIVITY
Before the children go outside, let them pour birdseed into margarine tubs. Have them carry the tubs outside. In the area where they have been feeding the birds, encourage them to sprinkle the birdseed on the snow in special designs or pictures.

DISPLAY THE ACTIVITY
Watch to see if any birds eat the seeds right away. Remember to check the food daily.

EXTENSION:
Keep careful watch as to what colors of birds are feeding. Mark the chart each day. At the end of the month, see if any new color of bird began to feed at school.

RAIN PAINTING

PREPARE FOR THE ACTIVITY

Gather The Materials
- Cut butcher paper the length of your bulletin board.
- Pour different colors of powdered tempera paint into salt shakers.
- Fill spray bottles with water.

Talk With The Children: Rain is a sign of Spring. Throughout the month note the different types of rain in your area. Sometimes rain is light and called a sprinkle, other times it is very heavy and called a thunderstorm. Other terms for rain are drizzle, downpour, and shower. Each time it rains, encourage the children to look at the rain from the classroom window. Talk about what is happening.

Tell the children that today they are going to enjoy an outside art activity.

ENJOY THE ACTIVITY

On a warm, sunny day have the children help you take a sheet of butcher paper, the salt shakers filled with tempera paint, and the spray bottles outside. Lay the sheet of paper on the ground. Let the children sprinkle powdered tempera paint onto sections of the paper and then pretend it is raining by spraying water on it. What did the rain do to the powdered paint?

DISPLAY THE "RAIN PAINTING"

After the Painting has dried, bring it inside and hang it on your bulletin board.

EXTENSIONS:

Just before a real rain sets in, lay another sheet of butcher paper on the ground. Have the children sprinkle it with dry tempera. Let it rain. When the rain stops, go outside and look at the paper. What happened this time? How are the two paintings different? The same?

Read *THE RAIN PUDDLE* by Adelaide Holl.

KITES

Gather The Materials

- Cut butcher paper the size of your bulletin board.
- Have: wide straws about 5-6 inches long (save short pieces for your collage box)
 gray tempera paint, slightly watered down
 tablespoons
 all colors of tissue paper
 plastic containers
 liquid starch or watered-down white glue
 brushes for the starch/glue
 construction paper
 blunt-tipped scissors

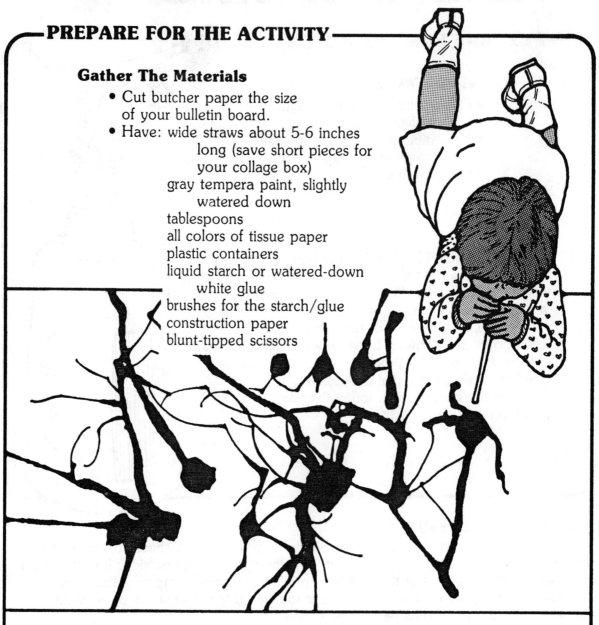

Talk With The Children: Using several inflated balloons, let the children pretend they are the March wind. Blow one of the balloons to a child. He should blow it to a friend and so on. Once they get the rhythm of the activity, use two or three balloons at the same time.

Tell the children that at art they are going to once again pretend to be the March wind. This time they are going to blow paint around a large piece of paper. When the paint has dried, they will add a giant kite blowing in the wind.

ENJOY THE ACTIVITY

First make the background design. Spread the butcher paper on the floor in the art area and put the straws, tablespoons, and the containers of gray paint around it. When the children come to the area, let them choose a straw. Spoon some gray paint onto the paper in front of them. Now they can pretend to be the strong March wind by blowing through their straws and moving the paint all over the paper. Spoon more paint and continue to blow like the wind.

When the background paper has dried, lightly draw the outline shape of a kite on it. Put the tissue paper, starch, and brushes around the kite outline. Have the children tear pieces of tissue paper, brush starch over a section of the kite, and press the papers down firmly. Continue until the kite is covered. Finally enjoy cutting strips of construction paper and making a chain for the tail of the kite.

DISPLAY THE "KITE"

When the Kite has dried, carry the butcher paper over to the bulletin board. Let the children help you tack it up.

EXTENSIONS:

On a warm, windy day, let the children make small kites out of construction paper, add a three or four foot string, and fly them outside.

Enjoy this rhyme with the children:

KITES

The wind blew gently across the ground.
The kite began to fly.
I held onto the string and pulled
As it rose into the sky.

Higher than my mother's head.
Higher than the tree.
Up to where the airplanes fly
And all controlled by me.

Dick Wilmes

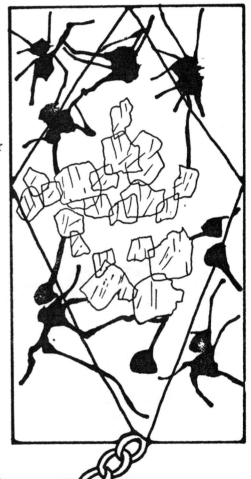

POT OF GOLD

Gather The Materials

- Cut butcher paper the size of your bulletin board.
- Draw a large caldron shape on fingerpaint paper.
- Draw all size circles on yellow construction paper.
- Have: food coloring
 - small bowls of water
 - wide paint brushes
 - black fingerpaint
 - blunt-tipped scissors
 - fine-lined markers
 - small basket
 - cellophane tape

Talk With The Children: Ask the children if any of them have ever seen a rainbow. Tell them that rainbows appear in the sky when the sun is shining in a special way through light rain. A rainbow consists of many colors that form an arch in the sky. Talk about the colors — red, blue, green, yellow, orange, purple, etc.

Tell the children about leprechauns and how they think there is a pot of gold at the end of every rainbow. Show the children the big caldron you drew. Tell them that at art they can cut out and then fingerpaint the pot and cut out circles of gold to put in it.

MARCH

ENJOY THE ACTIVITY

Lay the butcher paper on the floor in the art area. When several children come to art, have them mix the rainbow colors by adding food coloring to each bowl of water and stirring. After the colors have been mixed, put them and the brushes around the edges of the paper. Have the children paint the background. Let it dry and hang it on the bulletin board.

Put the caldron and black fingerpaint at one end of the art table and the construction paper, scissors, basket, and markers at the other end. Those who want can cut out the caldron and then fingerpaint it. Let it dry. Encourage all of the children to cut pieces of gold for the pot. After each child has cut a piece of gold, have him make a wish for something he might like to have. Write his wish on the piece of gold he cut out. Maybe he would like to cut more. Put all of the gold pieces in the basket.

DISPLAY THE "POT OF GOLD"

When the caldron has dried, tack it to the bulletin board. Before taping the children's wishes to the board, bring the basket of gold pieces to circle time. Read the wishes to the children. After you have read each wish, put a piece of tape on it, give it to a child, and let him put it on the board and then return to the group.

EXTENSION:

While the children are out of the room, lay a trail of leprechaun footprints going under tables, on top of shelves, across the floor, and finally up onto a counter and out the window. When the children arrive, follow the trail and see if they can find the leprechaun. When they discover he has already disappeared discuss where he might have gone.

HAPPY ST. PATRICK'S DAY

PREPARE FOR THE ACTIVITY

Gather The Materials

- Draw a large shamrock on a piece of easel paper.
- Collect a variety of green papers such as wrapping paper, tissue paper, tablecloth, napkins, paper towels, etc. Put each type of material into a separate container.
- Cut green and white pipe cleaners into pieces approximately six inches long.
- Have: glue
 blunt-tipped scissors
 heavy-duty tape

Talk With The Children: Show the children a shamrock plant or several clovers you found in the grass. Count the petals on several of the individual shamrocks (clovers) with the children. How many are there? Look carefully. Do any of the shamrocks (clovers) have four petals? There is a saying that anyone who find a clover with four petals will have good luck. Discuss what good luck means.

Show the children the large shamrock which you have drawn. How many petals does it have? Tell them that at art they are going to cut out the shamrock and then glue a variety of green materials on it.

136

ENJOY THE ACTIVITY

Lay the shamrock shape in the middle of the table with the scissors, glue, and green materials around it. The first children coming to the art table should cut the shamrock out and tear the green papers and put them into the containers. When the other children come, have them choose green papers and glue them to the shamrock. Continue adding green until the shamrock is full.

DISPLAY THE "SHAMROCK"

When the Shamrock has dried, hang it on the classroom door. If the children would like to add a border, let them link green and white pipe cleaners into a chain to go around the door frame or around the Shamrock itself.

EXTENSIONS:

Buy a shamrock plant and put it on the window ledge.

Patrick is another familiar symbol of St. Patrick's Day. Enjoy this rhyme with the children:

WEE LITTLE PATRICK
Patrick is a leprechaun.
He has a sack of gold.
He hides it in a special place
Between two stumps, I'm told.

I think I once saw Patrick
Out in the woods at play.
He smiled and laughed and winked his eye,
And then he ran away.

Don't try to follow Patrick
To find his treasure sack.
He'll twist and jump and run away
And never will come back.
 Dick Wilmes

Talk about all of the places Patrick might hide.
Pretend he is in a forest, where would he hide?
Pretend he is in a house, where might he hide?

SPRING BOUQUET

PREPARE FOR THE ACTIVITY

Gather The Materials

- Cut butcher paper the size of your classroom door.
- Pour a variety of pastel colored tempera paints into shallow dishes.
- Cut sponges into one to two inch pieces. Clip a clothespin to each one for a handle.
- Have: Easter grass
 glue
 brushes for glue
 double-sided cellophane tape

Talk With The Children: Show the children a bouquet of Spring flowers which bloom in your locale. Talk about colors, the different parts of each blossom, and where the blossoms were growing.

Lay the piece of butcher paper on the floor so they can all see it. Show them the stems of the real blossoms. With a wide marker, draw long stems for the Spring Bouquet on the butcher paper. Tell the children that they can sponge paint blossoms on the stems at the art area. Have several children carry the paper over to the art area and lay it on the floor or table.

ENJOY THE ACTIVITY

After the paper has been laid in the art area, spread the containers of tempera paint and the sponges around the edges. When the children come to the area have them sponge paint a variety of shapes and colors all along the stems. As they are painting, talk about the flowers, trees, and blossoms which are blooming in their neighborhood. Ask them if any are blooming at their homes. When the stems are full of blossoms, have the children brush glue along the bottom of the bouquet and glue Easter grass around the stems.

DISPLAY THE "SPRING BOUQUET"

Have the children help you carry the Spring Bouquet to the door and tape it up. When the children come to school, talk about real flowers they might have seen blossoming. Are any of them the same color as the blossoms on the door?

EXTENSION:

Plant several different types of flower seeds in starter pots. Put them in a sunny window and care for them. When they mature enough, plant them outside or let the children take them home to plant. (The children could wait until Mother's Day and give their moms the plants they have been caring for.)

SPRING MELT

PREPARE FOR THE ACTIVITY

Gather The Materials
- Peel the paper off of old crayons be sure to use a variety of light and dark colors.
- Have: old muffin tin
 - warming tray
 - light colored
 - construction paper
 - pot holder
 - cellophane tape

Talk With The Children: Tell the children they are going to make hockey puck crayons. Put the old crayons and muffin tin on the art table. Have the children break the crayons into small pieces. As they are breaking the crayons, talk about all of the different colors. When all of the crayons have been broken, have the children fill each muffin cup about half-way with crayon pieces. Preheat the oven to about 200°. Let the crayons melt for about fifteen minutes. (Do not open the oven door!!) Turn the oven off and let the muffin tin sit in the oven overnight so the crayons will harden. The next day pop all of the new crayons out of the tin. Examine each one with the children. What colors do they see?

ENJOY THE ACTIVITY

Place the warming tray in a safe spot in the art area. Turn it on a low temperature. Put the hockey puck crayons and construction paper near the warming tray. When a child comes to the warming tray, have him choose a piece of paper and take a crayon. Put the construction paper on the warming tray. Holding it steady with the pot holder, use a hockey puck crayon to color a design. As the children move their crayon over the construction paper, they can pretend that the snow is melting and the spring colors are appearing.

DISPLAY THE "SPRING MELT"

As each child finishes his design, have him choose a spot on the window where he would like to hang it. Have him tape it in place.

EXTENSION:

Remove the paint from one side of your painting easel. Put the hockey puck crayons in the tray on that side. Encourage the children to use the crayons on the large sheets of easel paper.

BLACK BEAR

PREPARE FOR THE ACTIVITY

Gather The Materials
- Cut a large bear shape out of posterboard.
- Shake cotton balls in powdered black tempera paint.
- Have: glue
 - brushes for the glue
 - heavy-duty tape

Talk With The Children: Many animals who have been completely or partially hibernating during the winter months are now beginning to wake up and resume active life. Bears are one of the animals. They have been spending the colder months in caves. Go on a bear hunt with the children.

GOING ON A BEAR HUNT
Let's go on a bear hunt.
All right.
Let's go.
Oh look,
I see a wheat field!
Can't go around it,
Can't go under it,
Can't go over it,
Let's go through it.
All right.
Let's go.
Swish, swish, swish.

Oh look,
I see a tree!
Can't go over it,
Can't go under it,
Can't go through it,
Let's go up it.
All right.
Let's go.
Climb, climb, climb.

Oh look,
I see a swamp!
Can't go around it,
Can't go under it,
Can't go over it,
Let's swim through it.
All right.
Let's go.
Swim, swim, swim.

Oh look,
I see a bridge!
Can't go around it,
Can't go under it,
Can't go through it,
Let's cross over it.
All right.
Let's go.
Tramp, tramp, tramp.

Oh look,
I see a cave!
Can't go around it,
Can't go under it,
Can't go over it,
Let's go in it.
All right.
Let's go.
Tiptoe, tiptoe, tiptoe.

Golly it's dark in here.
Better use my flashlight.
Oh, no — doesn't work.
I think — I see
something.
It's big!
It's furry!
It's got a big nose!
I think — it's a bear!
IT IS A BEAR!
LET'S GO!
Run, run, run.

(Repeat the rhyme in reverse order until you're safely back home.)

Show the children the bear shape and black cotton balls. Tell them that they are going to glue the cotton balls to the bear at the art table.

ENJOY THE ACTIVITY

Put the bear shape, cotton balls, glue, and brushes on the art table. When the children come to art have them brush glue on a section of the bear and press the cotton balls on the spot. Continue until the children have glued all of the cotton balls to the bear.

DISPLAY THE "BLACK BEAR"

Tape the Black Bear low on a classroom wall. Encourage the children to bring in black materials to glue onto the bear. As they are gluing their materials, talk about other things around the room that are black. At the end of march, tape the Black Bear to the Wall of Colors.

EXTENSION:

Put a full length mirror near the Black Bear. Throughout the month have the children look at their hair and eyebrows and decide what color they are. Make a simple chart showing the children's hair and eyebrow colors.

ZOOM! ZOOM!

PREPARE FOR THE ACTIVITY

Gather The Materials
- Have: a roll of shelf paper
 gray and yellow tempera paint
 wide brushes
 narrow brushes
 car, truck, and bus brochures
 blunt-tipped scissors
 glue
 heavy-duty tape

Talk With The Children: Bring several long unit blocks and a variety of cars, trucks, and buses to show the children. Talk about riding in each type of vehicle. When do they ride in buses? Where do they go? Who goes in cars with them? What are trucks for? Build a simple road with the blocks. Let several children drive the vehicles on the road while the others chant *"Zoom, Zoom."* Tell the children that they are going to paint a large road at the art table and then glue pictures of vehicles to it.

ENJOY THE ACTIVITY

Spread the shelf paper on the floor in the art area. Put the gray paint and brushes around the edges of the paper. When the children come to art, have them paint their road gray. Let it dry. Add a yellow stripe down the middle of the road.

Put the brochures and glue on the art table. Let the children look through them, cut or tear out their favorite vehicles, and glue them on the road.

DISPLAY THE *"ROADS"*

Securely tape the Road low on the wall in the block area. Encourage the children to build roads and expressways with the blocks and then use all of their vehicles on the road.

EXTENSION:

As a child or children are involved in a construction project, have them dictate a story to you about their building. Write what they say on a large sheet of chart paper. Ask them if they would also like to draw a picture of their building. Read their experience story to the group that day and then hang it in the block area.

CURLY-QUES

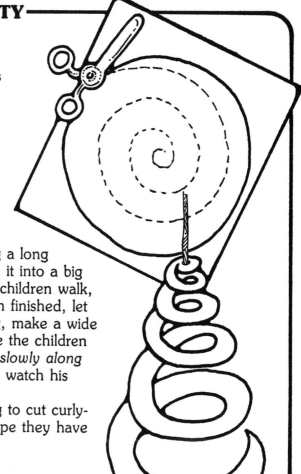

PREPARE FOR THE ACTIVITY

Gather The Materials
- Draw large circles on pieces of construction paper.
- Have: blunt-tipped scissors
 thin yarn
 paper punch

Talk With The Children: Bring a long clothesline to show the children. Shape it into a big circle. Talk about the shape. Have the children walk, hop, slide, etc. around the circle. When finished, let the children rest. While they are resting, make a wide snake-like coil with the rope. Now have the children sit around the coil. Say *"Jeremy, walk slowly along the rope."* As he walks have the others watch his path. Continue with others.

Tell them that at art they are going to cut curly-ques which look similar to the coiled rope they have been playing with.

ENJOY THE ACTIVITY

When the children come to art, have them cut circles out of the construction paper. As they finish each circle, ask them *"Do you want me to draw a curly-que line on the circle for you to follow as you cut or do you want to cut around and around without a line?"* If they want you to draw a line, remember to leave a wide path between the loops. Let the children cut as many curly-ques as they want.

DISPLAY THE "CURLY-QUES"

Punch a hole at one end of the Curly-Ques. Cut a piece of yarn and loop it through the hole. Hang them at different lengths from the ceiling.

EXTENSION:

When you are outside, have the children hold hands making a long line. At first the line is straight. Now curve the line into circle. Next begin to coil the line, just like the curly-ques the children made. When the children are all coiled up, jump up and down and then slowly uncoil into the circle shape and then back to the straight line.

SUNSHINE

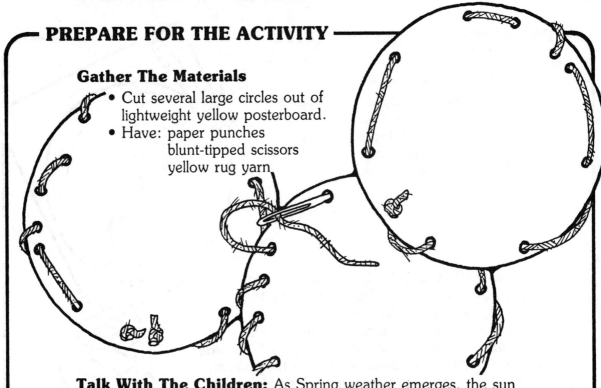

PREPARE FOR THE ACTIVITY

Gather The Materials
- Cut several large circles out of lightweight yellow posterboard.
- Have: paper punches
 blunt-tipped scissors
 yellow rug yarn

Talk With The Children: As Spring weather emerges, the sun shines on your neighborhood longer and more directly, thus causing more daylight and warmer temperatures. Talk with the children about the types of clothes they are wearing now compared to the ones they wore in the winter. Ask them how they would feel if they wore their snowclothes when the warm sun was shining. Besides keeping people warmer, the sun helps gardens grow, signals some animals to come out of hibernation, and signals other animals to migrate back from the warmer southern climates.

Show the children the suns you cut out of posterboard. Tell them that at art they can punch holes around the suns and then sew a border of yarn around them.

ENJOY THE ACTIVITY
Put the yellow circles on the art table along with the paper punches. Have the children (they may need help) punch holes around the edges of the circles. With the blunt needles and yellow yarn, have them sew a border around each sun.

DISPLAY THE "SUNS"
Hang the Suns over the different areas of the classroom so they can bring the warmth and brightness of Spring to everyone, even on gloomy days.

EXTENSION:
Make a simple chart for the month of March, keeping track of the sunny and gloomy days.

MARCH CHIMES

PREPARE FOR THE ACTIVITY

Gather The Materials

- Have: several wooden paint stirrers
 with holes drilled in them
 variety of nuts, bolts, washers
 string
 blunt-tipped scissors

Talk With The Children: Strong wind is one of the characteristics of March weather. On a windy day take a short walk around the neighborhood. After the walk, talk about how the wind felt. Have the children close their eyes and pretend the wind was very strong. What do they think the wind could blow around?

Tell the children that at art they are going to construct wind chimes to hang outside. Show them the paint stirrers with the holes drilled in them. Count the holes. Tell them that they will be tying strings to nuts, bolts, and washers and then attaching the strings onto the paint stirrers.

ENJOY THE ACTIVITY

Bring the drilled stirrers to the art area. Have the nuts, bolts, washers, and string on the table. Have the children work in pairs cutting pieces of string, tying them around the heads of the bolts and through the holes of the nuts and washers. Next have them loop the strings through the holes in the stirrers. Make a series of them. Crisscross two stirrers and firmly tie them in the middle. Attach a long piece of string in the middle to hang the chimes.

DISPLAY THE "CHIMES"

When the March Chimes are finished, hang them outside. As the children play outside, have them be aware of when the chimes ring. How strong was the wind? How loud were the chimes?

EXTENSIONS:
Enjoy this rhyme:
WIND TRICKS
The wind is full of tricks today.
He blew my daddy's hat away.
He chased our paper down the street.
He almost blew us off our feet.
He makes the trees and bushes dance.
Just listen to him howl and prance.
Read *GILBERTO AND THE WIND* by Marie Hall Ets.

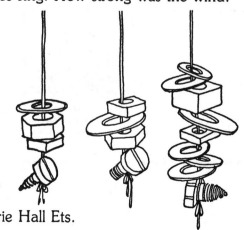

145

PARKING LOT

PREPARE FOR THE ACTIVITY

Gather The Materials

- Get a thin piece of plywood for the base.
- Collect scrap pieces of lumber from the lumber yard.
- Have: white glue
 brushes for the glue
 wide brushes
 tempera paint

Talk With The Children: Several days before constructing the wooden parking lot, spend extra time in the block area encouraging the children to build roads, bridges, and parking lots with the blocks. While building, talk about large parking spaces for trucks and buses and smaller ones for cars. Add several different cars and other vehicles as the children are building. Talk about times when their parents and grandparents have parked in parking lots. Do any of them remember what types of parking lots they have been in? Depending on their background, discuss underground, street level, and multi-tiered lots.

Tell the children that you are going to put wood, brushes, and glue in the art area so they can construct a parking lot for the block area.

ENJOY THE ACTIVITY

Lay the base in the art area and put the scrap lumber, brushes, and glue around it. Have the children drizzle and/or brush glue onto the lumber and build a wooden structure. (Remember they will need to hold the pieces together a little while so they will adhere.) As they are building, talk with them about the size of the different areas where they can park the cars and what types of vehicles can be parked in them. Let it dry and then paint it.

DISPLAY THE "PARKING LOT"

When the paint is dry, have the children help you slide the Parking Lot to the block area. Encourage them to use the Lot for their cars, trucks, and buses.

EXTENSIONS:

Take a walk to a nearby parking lot. Look at all of the different cars. Are there people in the lot? Are any of them getting in or out of their cars? How many cars are on the lot — a lot or a few? Count them if appropriate. What other types of vehicles are in the lot?

Enjoy this rhyme with the children:

THE WHEELS ON THE BUS

The wheels on the bus go 'round and 'round
'Round and 'round, 'round and 'round.
The wheels on the bus go 'round and 'round
All through the town.

The door on the bus goes open and shut
Open and shut, open and shut.
The door on the bus goes open and shut
All through the town.

The wipers on the bus go swish, swish, swish
Swish, swish, swish; swish, swish, swish.
The wipers on the bus go swish, swish, swish
All through the town.

The driver on the bus says, "Move on back,
Move on back, move on back!"
The driver on the bus says, "Move on back!"
All through the town.

(Add additional verses of you want: windows go up and down; babies go whaa, whaa, whaa; mommies go sh, sh, sh, and so on.)

PIZZA

Gather The Materials

- Have: large pizza board
 fingerpaint paper
 beige fingerpaint
 different colors of
 construction paper
 blunt-tipped scissors
 pizza box

Talk With The Children: Have a pizza for snack the day you enjoy the art activity. Before you cut the pizza into pieces, talk about times when the children have had pizza with their families. Have they ever had pizza at a restaurant? Was it good? What was on the pizza? Now cut the pizza into slices for each child. Pass it out. What is on the pizza? Do they like it?

Show the children the pizza board. Tell them that at art they are going to make a pretend pizza and put it on the pizza board.

ENJOY THE ACTIVITY

Put the fingerpaint and pieces of fingerpaint paper at one end of the art table and the construction paper and scissors at the other end. Have several children make the crust of the pizza by fingerpainting the large piece of fingerpaint paper. When the paint has dried, cut it into a circle to fit the pizza board. Glue the crust on the board. One child should cut a large red circle from construction paper for the tomato sauce and lay it on the pizza. Others can cut cheese strips, sausage and pepperoni rounds, onion pieces, mushroom caps, red and green pepper slices, and so on. If the children would like to curl the cheese strips, have them loosely wrap their strip around their index finger and then pull it out. As the ingredients are finished, have the children put them on the pizza.

DISPLAY THE *"PIZZA"*

Put the pizza board and all of the ingredients in a pizza box. Have a child carry it over to the housekeeping area. Encourage the children to make pizza for friends when they come over for dinner.

EXTENSIONS:

Take a field trip to the local pizza parlor. Let the children see how pizzas are made. Stay at the restaurant for a pizza lunch.

Change the dramatic play area into a pizza parlor. Add rolling pins, menus, paper, pencils, money, cash register, aprons, placemats, baker's hats, additional pizza boards, boxes, and ingredients. Encourage children to be bakers, waitresses, waiters, and patrons.

148

MARCH MATS

PREPARE FOR THE ACTIVITY

Gather The Materials
- Have: heavy-duty paper towels
 watercolors
 large pieces of construction paper
 clear adhesive paper

Talk With The Children: Make a tablecloth with the children for the housekeeping area. Bring newspaper, the roll of paper towels, and watercolors to show the children. Lay the newspaper on the floor, tear a section of paper towels (about 4) off the roll, and lay it on the newspaper. Have the children paint the tablecloth by putting paint on their brushes and dropping dots of color onto the towel. Talk about the colors and designs as the children are painting. Let it dry and carry it over to the housekeeping area.

Tell the children they are going to paint placemats for themselves in the same way in the art area.

ENJOY THE ACTIVITY
When the children come to the art table, let them choose a paper towel and watercolor tray. Instead of painting the watercolors on the paper towel, encourage them to dip the brush in the paint, hold it upright over the paper, let the paint drip off the brush, and dot the towel with color. Continue, adding a variety of colors to the placemat. As the children are dotting paint on the towel, talk about what happens to the paint when it lands on the towel.

After each towel is thoroughly dry, lay it on a piece of construction paper and cover both sides of the placemat with clear adhesive paper, leaving a half inch border.

DISPLAY THE *"MARCH PLACEMATS"*
Put the March Mats near the snack table and use them each day. Talk about things the different drops of color remind the children of.

EXTENSION:
Enjoy making Springtime snacks with the children:

ANTS ON A LOG
You'll need: To Make: Wash the celery and
 Celery cut it in short pieces. Have
 Peanut Butter the children spread peanut butter
 Raisins on the celery and then dot
 each piece with several raisins.

GAS PUMPS

Gather The Materials

- Get several tall, narrow type boxes from the grocery store or hardware store — shovel and broom boxes are great.
- Get cardboard bases that the tall boxes will fit on.
- Have: sandpaper
 white glue
 brushes for the glue
 pieces of hose
 different colors of
 tempera paint
 wide brushes
 utility knife (for adult use)
 heavy-duty tape

Talk With The Children: Ask the children if they have ever helped their parents pump gas. What do they do to get gas into their car, truck, etc.? Why do vehicles need gas? After this discussion, ask the children if they ever do anything else at the gas station. What?

Show them one of the tall boxes. Tell the children they are going to pretend that these boxes are gas pumps. At art they are going to paint them.

ENJOY THE ACTIVITY

Bring the bases, boxes, and paint to the art area. Have the children put the tall boxes on the bases so they can see what they will look like. After the children have decided how they want to build their gas pumps, take the pumps off of the bases, sand them, and paint them. Add as many features to the pumps as the children want. When the paint has dried, cut several small holes in the pumps for the hoses. Tape the hoses securely into the holes. When the pumps are completely dry, glue them to the bases.

DISPLAY THE *"GAS PUMPS"*

Use the Pumps outside. Put them near the parking lot where all of the riding toys are kept. Children can get fuel as they ride around the area.

EXTENSIONS:

Many gas stations also sell food. Add a grocery store to the area where the pumps are. Get a table, cash register, and empty cans and boxes of food and drinks. As the children buy gas they might need to pick up some groceries also.

Construct inside gas pumps using smaller boxes. Add these pumps to your Block Area.

ARM DANCING

PREPARE FOR THE ACTIVITY

Gather The Materials

- Cut a piece of mailing paper, shelf paper, and flocked wallpaper the length of your bulletin board.
- Have: crayons
 chalk
 fingerpaint
 heavy-duty tape
 record player
 several records

Talk With The Children: Play records with fast and slow beats. Let the children dance. After each song, talk with the children about dancing. How do they move when the music is fast — slow?

Tell them that at art they are going to dance with their arms. While they are dancing they will be creating a crayon design on a large piece of paper.

ENJOY THE ACTIVITY

Lay the mailing paper on the floor in the art area along with the record and record player. Have the children space themselves around the paper, leaving several feet between each other. When everyone is ready to begin, pass the container of crayons around and have every child take two, one for each hand. When the music begins, the children's arms can begin to dance. As their arms dance, they will color the paper. Periodically stop the record. Talk about the marks on the paper. Dance again.

Enjoy Arm Dancing again. Use fingerpaint on a piece of flocked wallpaper and chalk on shelf paper.

DISPLAY THE "ARM DANCING"

Hang the first Arm Dancing design as low as possible on your bulletin board. Display the next one just above the first and so on. Enjoy looking at and discussing the effects made with different media.

EXTENSION:

Play a great variety of music. Encourage the children to dance. Give them scarves and crepe paper streamers to wave high and low as they sway and move to the music.

RAINY DAY WINDOW

Gather The Materials

- Cut pieces of waxed paper the size of your bulletin board. Tape them together with clear tape so they cover the entire board.
- Draw simple boot, hat, and umbrella shapes on construction paper.
- Have: gray tempera paint (add a little liquid soap so it
 adheres to the waxed paper better)
 easel brushes
 chalk
 blunt-tipped scissors
 glue
 fixative such as hair spray
 brushes for glue
 sturdy stool

Talk With The Children: One day when it is lightly drizzling, have the children put on their rain clothes and take a rainy day walk. Give each of them a piece of waxed paper. As they walk, encourage them to catch raindrops. Just before the walk is over, have them catch several more drops, carefully carry them inside and lay them down. After taking off their coats, look at the raindrops and discuss them. Have the children tip their pieces of waxed paper. What happens to the raindrops? After the discussion, read *RAIN DROP SPLASH* by Alvin Tresselt.

Tell the children that at art they are going to pretend that a large piece of waxed paper is a window. They are going to paint rain all over it.

ENJOY THE ACTIVITY

First make the background design. Lay the large piece of waxed paper on the floor in the art area. Put the brushes and containers of gray paint around the edges of the paper. Have the children lightly dip their brushes into the paint and then push the tip of the brush against the paper. Continue dabbing raindrops until the entire window is covered with rain. Let it dry and hang it on the bulletin board.

Put the umbrellas, hats, boots, scissors, and chalk on the art table. Have the children cut out the rain gear and color them with chalk. Spray a fixative on each one as the children finish.

DISPLAY THE *"RAIN CLOTHES"*

Have the children brush glue on the backside of their boots, hats, and umbrellas, carry them over to the Rainy Day Window, and stick them up where they want. (You may need a sturdy stool to help the children reach the board.) The children might want to add a frame to their Window by cutting wide strips of construction paper and tacking them around the edges.

EXTENSIONS:

Make a felt child with all of the different pieces of rain gear. Talk with the children about different ways to keep dry on a rainy day. After the discussion, use your felt board and dress the child for a walk in the rain.

Enjoy a rainy day game with the children. You'll need a real umbrella. Have the children sit in a group. Ask one child to leave the room. After he has gone, have another child hide behind the open umbrella. Call the first child back. Have him look around the group and try to figure out who is hiding. When he thinks he knows, have him call out a name. If he's right, the child behind the umbrella should stand up and hold the umbrella over his head. If it's not the child, the group should chant *"Guess again."* Play several times.

SPRING HATCHING

Gather The Materials
- Cut butcher paper the size of your bulletin board.
- Draw several large egg shapes on butcher paper.
- Pour different colors of powdered tempera into salt shakers.
- Have: rolling pins
 - colored egg shells — ask parents to bring the shells from their Easter eggs
 - small containers
 - watered-down white glue
 - brushes for glue
 - blunt-tipped scissors
 - fixative such as hair spray
 - brads
 - cotton balls

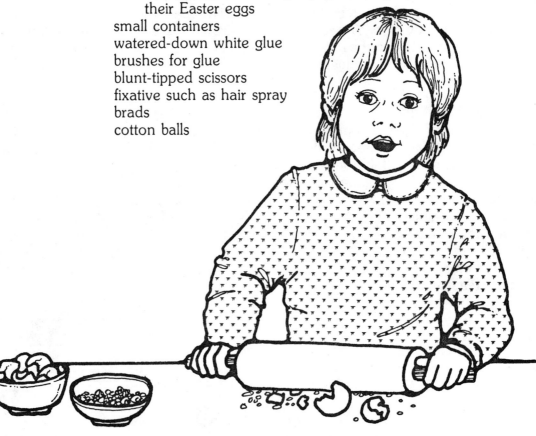

Talk With The Children: As you and the children develop this bulletin board, talk about different animals that hatch from eggs such as birds, reptiles, fish, insects, dinosaurs, etc. Take this opportunity to hatch chicks in your classroom, to find eggs in nests (do not touch or get too close), or to visit a zoo.

Show the children a large egg shape. As you are talking, cut it out. Tell the children that at art they are going to cut out more eggs and then make different baby animals which hatch from eggs.

ENJOY THE ACTIVITY

First create a background design. Put the egg shells, rolling pins, and small containers on the art table. Using rolling pins, crush all of the egg shells and put them in the containers. Spread the butcher paper on the floor in the art area. Brush glue onto an area of the paper. Lightly sprinkle the crushed egg shells on the glue. Brush glue in another area and sprinkle more egg shells. Continue until the paper is dotted with eggshells. Let it dry and then hang it up.

Bring the egg shapes, dry tempera, and cotton balls to the art table. Have the children cut out the egg shapes and then color each egg by sprinkling dry tempera paint onto the paper and rubbing it in with cotton balls. (If you want the eggshell to be scientifically accurate, give the children the correct color of dry tempera.) Spray a fixative on the eggs. Cut the eggs horizontally in half and connect the halves with a brad. Tack the cracked eggs to the bulletin board. On each day of the week have the children make a different baby animal which hatches from eggs. Start with chicks. (Alternative: Have the children find pictures of baby animals in magazines such as *BIG BACK YARD, RANGER RICK,* or *NATIONAL WILDLIFE* and glue them to the eggs.)

DISPLAY THE *"BABY ANIMALS"*

As the children make each type of baby animal, have them glue that animal to one of the cracked eggs. Soon they will have chicks, ducks, snakes, alligators, robins, sparrows, and fish on display.

EXTENSION:

Have a forest ranger from your community visit the classroom. Ask the ranger to bring a display of different eggs which have been collected from the area. Discuss how each type of animal lays a distinct egg. Talk about respecting the animals and their homes.

EASTER HUNT

Gather The Materials

- Cut a large basket shape out of construction paper. Cut vertical slits in it for weaving.
- Draw Easter egg shapes on a variety of paper such as corrugated cardboard, textured wallpaper, newspaper, aluminum foil, etc.
- Have: several large sheets of
 construction paper
 glue
 Easter grass
 a variety of art media such
 as tempera paint,
 crayons, chalk,
 fingerpaint, and
 watercolors
 blunt-tipped scissors
 double-stick cellophane tape

Talk With The Children: Have an Easter egg hunt. Before the children get together, hide several dozen plastic eggs throughout the classroom. Put an Easter basket on a table. As the children find the eggs, have them put the eggs in the basket. When all of the eggs have been found, carefully dump them onto the floor. Have the children sort them by color and then count how many eggs are in each group.

Now show the children some of the paper eggs. Talk about different ways to decorate them. Tell the children that they can help weave a basket at the art table and decorate as many eggs as they would like to.

ENJOY THE ACTIVITY

At one end of the art table, lay the large basket, construction paper, and scissors. Let the children cut construction paper strips, weave them across the basket, and glue the ends. Add a handle. Hang the empty basket low on the door. Add a little Easter grass.

At the other end of the art table, put the egg shapes and various art media. The children can decorate the Easter eggs by cutting them out and then coloring them — try tempera paint on the corrugated eggs, watercolors on the textured wallpaper eggs, chalk on newspaper eggs, fingerpaint on aluminum foil eggs, and so on.

DISPLAY THE *"EGGS"*

After the children color their Eggs, have them tape the Eggs on the door so they nestle into the basket. Each day stand back and enjoy looking at all of the colorful Eggs. Add more as the children color them.

EXTENSION:

Color real eggs. Let them dry overnight in the refrigerator. Have an Easter egg hunt outside and then have the eggs for a snack.

ONE LITTLE DUCK

PREPARE FOR THE ACTIVITY

Gather The Materials
- Draw a large simple duck shape on butcher paper.
- Gather a variety of fluffy fabric scraps and feathers. Sort them onto separate trays.
- Have: glue
 blunt-tipped scissors
 double-stick tape

Talk With The Children: Enjoy this rhyme:

FIVE LITTLE DUCKS

Five little ducks that I once knew,
Fat one, skinny one, tall ones two,
But the one little duck with the
Feather on his back,
He led the others with a "Quack, Quack, Quack,"

Down to the river they would go,
Wibble wobble, wibble wobble to and fro.
But the one little duck with the
Feather on his back,
He led the others with a "Quack, Quack, Quack,"

Show them the large duck shape. What is he missing? Pass the fluffy feathers to the children. How do they feel? After the discussion tell the children that at the art table they can glue the fabrics and feathers onto the duck.

ENJOY THE ACTIVITY
Put the large duck, scissors, fabrics, feathers, and glue on the art table. Have the first several children who come to art cut out the duck and lay him on the art table. First have the children glue the fabrics to the duck and then add the feathers. If you have one big feather, ask the children if they would like to glue that one to the duck's back, so he'll be similar to the duck in the rhyme.

DISPLAY THE *"FLUFFY DUCK"*
Hang the Duck low on the classroom door. Encourage the children to feel the different textures. Which ones are the softest?

EXTENSIONS:
Have the children pretend they are ducks. How do ducks talk? What do they say? How do ducks move? What do they eat? What games do they play?
Read the children *MAKE WAY FOR DUCKLINGS* by Robert McCloskey.

APRIL SUNCATCHER

PREPARE FOR THE ACTIVITY

Gather The Materials

- Draw egg shapes on 5" by 5" pieces of sandpaper.
- Have: 6" by 6" pieces of white or pastel construction paper
 - crayons
 - newsprint
 - paper punches
 - colored string
 - blunt-tipped scissors
 - stack of newspapers
 - electric iron

Talk With The Children: Pass out pieces of sandpaper to the children. Have them feel both sides of the paper. Tell the children that at art they are going to use crayons to color a design on the rough side of sandpaper eggs. Have them pretend their index finger is a crayon and let them make a design on the sandpaper. How does it feel? What do they think will happen to the crayon on the rough, bumpy surface?

ENJOY THE ACTIVITY

At the beginning of the activity, put the iron in a safe place. Turn it on a low setting. Have the sandpaper, construction paper, crayons, and scissors on the table.

When the children come to art, have them take a piece of sandpaper, cut out the egg, and color a design on it with crayons. (Encourage them to press hard.) After the eggs are decorated, have the children pick out a piece of construction paper and bring it and the sandpaper egg over to the ironing place. Lay the piece of construction paper on the stack of newspapers. Put the crayon side of the egg facing down on the construction paper. Lay several pieces of newsprint over the sandpaper and iron it until the crayon design has melted onto the construction paper. Let the children decide if they would like to cut out the construction paper egg shapes.

DISPLAY THE *"EGGS"*

Have the children punch holes in their Eggs, loop pieces of string through them and hang them in a sunny window. How do the children like their Eggs?

EXTENSION:

Use this same idea to make greeting cards. Have the children fold a piece of construction paper in half. Opening up the card, iron the crayoned transfer on the right side and glue the sandpaper egg to the left side. Happy Easter!

IT'S ME AGAIN

PREPARE FOR THE ACTIVITY

Gather The Materials
- Cut butcher paper the length of your wall.
- Put a full-length mirror in the art area.
- Draw a kite shape for each child on pieces of construction paper.
- Have: non-toxic markers
 - green tempera paint in shallow dishes
 - sponge-type paint brushes
 - blunt-tipped scissors
 - string
 - paste
 - marker
 - heavy-duty tape

Talk With The Children: Enjoy several rhymes with the children about different parts of the body. Begin with some of their favorites and then teach them some new ones.

HERE ARE MY EARS	TOUCH YOUR NOSE
Here are my ears.	*Touch your nose,*
Here is my nose.	*Touch your chin;*
Here are my fingers.	*That's the way this game begins.*
Here are my toes.	*Touch your eyes,*
Here are my eyes,	*Touch your knees;*
Both open wide.	*Now pretend you're going to sneeze.*
Here is my mouth	*Touch your hair,*
With white teeth inside.	*Touch one ear;*
Here is my tongue	*Touch your two red lips right here.*
That helps me speak.	*Touch your elbows*
Here is my chin,	*Where they bend;*
And here are my cheeks.	*That's the way this touch game ends.*
Here are my hands	
That help me play.	
Here are my feet	
For walking today.	

Tell the children that at art they can draw a picture of themselves flying a kite.

ENJOY THE ACTIVITY

Lay the butcher paper on the floor in the art area. Lay the markers, tempera paint, and sponge brushes near the bottom of the paper. Put the outlines of kites, scissors, string, and paste on the art table. Place the full-length mirror near the paper so the children can easily see themselves. When the children come to art, let them use colored markers to draw pictures of themselves flying kites. If they want to add grass, have them paint some under their feet.

After they've drawn themselves, have them cut out a kite and a piece of string at the art table and then go back to their figure and paste the kite and string as if it were flying in the air. Let each child (or you) write his name in the kite.

DISPLAY THE *"ME AGAIN"* DRAWINGS

After everyone has had the opportunity to draw himself flying a kite, hang the mural low on a wall. Talk with the children about times they have flown a kite.

EXTENSIONS:

Update the growth chart you began in October.

On a warm, windy day, blow up a balloon for each child. Tie a three to four foot string on each one. Give a balloon to each child as he goes outside. Let him pretend his balloon is a kite and fly it around the playground. When each child is finished flying his balloon, tie it securely to the fence. Later in the day, he can take his balloon home.

BROWN BUNNY

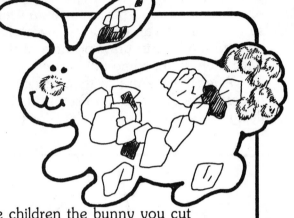

PREPARE FOR THE ACTIVITY

Gather The Materials
- Cut a large bunny shape from posterboard.
- Have: various shades of brown construction paper
 paste
 heavy-duty tape
 cotton balls

Talk With The Children: Show the children the bunny you cut out. Ask them if they have a stuffed bunny at home. When do they play with it? Ask them if they have ever seen a real bunny. What was he doing?

Tell the children that at art they are going to tear scraps of brown paper and paste them to the bunny shape.

ENJOY THE ACTIVITY

Put the bunny shape in the middle of the art table with the construction paper, scissors, and paste on both sides. When the children come to art, have them tear the brown papers into small pieces and paste them on the bunny. Let them continue to tear and paste until their bunny is covered. If the children want, add a cotton nose and tail.

DISPLAY THE "BROWN BUNNY"

Tape the bunny low on a wall. Throughout April, encourage the children to bring in brown materials. When they have brought in something brown, have them show it to the others and then paste it to the bunny. At the end of April, add the Brown Bunny to the Wall of Colors.

EXTENSIONS:

Read *THE VELVETEEN RABBIT* by Margery Williams to the children.

Enjoy this rhyme with the children. Have them form bunny ears by making a V-shape with their index and middle fingers. The bunnies should all hop during the rhyme.

BROWN BUNNY

There was a brown bunny who lived in the wood.
He wiggled his ears as a good bunny should.
He hopped by a squirrel.
He hopped by a tree.
He hopped by a duck.
He hopped by me!

He stared at the squirrel.
He stared at the tree.
He stared at the duck.
But — he made faces at me!

BUNNY MOBILE

PREPARE FOR THE ACTIVITY

Gather The Materials

- Collect collage materials appropriate for creating bunny faces, such as cotton, furry fabrics, broom straws. Each material should be in a separate container.
- Pull wire hangers into circular shapes.
- Have: construction paper
 - markers
 - blunt-tipped scissors
 - glue
 - yarn

Talk With The Children: Show the children a stuffed bunny. Discuss his different features. How many feet does he have? What does his face look like? What kind of ears does he have? How does his fur feel? Tell the children that at art they can create bunny faces by gluing various materials onto construction paper and then frame them with the hangers which have been formed into circular shapes.

ENJOY THE ACTIVITY

Put the hangers, collage materials, and glue containers within easy reach of everyone at the art table. When the children come to art, have each of them take a piece of construction paper, lay it on the table, and put the hanger on top of it. Holding the hanger in place, have the children make a tracing around the outside of the hanger as a guide for the bunny's face. Cut out the bunny's face. Using the collage materials, have the children design bunny faces. Remember his ears!

When a child is finished, have him drizzle glue around the edge of the bunny face and lay the hanger frame on top of it. Pressing down on the hanger, let the glue dry. When dry, let another child glue his bunny face on the other side of the hanger.

DISPLAY THE *"BUNNIES"*

Loop pieces of yarn to the hooks on the hangers and attach them from your ceiling.

EXTENSIONS:

Call your local animal shelter and see if it has a Pet-On-Loan policy. If it does, reserve a rabbit for a week. Remember to get all of the care and feeding instructions from the shelter personnel.

Read *RUNAWAY BUNNY* by Margaret Wise Brown and *THE TALE OF PETER RABBIT* by Beatrix Potter to the children.

GIANT EASTER EGGS

PREPARE FOR THE ACTIVITY

Gather The Materials
- Have: different size balloons
 - liquid starch in shallow containers
 - light to medium weight yarn
 - meat trays
 - narrow ribbon
 - blunt-tipped scissors

Talk With The Children: Show the children a balloon. Ask them, *"What do you do with balloons?"* Talk, think, and let them extend their imaginations throughout the discussion. Now blow up another balloon and tell the children that at art they are going to weave Giant Easter Eggs by wrapping yarn dipped in starch around large balloons. Be sure to talk about how to gently handle balloons so they will not pop.

ENJOY THE ACTIVITY

Blow up several balloons when the children come to art. Have the skeins of yarn and the containers of starch on the table. Let the children cut several long pieces of yarn from the skeins, dip them into the starch, squeeze off the excess starch, and then begin to wrap the yarn around the balloons as other children hold them. As the children continue wrapping the starched yarn, have them overlap the beginning of one strand and the end of another. When they are finished wrapping the balloons, have them gently lay them on meat trays. Let the yarn dry overnight. When they are thoroughly dry, pop the balloons. The stiff yarn will stay in egg shapes.

DISPLAY THE *"EGGS"*

Have the children loop pieces of ribbon to each Egg and hang them from the ceiling.

EXTENSION:

Make swatters for each of the children by stretching metal hangers into diamond shapes. Pull nylon stockings over the hangers and tape them at the bottom. Wrap the handles with tape for safety.

Bring the swatters and blown up balloons for the children to use. Play some fast dancing music, let the children dance and use their swatters to try to keep the balloons in the air. Switch the pace of the music and let the children dance again with their swatters and balloons.

BIRD NESTS

PREPARE FOR THE ACTIVITY

Gather The Materials
- Mix wheat paste in a large bowl.
- Have: sawdust
 - small sticks
 - feathers
 - grasses
 - leaves
 - tiny stones
 - several large meat trays
 - spoons
 - strips of construction paper
 - marker

Talk With The Children: Bring a real bird's nest to show the children. Carefully pass it around. As each child looks at it, have him try to figure out what materials the bird used to build the nest. Make a list of the different materials. Read the list back to the children.

Tell the children that at art they are going to build Bird Nests.

ENJOY THE ACTIVITY

Bring the wheat paste, sawdust, and trays of bird nest materials to the art table. Have the first several children help you mix the sawdust into the wheat paste. When the paste and sawdust have been thoroughly mixed, spoon a large clump of the mixture onto one of the meat trays. Have several children work together to form a nest out of the mixture. As they are molding, encourage them to add the nesting materials to the nest shape. When it is finished, write the children's names on a strip of construction paper and put it on the nest. Have the children carry their nest to a safe place to dry. As other small groups of children come to the art table, help them get started building their nest. Continue until all of the nests have been built.

DISPLAY THE "BIRD NESTS"

When the Nests have dried, set them on the Discovery Table. Add several bird books and encourage the children to look at the pictures of the different birds, their nests, and eggs.

EXTENSIONS:

At the playdough table some children might want to mold bird eggs and birds. They can add them to their nests.

Collect more twigs, feathers, stones, and grasses. Let the children build additional nests using mud instead of wheat paste as the base. When these nests have dried, put them on the Discovery Table and compare the similarities and differences between these and the first nests they made.

BUDDING TREE

Gather The Materials

- Construct a 3-dimensional tree out of large pieces of 2-ply or 3-ply corrugated cardboard.
 1. Cut (use a sabre saw or utility knife) two identical trees. (See diagram)
 2. Slot one of the trees from the center of the base up to the middle of the trunk.
 3. Slot the other tree from the center of the crotch down to the middle of the trunk.
 4. Slide the two trees together by inserting one slot into the other.
- Have: black tempera paint
 wide paint brushes
 thin layers of glue in
 shallow dishes (add
 green and red food
 coloring to the glue)
 sawdust in bowls

Talk With The Children: Take a walk around the neighborhood with the children. While walking, have them examine the trees. They can look at and feel the bark. How does it feel? Have them look very carefully at the branches. What is growing on them? Do the branches have buds on them? Have some of the buds popped and leaves begun to grow? If you find a branch which has broken off of its tree, bring it inside and put it on the Discovery Table.

When you return from your walk, show the children the tree you constructed from the cardboard. Tell them at art they are going to paint it and then add buds to the branches.

ENJOY THE ACTIVITY

Take the tree apart. Lay both pieces on the floor or the art table. Put the brushes and paint by the trees. Have the children paint one side of each tree. Let them dry and then paint the other sides. Let them dry.

Put the dishes of glue and the sawdust on the table. Have the children add buds to the trees by dipping their thumbs into the glue, pressing them to a branch, and then sprinkling sawdust on the glue. Continue adding buds until the branches on both sides of each tree are filled. Let the trees dry.

DISPLAY THE *"BUDDING TREE"*

When the trees have completely dried, carefully slide the two pieces back together. Ask the children where they would like to put their tree — maybe by the Discovery Table so they can compare the real buds to the sawdust ones.

EXTENSIONS:

Read *A TREE IS NICE* by Janice Udry and *A GIVING TREE* by Shel Silverstein to the children.

When the buds in your area have popped and leaves begin to grow, add leaves to your tree.

RAINY DAY HOUSE

PREPARE FOR THE ACTIVITY

Gather The Materials

- Get a large, sturdy appliance box.
- Have: assorted tempera paint
gray tempera paint
wide brushes
easel brushes
utility knife (adult use only)

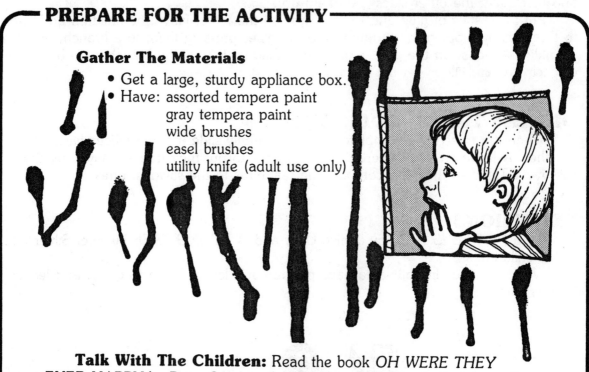

Talk With The Children: Read the book *OH WERE THEY EVER HAPPY* by Peter Spier to the children. Talk about all of the colors the children in the story painted their house. Tell the children they are going to paint a house for the classroom. Show them the appliance box. Let them decide what color they would like their house to be.

ENJOY THE ACTIVITY

Have the children help you lay the appliance box horizontally on the floor in the art area. Have brushes and paint near the box. Paint it. Let the box dry. Now add rain. Have the children dip easel brushes into the gray tempera paint and then push the brushes against the sides of the box near the top. The paint will squeeze out of the brushes and slowly drizzle down the box. Continue adding rain to all sides of the house. Let it dry. Using the utility knife, cut windows and a door in the house.

DISPLAY THE *"HOUSE"*

Put the House in an open area of the classroom. Let the children enjoy rainy day activities in it. Add several cushions, puzzles, small blocks, and a pegboard.

EXTENSION:

On several different occasions, write experience charts with the children about rainy day weather. One day bring the chart paper and marker and discuss *"How do we keep dry in rainy weather?"* Write their responses on the paper. Another time discuss, *"Things we do in rainy weather."* On another day talk about *"Why we like (don't like) rainy weather."* Hang the charts near the Rainy Day House.

TUBE SCULPTURE

PREPARE FOR THE ACTIVITY

Gather The Materials

- Have: a large flat corrugated base
 different size cardboard tubes,
 such as from toilet paper
 rolls, paper towel rolls,
 wrapping paper rolls
 other curved shape cardboard
 such as paper cups,
 oatmeal boxes, salt boxes,
 and so on
 glue in small shallow containers
 masking tape
 tempera paint
 brushes

Talk With The Children: Bring a variety of
tubes to show the children. Give each child several.
Let them stack tubes in a couple of different ways.
Tell the children that at the art table they can glue all
of the tubes together. They will start with a flat base
and build from there.

ENJOY THE ACTIVITY

Have the children help you carry all of the tubes to the art area. Have the base
and glue containers ready. Whoever wants, can stay at art and begin constructing the
sculpture. Encourage the children to glue and tape the tubes together in as many ways
as they can. Because it takes time for the glue to dry, this building process will
probably take several days. When dry, let the children paint it.

DISPLAY THE "TUBE SCULPTURE"

When the sculpture has completely dried, let the children decide where to display
it. Make a large sign which reads "Our Tube Sculpture" and attach it to the top.

EXTENSIONS:

Encourage the children to bring in more tube shapes. As they do, let them tape
and glue the tube/s to the sculpture.

Cut toilet paper rolls into two inch pieces. Add the pieces to your playdough
table. Encourage the children to use them as cutters.

HOLIDAY TABLECLOTH

Gather The Materials
- Cut butcher paper the size of the table the children eat at.
- Cut different size egg shapes from styrofoam meat trays.
- Have: Easter cookie cutters
 tempera paint
 easel brushes
 brayer or other type of roller

Talk With The Children: Easter is a fun holiday. It is a time of colored eggs, filled baskets, hopping bunnies, hatching chicks, and so on. Let the children pretend they are Easter bunnies planning a party. Discuss the games, food, and decorations. Tell the children that at art they are going to print Easter designs on a large piece of paper. When it is dry, they will use it for their Easter party.

ENJOY THE ACTIVITY
Put the styrofoam eggs and cookie cutters on the art table. Have the children imprint Easter designs in the styrofoam eggs by pressing cookie cutters into the styrofoam until they make clean, deep indentations.

Spread the butcher paper on the art table. Put the imprinted eggs, paint, brushes, and brayers around it. Have the children paint the eggs on the imprinted side, turn them over on the butcher paper and roll over them several times with the brayers. Have the children carefully lift the eggs and admire their prints.

DISPLAY THE *"TABLECLOTH"*
Enjoy using the printed Tablecloth during the Easter party.

EXTENSION:
Make soft playdough. Have rollers and the Easter cookie cutters available. Encourage the children to make shapes in the dough.

EGG TREE

PREPARE FOR THE ACTIVITY

Gather The Materials

- Collect a bunch of Leggs® containers.
- Have: tempera paint (add a little liquid detergent so it adheres better to the plastic)
 brushes
 pipe cleaners or twistems
 large basket
 wide ribbon

Talk With The Children: Using colored chalk, draw a tree on your chalk board. Talk about roots, branches, buds, and leaves as you draw. Ask the children if they have ever seen Easter eggs growing on trees.

Tell the children they are going to color eggs for a tree by painting plastic eggs different colors and then hanging them from the branches.

ENJOY THE ACTIVITY

Bring the Leggs® containers, paint, and brushes to the art table. Paint them all different colors. When the eggs have dried, have the children open each one, put a pipe cleaner or twistem between the edges of the egg, and close it back up. (Add a drop of glue if necessary.) Make a hook at the top of each pipe cleaner or twistem. Put the eggs in a large basket.

DISPLAY THE *"COLORED EGGS"*

Bring the basket of eggs outside and let the children hang the eggs on a tree near the school. As the children walk by the tree, talk about all of the colors hanging from the tree. Add bows looped from wide ribbon to the branches for additional color.

EXTENSION:

Construct a number game. Get ten (or more) plastic eggs. Write the numerals 1-10 on the eggs. Have a bag full of dried lima beans. Put the eggs and beans in an Easter basket. Encourage the children to read the numeral on each egg and put that amount of beans inside it. Continue until all of the eggs are filled.

BUTTERFLY WINGS

PREPARE FOR THE ACTIVITY

Gather The Materials
- Cut butcher paper the size of your bulletin board.
- Pour several colors of tempera paint into shallow pans.
- Draw simple butterfly shapes on pieces of wallpaper.
- Have: blunt-tipped scissors
 chairs
 staplers
 glue
 pipe cleaners
 paper scraps

Talk With The Children: A week or so before you do this activity with the children, put four or five books featuring butterflies on the bookshelf. Talk with the children about the shapes and the different colors in the butterflies' wings.

The day you print the background design, have the children put their hands together and pretend they are butterflies flapping their wings. Now have them take off their shoes and socks, stand up, and put their feet together. What do their feet look like? Tell them that at art they are going to print butterflies with their hands and feet.

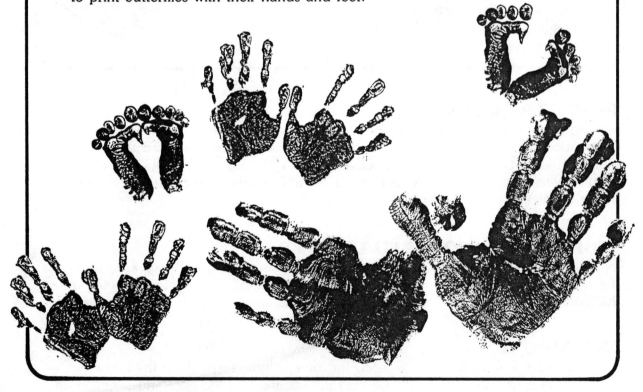

ENJOY THE ACTIVITY

Lay the butcher paper on the floor in the art area. Place several pans of tempera paint around the paper. Let the children handprint and/or footprint butterfly wings on the paper. To make the handprint butterflies the children should dip the flat of both of their hands into the paint, put their hands together so their thumbs touch, and then print. To make the footprint butterflies, the children should sit on a chair, stick their bare feet into the tempera paint, take their feet out of the paint, put them together, and paint butterflies on the paper. When the design is dry, hang it on the bulletin board.

Let the children make butterflies in a different way. Put the butterfly shapes, scissors, and staplers (or glue) on the table. Have the children cut out two butterflies, put them together, and staple (or glue) them in the middle. Fold the front wings out, and leave the back wings flat. If the child would like to add more detail, have pipe cleaners, paper scraps, and glue available.

DISPLAY THE *"BUTTERFLIES"*

As the children finish their Butterflies, help them tack the Butterflies to the background design.

EXTENSIONS:

Take a slow walk around the block. Periodically stop along the way, have the children cup their hands into binoculars, and look for butterflies. What are the butterflies doing?

Order caterpillars from your favorite educational supplier who carries science materials. Watch them grow, spin their cocoons, hatch into butterflies, and then release them.

WREATH OF FLOWERS

PREPARE FOR THE ACTIVITY

Gather The Materials
- Use a large round pizza board or cut a large circle out of cardboard. Cut a small hole in the center.
- Have: a variety of sizes and colors of cupcake liners
 pastel colored tissue paper
 green construction paper
 glue
 heavy-duty tape

Talk With The Children: Bring a bouquet of fresh flowers for the children to examine. How do they look, feel, smell? Do they make any noise? Have a child put the bouquet on the art table for the children to enjoy during art.

Tell the children they are going to create a wreath of flowers for the classsroom door by decorating cupcake liners with different colors of tissue paper and then gluing the blossoms to the wreath.

ENJOY THE ACTIVITY

Lay the cardboard base on the art table. Put the cupcake liners, tissue paper, and other materials near the base. When each child comes to art, have him choose a liner for his flower, wad-up tissue paper into small balls, and glue them onto the blossom. Add other detail and glue the blossom/s to the wreath. Have the children add construction paper leaves to their blossoms if they wish. Continue filling the wreath with springtime flowers.

DISPLAY THE *"WREATH OF FLOWERS"*

Have several children carry the Wreath to the door and help you tape it at their eye level. How do the flowers on the Wreath look, feel, and smell? Are they the same as the real ones?

EXTENSIONS:

After everyone has enjoyed the activity, put the fresh flowers on the Discovery Table along with several magnifying glasses. Encourage the children to closely examine all of the parts of the flower — stem, leaves, and blossoms.

Make a variety of sizes of simple felt flowers. Put the pieces near the felt board. Encourage the children to either plant a garden on the felt board or arrange the flowers from largest to smallest and vice-versa.

GIANT SCARECROW

PREPARE FOR THE ACTIVITY

Gather The Materials

- Have: long sheet of wide brown
 mailing paper
 marker
 blunt-tipped scissors
 tempera paint
 brightly colored scraps
 of fabric and paper
 yarn
 straw
 glue
 heavy-duty tape

Talk With The Children: Farmers and home gardeners work very hard to protect their crops from unwanted animals. One thing they do is construct large scarecrows and put them in their fields. The name scarecrow gives you a clue as to what type of animal the farmer is trying to keep away. What do you think it is?

Tell the children they are going to dress a scarecrow. First they will need to trace the basic figure. Roll the paper out onto the floor. Have an adult lay on the paper and several children trace around the adult's shape. After the whole body has been traced, cut it out. Tell the children they can glue all of the features to the figure at art. Have several children carry the tracing to the art area.

ENJOY THE ACTIVITY

Lay the scarecrow shape on the art table with the paint, collage scraps, yarn, straw, and glue nearby. First dress the scarecrow by painting him and then add details with the collage materials.

DISPLAY THE *"SCARECROW"*

Tape the Scarecrow to the door. Fasten a pole or yardstick behind him. The children might want to cut out some big crows to fly around the Scarecrow. If so, tape them on the door as the children finish.

EXTENSIONS:

Encourage the children to look for real scarecrows in gardens around their homes and in farm fields as they drive through the country. What did these scarecrows look like?

Read *BLUE BUG'S VEGETABLE GARDEN* by Virginia Poulet and *HOW MY GARDEN GREW* by Anne and Harlow Rockwell.

FLOWER GARDEN

Gather The Materials

- Have: small coffee filters
 red, yellow, and blue food
 coloring
 white vinegar/water
 combination, 50-50
 medicine droppers
 plastic bowls
 newspaper
 construction paper for
 leaves and stems
 blunt-tipped scissors
 glue
 double-sided cellophane tape

Talk With The Children: Prepare the food coloring and vinegar solution with the children. Using a medicine dropper let a child squeeze "10" drops of coloring into a bowl. Everyone count as he squeezes the drops. (Remember, squeezing the drops is rarely accurate, so be flexible.) Then have another child slowly pour the vinegar-water solution into the bowl. Does it smell? Like what? What happened to the coloring? Mix all of the colors in this way. Tell the children that at art they are going to use these colors along with medicine droppers to paint coffee filter blossoms.

ENJOY THE ACTIVITY

Let the children carefully carry the bowls filled with food coloring over to the art table. Put medicine droppers in each container and place them within easy reach of everyone doing the activity. Have the newspaper and filters on the table. The children should pick up a piece of newspaper and lay the filter on it. Using the medicine droppers, let them color their blossoms by dropping dots of food coloring all over the filters. As they are dotting their blossoms, talk about the different colors dripping onto the filters. When the blossoms have dried, the children can cut slits in the filters for petals and add construction paper stems and leaves if they want.

DISPLAY THE "FLOWERS"

Tape the Flowers to a sunny window. Soon the children will see their brightly blooming garden.

EXTENSIONS:

When the children have finished the activity put all of the small containers of food coloring on a tray and get a large clear bowl. Have one child pour the food coloring from the first container into the big bowl. Ask *"What color is it?"* Have another child pour the second color into the bowl. What color is it now? Continue with each color. What color is the final mixture?

Mix the colors again in a more systematic way. Using the medicine droppers and primary colors, mix the secondary colors. Have a child pour red food coloring into a clear bowl and another child add a drop of blue. Mix it. What new color do you have? Now pour yellow into another clear bowl and add a red drop. What is your new color? Lastly pour yellow into a clear bowl and add a drop of blue. Presto! What color now?

WALL FLOWERS

PREPARE FOR THE ACTIVITY

Gather The Materials

- Have: large pieces of construction
 paper and wallpaper
 large paper doilies
 collage materials
 glue
 blunt-tipped scissors
 watercolors
 roll of brown mailing paper
 heavy-duty tape

Talk With The Children: Before the activity cut a large flower (stem, leaves, blossom) out of felt. Using the felt flower, discuss the different parts of the flowers with the children. During the discussion, talk about what is needed to help a flower grow and mature — sun, water, dirt, etc. Enjoy this poem:

PLANTING

I took a little seed one day
About a month ago.
I put it in a pot of dirt,
In hopes that it would grow.

I poured a little water
To make the soil right.
I set the pot upon the sill,
Where the sun would give it light.

I checked the pot most every day
And turned it once or twice.
With a little care and water
I helped it grow so nice.

Dick Wilmes

Show the children the wallpaper, construction paper, and doilies. Tell them that when they come to art they are going to plant a garden by creating springtime flowers from these papers.

178

ENJOY THE ACTIVITY

Have the papers, scissors, collage materials, glue, and watercolors on the table. The children can begin to create large flowers using large paper doilies or cutting construction paper or wallpaper blossoms. Once the blossoms are cut, encourage the children to glue detail on their blossoms or paint them with watercolors. Next the children can cut and glue the stems and leaves to the blossom.

DISPLAY THE *"FLOWERS"*

Cut a long sheet of mailing paper for the dirt. Have the children help you fold the paper back and forth in accordion fashion and take it to the wall where your garden is going to be planted. Gradually unfold the paper and tape it very low on the wall. As the children finish their flowers have them tape the flowers in the garden. During the next month or so encourage the children to compare their classsroom garden to real gardens blooming all around.

EXTENSION:

Create an experience chart with the children. Get a sheet of chart paper. Draw a vertical line down the middle of the paper. On one side write *"Things that help flowers grow"*. On the other side write *"Things that help people grow"*. Talk with the children and make a list as they think of things for flowers and people. Add simple pictures next to each word. Hang the list near some plants in the classroom.

GREEN LEAF

PREPARE FOR THE ACTIVITY

Gather The Materials
- Cut a large leaf shape from posterboard.
- Have: green leaves the children have collected
 glue
 heavy-duty tape

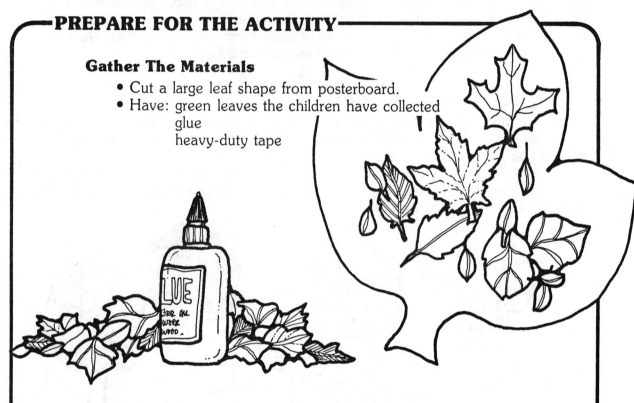

Talk With The Children: The day of the activity, take a leaf walk. Have the children collect all of the green leaves which have fallen onto the ground. When everyone returns to the classroom, look at the leaves. Talk about the color green.

Show the green leaf shape to the children. Tell them that you are going to put this leaf on the art table and you want them to put all of their green leaves on the table.

ENJOY THE ACTIVITY

Put the large leaf shape on the art table along with the glue and collected green leaves. Have the children glue the real leaves to the giant leaf.

DISPLAY THE "GREEN LEAF"

Tape the Leaf low on a wall in the classroom. Throughout May, have the children bring in more green items to glue onto the leaf. As they do, let them show their green things to the other children and then glue the items to the giant leaf. At the end of May, have the children help you tape the Green Leaf to the Wall of Colors.

EXTENSION:

Have a green day at school. Wear green, eat green, paint with green, make green playdough, and so on.

DINOSAUR LAND

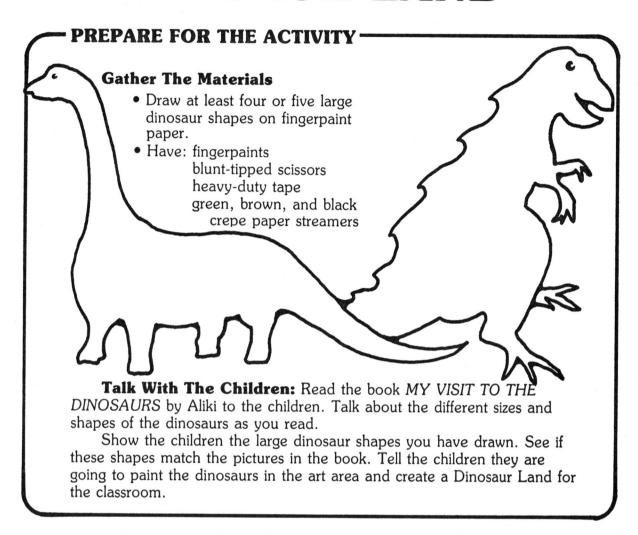

PREPARE FOR THE ACTIVITY

Gather The Materials
- Draw at least four or five large dinosaur shapes on fingerpaint paper.
- Have: fingerpaints
 blunt-tipped scissors
 heavy-duty tape
 green, brown, and black
 crepe paper streamers

Talk With The Children: Read the book *MY VISIT TO THE DINOSAURS* by Aliki to the children. Talk about the different sizes and shapes of the dinosaurs as you read.

Show the children the large dinosaur shapes you have drawn. See if these shapes match the pictures in the book. Tell the children they are going to paint the dinosaurs in the art area and create a Dinosaur Land for the classroom.

ENJOY THE ACTIVITY

Put the dinosaur shapes, scissors, and paint on the art table. Have the first several children at art cut the dinosaurs out. As they are cutting, continue the discussion of the different sizes and shapes of the dinosaurs. Lay the shapes on the art table along with the fingerpaint. Have the children paint the dinosaurs. Let them dry.

DISPLAY THE *"DINOSAURS"*

Create the ground by taping green, brown, and black strips of crepe paper streamers along the bottom of the wall where Dinosaur Land will be. When the dinosaurs have dried, tape them to the wall. Add trees, plants, and rocks if you want.

EXTENSIONS:

Talk with the children about how the different dinosaurs moved. (Pterodactyl flies, Stegosaurus swishes his tail). Let them pretend to be dinosaurs and move in various ways.

Put plastic dinosaurs in wet sand. Have several spray bottles filled with water so the children can always keep their sand wet.

SPIDER WEB

Gather The Materials

- Have: liquid starch in small
 containers
 different colors of
 medium-weight yarn
 large meat trays
 blunt-tipped scissors
 double-stick cellophane tape

Talk With The Children: Spiders weave webs mainly to catch their prey — flies, mosquitoes, bees, etc. Have the children weave a pretend web, using their fingers and thumbs. What foods would they like to catch in their web?

Tell the children that at art they are going to weave more spider webs, this time out of yarn they dip in starch.

ENJOY THE ACTIVITY

Put the meat trays, yarn, and containers of starch on the art table. When the children come to art, have them take a meat tray and choose the colors of yarn they want to use to weave their spider webs. Have them cut pieces of yarn, dip them into the starch, and lay them on a meat tray. While they are wet, have the children pretend to be spiders and weave their webs by criss-crossing the starched yarn. When the webs are finished, let them dry overnight on the meat trays.

DISPLAY THE "WEBS"

Let each child pick a place on the wall where he would like to tape his Spider Web. Help him put it on the wall.

EXTENSION:

Pick a special section of the classroom and have the children construct a giant spider web. Using heavy-weight yarn, have a child begin the spider web by tying the first strand to a chair and walking to another chair in the area, looping the yarn around it and continuing from there. After the web gets started, more children can begin using additional strands of yarn and weaving under and over, in and out, back and forth until the web is finished. When anyone goes in the area he should pretend to be a spider as he moves through the web.

FIREWORKS

PREPARE FOR THE ACTIVITY

Gather The Materials
- Have: red, white, and blue construction paper
 blunt-tipped scissors
 paste
 red, white, and blue light-weight yarn
 staplers

Talk With The Children: Memorial Day is an American holiday. Many people display American Flags. Oftentimes cities and towns celebrate by having a parade and a fireworks display. Tell the children they are going to celebrate at art by pasting red, white, and blue construction paper strips into fireworks for the classroom.

ENJOY THE ACTIVITY

Have the pieces of construction paper, scissors, and paste on the art table. Let the children first cut strips of red, white, and blue paper and then criss-cross two of the strips and paste them in the middle. Cross another strip and paste it. Let them continue pasting more strips if they want. Encourage the children to cut and paste as many fireworks as they want. Let them all dry.

DISPLAY THE *"FIREWORKS"*

Have the children cut pieces of yarn and staple them to their Fireworks. Hang them in a cluster from the ceiling. What a spray of red, white, and blue color!

EXTENSIONS:

Encourage the children to attend firework displays sponsored by their town. Talk about their reactions, the colors of the fireworks, and so on.

Using your favorite playdough recipe make red, white, and blue dough with the children.

GIANT DINOSAUR

PREPARE FOR THE ACTIVITY

Gather The Materials

- Have: an old saw-horse for the
 dinosaur's body
 2x4 board about three feet long
 for the dinosaur's neck and
 head — add another for
 the tail if you want
 nails
 hammer
 chicken wire
 wire cutters
 heavy-duty tape
 newspaper
 large plastic bowl
 flour
 tempera paint
 wide paint brushes

Talk With The Children: Bring the sawhorse, 2x4, chicken wire, and supplies to show the children. Tell them that over the next several days they are going to help construct a dinosaur. Have several children hold the sawhorse steady at one end, while you nail the 2x4 to the other end. Now you have the simple base for the dinosaur. Cut pieces of chicken wire to wrap around each part of the dinosaur. Nail the wire to the base. (Put tape over any rough edges to avoid cuts.)

Tell the children they are going to cover the dinosaur frame with newspaper which has been dipped in a special paste made with flour and water.

ENJOY THE ACTIVITY

Before the children paper mache the dinosaur frame, have them tear lots of newspaper strips and put them in a box.

Bring the dinosaur and box of paper strips to the art area. (Maybe the children would like to work outside.) Mix the paste with the children. Put flour in a large plastic bowl. Slowly add water to the flour, stirring all of the time. Soon the mixture will be a watery paste consistency.

Have the children dip the newspaper strips into the paste, rub off the excess, and lay the strips onto the frame. Continue until the children have covered their dinosaur. Let the first layer dry. Add another layer if you want. When dry, paint it with tempera paint.

DISPLAY THE "GIANT DINOSAUR"

Let the children decide where they would like their Dinosaur, maybe just outside the classroom door to greet everyone each morning, maybe in Dinosaur Land. Wherever they decide, help them move it to the appropriate spot.

EXTENSION:

Enjoy this rhyme with the children.

THE ILL-MANNERED DINOSAUR

Never go to lunch with a dinosaur.
They're a mean, foul, nasty group.
They burp and slurp and never sit down.
They are likely to step in your soup.

The biggest are called vegetarians,
Which means they eat grass and trees.
But when you're longer than a school bus,
You can eat whatever you please.

The rest are called carnivores,
Which means they eat mostly meat.
If there aren't enough hot dogs to go around,
They probably will chomp on your feet.

And when it comes time to clear the plates,
They'll try to sneak away.
Instead of helping with the dishes,
They'll try to go out to play.

Dick Wilmes

SPRINGTIME PLACEMATS

PREPARE FOR THE ACTIVITY

Gather The Materials

- Have: sheets of construction paper
 empty thread spools
 thin layers of tempera paint in shallow pans
 non-toxic markers
 roll of clear adhesive paper

Talk With The Children: When the children are outside have them look for caterpillars on the sidewalk. Kneel down and watch how they move. How do they look? Tell the children that at art they are going to use spools to print caterpillars on construction paper for snacktime placemats.

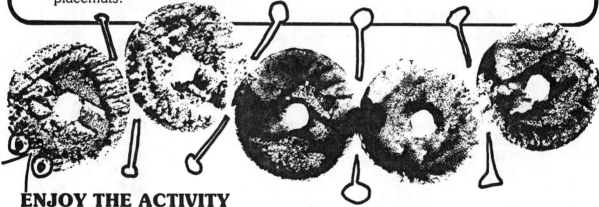

ENJOY THE ACTIVITY

Have the construction paper at one end of the art table and the paint and spools within easy reach of the children enjoying the activity. When the children come to the art table, have them choose what color of paper they would like to print their caterpillars on. Using the paint and the ends of the spools, have them print caterpillar bodies on their placemats. They can add antennae, eyes, legs, and other detail with the markers.

When the placemats are completely dry, cover both sides of them with the clear adhesive paper, leaving a half inch border.

DISPLAY THE *"PLACEMATS"*

Let the children use their Placemats at snack and mealtimes each day. Remember to sponge them off.

EXTENSION:

Enjoy reading *THE VERY HUNGRY CATERPILLAR* by Eric Carle to the children.

CATERPILLAR CENTERPIECE

PREPARE FOR THE ACTIVITY

Gather The Materials

- Have: paper egg cartons
 tempera paint
 brushes
 collage materials including
 pipe cleaners
 glue
 blunt-tipped scissors

Talk With The Children: After the children have watched several real caterpillars move, talk about their movement. Let the children lie down on the floor and pretend they are caterpillars who move slowly around, go to sleep, wake-up, stretch, and move some more.

Bring a section of an egg carton to show the children. Wiggle it as if it were a moving caterpillar. Tell the children that they are going to color caterpillars for the classroom by painting pieces of egg cartons like the one you are holding.

ENJOY THE ACTIVITY

Have the egg cartons, brushes, and paint on the art table. When the children are ready to enjoy art, ask them how many sections they would like to have in their caterpillars. Count that number of sections in the egg cartons with the children and help them cut their strips out. Paint the caterpillars. Let them dry and add details with the collage materials.

DISPLAY THE "CATERPILLARS"

Put all of the Caterpillars on a tray. Keep the tray near the snack table. Just before each snack, have several children arrange a caterpillar parade on the table.

EXTENSIONS:

Make felt pieces representing the stages of a butterfly's development. Talk about the stages. Put the felt board and the pieces in the language center for the children to use throughout the day.

Read *WHERE DOES A BUTTERFLY GO WHEN IT RAINS* by May Garelick to the children.

Give the children the opportunity to paint more caterpillars. This time tie a long string to the beginning of the caterpillar and let the children take them outside and pull them over the ground.

THE DINOSAUR TRAIL

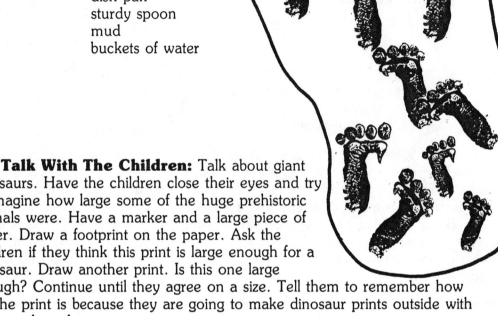

PREPARE FOR THE ACTIVITY

Gather The Materials

- Have: chalk
 - dish pan
 - sturdy spoon
 - mud
 - buckets of water

Talk With The Children: Talk about giant dinosaurs. Have the children close their eyes and try to imagine how large some of the huge prehistoric animals were. Have a marker and a large piece of paper. Draw a footprint on the paper. Ask the children if they think this print is large enough for a dinosaur. Draw another print. Is this one large enough? Continue until they agree on a size. Tell them to remember how big the print is because they are going to make dinosaur prints outside with chalk and mud.

ENJOY THE ACTIVITY

On a warm day take chalk, a dish pan, and a sturdy spoon outside. Have the children help you make a dinosaur trail by using chalk to draw the shape of dinosaur feet on the sidewalk. Then mix up some mud in the dish pan.

Have the children take off their shoes and socks and make mud prints in the dinosaur feet. How many children's footprints does it take to fill in one dinosaur footprint? A few or lots? Enjoy the mud printing for several days.

DISPLAY THE *"DINOSAUR TRAIL"*

Encourage the children to show their parents the Dinosaur Trail when they pick them up. Have the children and adults count how many footprints are in one dinosaur print. Maybe all of the adults would like to make mud prints in a dinosaur footprint.

When it is time to remove the Dinosaur Trail, toss buckets of water on it or hose it down.

EXTENSION:

Let the children think about this, *"Would they like to have a dinosaur for a pet?"* Why or why not? Read the *MYSTERIOUS TADPOLE* by Steven Kellogg.

FLY PAPER

PREPARE FOR THE ACTIVITY

Gather The Materials
- Cut a long sheet of butcher paper.
- Pour thin layers of tempera paint into shallow pans.
- Have: wide black markers
 fly swatters
 clothespins

Talk With The Children: Have the children name as many flying creatures as they can. Make a list as the children dictate. Discuss the fly. What do they know about a fly? How do they get rid of flies? Show them a fly swatter. Do they ever use one? How? Tell them that at art they can use fly swatters to paint with by dipping them in paint and swatting them onto paper.

ENJOY THE ACTIVITY

On a warm day take paper, paint, markers, and fly swatters outside. Lay the butcher paper on the cement. Using markers, have the children dot the paper with flies. Clip the fly paper to the playground fence. Lay the pans of tempera paint on the ground near the paper. Have several fly swatters in each color of paint. Let the children pretend they are shooing all of the flies away as they slap the paper with their fly swatters. Each time the children slap their swatters have them say *"Go away fly."* Let the fly paper dry. Are all of the flies gone?

DISPLAY THE *"FLY PAPER"*

If good weather is forecasted, leave the Fly Paper hanging on the outside fence, otherwise bring it inside and hang it on your bulletin board.

EXTENSIONS:

As real flies get close to the children, have them wave at the flies and say, *"Go away fly!!"*

Using fly swatters for the basic form, make puppets for the children. Glue fabrics and yarn to the swatters to create the faces of the puppets. Get a thick piece of styrofoam. Stick the fly swatter puppets into it. Put the puppets in the language area and encourage the children to tell stories with them.

CLASSROOM GARDEN

Gather The Materials

- Cut butcher paper the size of your bulletin board.
- Pour thin layers of pastel colored tempera paint into shallow containers.
- Collect a variety of materials such as doilies, cupcake liners, tissue paper, construction paper bits, styrofoam peanuts, etc.
- Have: different size real flowerpots
 - watercolor paints
 - glue
 - blunt-tipped scissors
 - wide marker

Talk With The Children: Show the children a variety of sizes of real flowerpots. Which one is the smallest pot? How much dirt do the children think would go into that size pot? Continue examining the pots and arrange them from the smallest to the largest one. When the children go outside, take the flowerpots, dirt, and seeds. Plant seeds in each of the pots. Care for them.

Tell the children that at art they are going to plant a classroom flower garden on the bulletin board. Show them the construction paper flowerpots which they can cut out and glue to the background. Then they can design blooming flowers with the collage materials.

ENJOY THE ACTIVITY

Lay the butcher paper on the floor in the art area. Place the tempera paints and flowerpots around the edges. When the children come to art have them print the background design on the butcher paper by dipping either end of a flowerpot into the tempera paint and printing onto the paper. Continue until the paper is full. Let it dry.

Have the flowerpot shapes and scissors at one end of the paper and the glue and collage materials within easy reach. Have the children choose what pot they would like to paint, cut it out, and glue it onto the background. Using collage materials, the children can create flowers in their pots by gluing right onto the butcher paper. As the children finish their flowers, have them (or you) write their names on the flowerpots with a marker.

When the children are finished, have them decide if they would like any other detail in the garden such as sky, sun, clouds, bugs, etc. If so, they can add it with the watercolor paints. Let it dry.

DISPLAY THE "CLASSROOM GARDEN"

Have several children help you carry the Garden to the bulletin board. Carefully staple it to the board. When it is up, stand back and look at all of the flowers. Point to each pot. Can the children recognize any of the names? Which ones?

EXTENSION:

Make namecards to match each of the names on the flowerpots. Put velcro dots on the flowerpots and on the backs of the namecards. Put the namecards in a box. The children can match the children's names on the flowerpots and cards by sticking the velcro dots together.

ZOO WALK

Gather The Materials

- Cut butcher paper the size of your bulletin board.
- Cut large simple stencils of seven or eight different zoo animals out of posterboard.
- Pour tempera paint into long shallow containers.
- Have: pail of water, wash cloths, and towels
 - fingerpaint in containers
 - crepe paper streamers
 - blunt-tipped scissors
 - glue

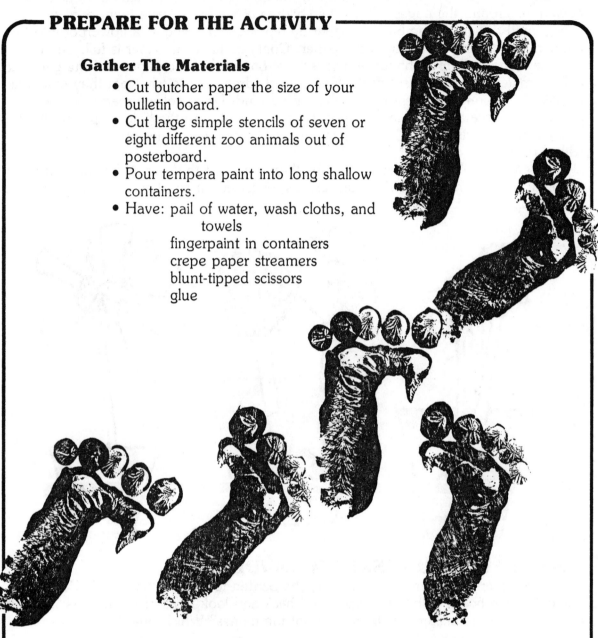

Talk With The Children: Take an imaginary trip to the zoo with the children. Pretend you are just walking into the zoo entrance. What is the first animal to greet you? Talk about that animal. Continue discussing the other animals the children see as they are strolling through the imaginary zoo.

Tell the children that at art they are going to take another imaginary walk around the zoo and then paint animals using stencils and fingerpaint.

ENJOY THE ACTIVITY

First, create the background. Lay the butcher paper on the floor and put the tempera paint and washing items at one end of it. As the children come to the art area, have them take off their shoes and socks, step into the paint, and pretend they are walking around the zoo as they footprint on the paper. (Hold their hands for safety.) As they are walking talk about different animals they imagine seeing. When the walk is over, have each child wash and dry his feet and put his shoes and socks back on.

When the background has dried, lay the animal stencils and fingerpaint around the paper. The children should choose stencils, lay them on the butcher paper, dip their fingers in the paint, and work the paint around the inside of the animals. Keep adding paint until the animals are completely painted. Carefully lift the stencil up. Continue adding as many animals as the children want. Let the zoo dry. Cut strips of streamers and glue a big fence around the animals.

DISPLAY THE "ZOO"

Carefully carry the Zoo over to the bulletin board and tack it up. Stand back. How many animals can the children find? How many giraffes? Are any of the animals painted a different color?

EXTENSION:

Make another set of stencils. Place them in a box and put it near the mural. Encourage the children to match the stencils to the fingerpainted animals.

RAINBOW

PREPARE FOR THE ACTIVITY

Gather The Materials
- Cut butcher paper the size of your bulletin board. Draw the arches of a rainbow on it.
- Collect a wide variety of textured fabric and paper scraps for each color in the rainbow. Separate them onto different trays.
- Have: tempera paint for each color in the rainbow
 wide brushes
 paste

Talk With The Children: Bring a picture of a rainbow to show the children. Point to each color and have the children call out what color it is. Now put red, orange, yellow, green, blue, and purple felt arches on your felt board. Ask the children which color arch would be on top of the rainbow. Have a child come up to the board, take a red arch, and place it at the top of the feltboard. Continue adding the other arches. When your rainbow is finished, compare the picture of the rainbow to the felt rainbow.

Tell the children that over the next several days they can form their own rainbow at the art table. This time they will use paints as well as paper and fabric scraps.

ENJOY THE ACTIVITY

Lay the butcher paper on the art table. Have the red paint and several brushes on the table along with the paste and the trays of the red paper and fabric scraps. When the first children come to art, have them paint the top arch red. When it has dried, the children can paste many red scraps along the red arch. Encourage the children to feel all of the textured papers and fabrics as they are pasting. When they have completed the red arch, paint the next one orange and continue in the same manner.

DISPLAY THE *"RAINBOW"*

When the Rainbow is completed, hang it on your bulletin board. It may be slightly heavy so have several adults along with the children help you.

EXTENSIONS:

Read *A RAINBOW OF MY OWN* by Don Freeman to the children.

Put prisms on the window ledge. Let the children hold them at different angles to form rainbows.

HELLO TO SUMMER!

PREPARE FOR THE ACTIVITY

Gather The Materials
- Cut white butcher paper the size of your door.
- Cut 2 huge hands from tagboard.
- Have: variety of colored tissue paper
 several spray bottles filled halfway with
 water
 wide markers
 double-stick cellophane tape

Talk With The Children: By the time it is June, summer has really begun. Discuss summer weather, clothes, flowers, and activities with the children. Bring a beachball, pail and shovel, and tricycle to show them. Talk about how each toy is used.

Tell the children that at art they are going to create a door decoration and then add a list of what they like about summer.

ENJOY THE ACTIVITY

On a warm, very calm day bring the butcher paper, tissue paper, and spray bottles outside. Lay the butcher paper on the concrete. When the children come to art, have them tear pieces of tissue paper and completely cover the butcher paper with them. Then, using the spray bottles, let the children take turns gently spraying the tissue paper. When all of the tissue is wet, stop spraying and let it dry.

While the papers are drying, bring the two huge hands and the markers outside. On one hand write, *Hello To Summer! We Like To.* Have each child tell you something he likes to do in the summer. Write it down. On the other hand write, *From.* Have each child 'write' his name on that hand. After the pieces of tissue paper have dried, carefully lift them up and throw them away. What happened to your white paper?

DISPLAY "HELLO TO SUMMER"

Have the children help you carry the butcher paper and the two hands inside. Hang them on your door. Add more summer fun activities to your list as the children think of them.

EXTENSION:

Have fun using spray bottles in other ways — for keeping sand wet so it is easy to mold, for creating water designs on the concrete, for spraying each other to keep cool, and for watering plants in your room.

GIANT BALLOON

PREPARE FOR THE ACTIVITY

Gather The Materials
- Cut a huge balloon from butcher paper to hang on your door.
- Draw large balloon shapes on pieces of construction paper.
- Have: blunt-tipped scissors
 markers
 paste
 crepe paper streamers
 heavy-duty tape

Talk With The Children: Show the children a blown-up balloon. Ask them what they like to do with balloons, when they play with them, and what colors they like best. Then ask them if they have ever been playing with a balloon when and all of a sudden it flew away. How did they feel? Then ask them *Where do you think your balloon flew to?* Help them stretch their imaginations and think of many possibilities.

Tell the children that at art they are all going to work together and construct a giant multi-colored paper balloon for the door.

ENJOY THE ACTIVITY

Have the first several children who come to art help you hang the huge balloon low on the door. Put the construction paper, scissors, markers, and paste on the art table. When the children come to art, have them choose paper balloons, cut them out, and then decorate them with markers. When finished, the children should turn their decorated balloons over and smear paste all over the backside. When the balloons have paste on them, have the children take them over to the door, pick a spot on the giant balloon, and put them on. (Depending on your children you can let then randomly paste their balloons or do it in a more orderly layered sequence.)

DISPLAY THE "GIANT BALLOON"

After everyone has had the opportunity to add his balloon, cut several long streamers from crepe paper. Let the children twist the streamers to make a string for the balloon.

EXTENSION:

Enjoy several rhymes about balloons with the children:

BALLOONS

This is the way we blow our balloons,
Blow, blow, blow.
This is the way we break our balloons,
Oh! Oh! Oh!

LITTLE BALLOON

I had a little balloon
That I hugged tightly to me.
There was a great big BANG!
No more balloon, you see.

But if I had five more,
I wouldn't hug them tight!
I'd just hold onto the strings
And fly them like a kite.

HERE'S A BALLOON

Here's a balloon,
And here's a balloon.
And a great big balloon I see.
Shall we count them?
Are you ready?
One! Two! Three!

ANIMALS ON PARADE

PREPARE FOR THE ACTIVITY

Gather The Materials

- Cut out large simple zoo animal shapes from posterboard.
- Put liquid vegetable oil in a bowl.
- Have: white bond paper
 wide black markers
 crayons or markers
 blunt-tipped scissors
 double-stick cellophane tape

Talk With The Children: Enjoy zoo animal riddles with your children. Here are a few and then you create more.

I have brown and yellow spots.
I eat leaves from the tops of trees.
I have very long legs and neck.
Who am I?

I am a black and white striped animal.
I look like a horse,
But most people do not ride me.
Who am I?

I am a large animal who hops.
Usually I use only my back legs.
I carry my babies in a pouch.
Who am I?

I can be black, brown, or white.
I like to stand tall on my back legs.
I have a mean growl.
Who am I?

Show the children the large zoo animals you cut out. Let them name each one. Tell them that at art they are going to trace around the shapes, cut them out, and then color them.

ENJOY THE ACTIVITY

Have the animal shapes, wide markers, paper, scissors, and crayons or markers on the art table. When the children come to art, have them choose a zoo animal and trace around the shape with a wide marker. Then cut it out and color it with the crayons and/or markers. After each child has finished coloring his zoo animal, pass him the bowl of vegetable oil. Have him turn his animal over so the colored side is down. He should dip his fingers in the oil and then rub it onto the backside of his animal. Continue adding oil until the entire backside of the animal is lightly coated. Let all of the animals dry.

DISPLAY THE "ANIMALS ON PARADE"

After the animals have dried, let the children form an Animal Parade by taping the animals in a row along a sunny window. When the children go outside have them look at their animals. How do they look from this direction?

EXTENSION:

Get a piece of chart paper and a marker. Have the group develop a list of all of the zoo animals they can remember. As a child calls out an animal name, write it down. Put zoo stickers next to as many animals as possible. Hang it for all to see. Read the animal names to children who are interested.

COLORFUL BALLOONS

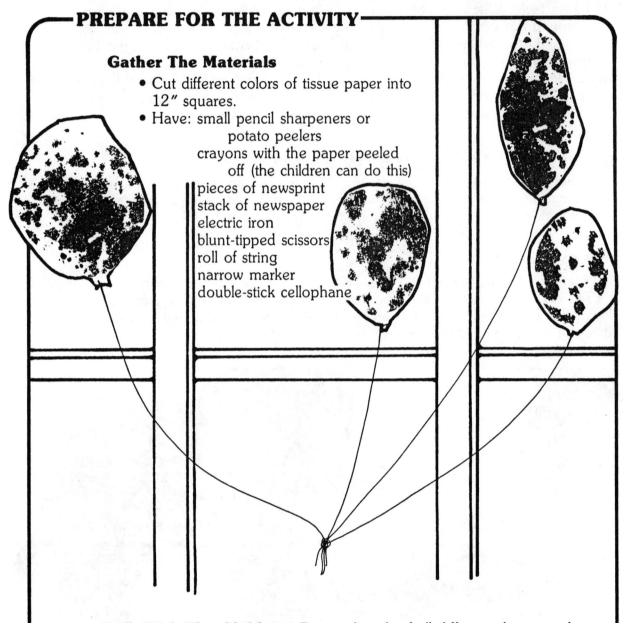

Gather The Materials

- Cut different colors of tissue paper into 12″ squares.
- Have: small pencil sharpeners or potato peelers
 crayons with the paper peeled off (the children can do this)
 pieces of newsprint
 stack of newspaper
 electric iron
 blunt-tipped scissors
 roll of string
 narrow marker
 double-stick cellophane

Talk With The Children: Bring a bunch of all different shapes and sizes of balloons to show the children. First talk about the color and shape of each balloon. Then discuss all of the places where the children might be able to buy balloons. Can they buy special balloons at the zoo, amusement park, carnival, or parade? What types?

Tell the children that at art they are going to color tissue paper, cut it into balloon shapes, and hang the balloons in the window.

ENJOY THE ACTIVITY

Establish a quiet place to iron the shaved crayons. Have the iron, stack of newspaper, and pieces of newsprint there. Turn the iron on a low setting.

Have the crayons, sharpeners, and pieces of tissue paper on the art table. When the children come to art have them choose a piece of tissue paper and shave crayon bits onto it. When each child has enough crayon shavings on his piece of tissue paper, he should carefully carry it over to the ironing spot and lay it on the stack of newspapers. Cover the crayon shavings with several pieces of newsprint and slowly iron over it. When the shavings have completely melted, carefully lift the piece of newsprint. Hold the piece of tissue up in the sun. How does it look? Ask each child what shape balloon he would like to cut out. Lightly draw that shape onto the tissue paper. Have him cut it out. (If necessary have the children work in pairs with one child holding the tissue paper as another one cuts.) After the balloon is cut out, have each child add a string to it.

DISPLAY THE "BALLOONS"

Let the children tear pieces of tape, stick them to their balloons, and tape the balloons to a sunny window. When all of the balloons are in the window, gather up the strings into one bunch and tie them together.

EXTENSION:

Make bubble blowers for the children to use outside. Get styrofoam cups and wide mouth straws. Stick a straw at an angle through the side of each cup near the top. Fill each cup about half full of water and add a tiny squirt of liquid detergent. Have the children begin to blow. Soon bubbles will appear. Do the children think the bubbles look like small balloons glistening in the sun? Do the bubbles look like the small balloons hanging in the sunny window?

FLAG DAY PENNANT

PREPARE FOR THE ACTIVITY

Gather The Materials

- Draw a very large pennant shape on butcher paper.
- Have: red, white, and blue tempera paint in separate spray bottles
 - blunt-tipped scissors
 - dowel rod or other type of pole

Talk With The Children: A week or so before the children paint their Flag Day Pennant, fill spray bottles with water and add them to the sand play. Encourage the children to use the spray bottles everyday to wet down the sand. Talk with them about how to work the spray bottles and how to fill them when they are empty. Add small toys to the sand, such as cars, fire engines, people, etc. Using wet sand the children can mold and shape hills, towns, roads, and holes for their new toys.

On Flag Day talk about the colors in the United States flag. Tell the children that you have filled the spray bottles they have been using in the sand area with red, white, and blue paint. Show them the pennant. Tell them that they are going to take the paint and pennant outside and spray-paint a colorful pennant for the classroom.

ENJOY THE ACTIVITY

Have the children carry the pennant, scissors, and spray bottles outside and put them in a quiet place on the playground. Have several children cut the pennant out. As the children want to take a break from their large muscle play, they can add color to the pennant by spraying paint on it. Let it dry. Turn it over and spray color on the other side.

DISPLAY THE *"PENNANT"*

After the Pennant has dried, glue or staple a pole to it. Display it on a wall or in an appropriate place outside.

EXTENSION:

As the children are leaving on Flag Day, June 14, encourage them to look for United States flags hanging in shopping centers, atop flagpoles, at people's homes, etc. The next day discuss the places the children saw the flags.

GRAY ELEPHANT

PREPARE FOR THE ACTIVITY

Gather The Materials
- Cut a large elephant shape from gray posterboard.
- Have: gray sandpaper
 paste
 heavy-duty tape

Talk With The Children: Elephants are vegetarians which means that they eat plants. Tell the children that they should close their eyes and pretend that they are elephants waiting for their dinner. After a couple of minutes say to them, *"OK, elephants, what would you like to eat for dinner?"* Talk about the vegetables the elephants might like. Then ask the children to pretend they are elephants once again and think of vegetables they would not like to have for dinner. Talk about these also.

Tell the children that elephants have very tough, rough skin. At art they can give the paper elephant a rough skin by pasting gray sandpaper pieces on him.

ENJOY THE ACTIVITY

Put the elephant shape, paste, and sandpaper on the art table. When the children come to art, have them tear the sandpaper into small pieces , add paste to the backside of the pieces, and put them on the elephant. Continue until the Gray Elephant is covered with a rough, tough skin.

DISPLAY THE *"GRAY ELEPHANT"*

Tape the Gray Elephant low on a wall. Throughout June encourage the children to bring in other gray materials to add to the Elephant. Before they paste them on, decide if the material is rough and tough like a real elephant's skin or has some other texture. At the end of June add the Gray Elephant to your Wall of Colors.

EXTENSION:

Enjoy this elephant rhyme with the children:

ELEPHANT
Right foot, left foot, see me go.
I am gray and big and slow.
I come walking down the street
With my trunk and four big feet.

WIND CHIMES

PREPARE FOR THE ACTIVITY

Gather The Materials

Have: red Mexican pottery
 clay (does not need firing)
needles
heavy-duty thread
blunt-tipped scissors
glue
hangers

Talk With The Children: Summer winds are usually soft and gentle, however, they get much stronger when they are blowing up a storm. Have the children pretend they are the gentle summer wind by holding their hands in front of their mouths and blowing softly. How does the gentle breeze feel? Now have the children pretend they are the summer wind blowing up a storm. Encourage the children to blow hard and rough. How does the rough wind feel?

Tell the children that at art they are going to construct wind chimes by forming clay into balls, stringing them on thread, and then hanging them from a hanger.

ENJOY THE ACTIVITY

Put the clay, needles, thread, scissors, and hangers on the art table. When a child comes to art, give him a large piece of clay. Encourage him to form balls and other shapes. When he's finished, give him a threaded needle and let him string his shapes onto the thread. Tie the first one on for him. When each child has finished he can tie his thread to the hanger. Add a dab of glue to cover the knot. Let the clay dry.

DISPLAY THE *"WIND CHIMES"*

Hang the Chimes in a windy area of the playground. Be aware of when the Wind Chimes sound the loudest. When do they? Why?.

EXTENSION:

Make another set of Wind Chimes, only this time have the children roll out the clay and use zoo animal cookie cutters to form the pieces. String the animals as before. Hang these chimes in another area of the playground.

YOUR ZOO

PREPARE FOR THE ACTIVITY

Gather The Materials

- Get two large cardboard boxes. Cut them so they are about ten inches high and open at the top.
- Have: tempera paint
 brushes
 rocks, twigs, sand, etc.
 plastic land and water animals

Talk With The Children: Take a field trip to a nearby zoo. Enjoy all of the animals. As you are walking around be aware of the animals which live on land and in the water. When the children return, make a list of the different land and water animals they remember seeing.

Bring the large boxes to show the children. Tell them that at art they are going to use these boxes to build homes for the water and land animals. Discuss how they would like to paint them and what accessories they might need. Using their ideas set up the activity.

ENJOY THE ACTIVITY

Put both boxes and the paint on the art table. Have the children decide which box is for land animals and which one is for water animals. Paint each one. Let the boxes dry. Add detail, such as rocks, twigs, sand, and whatever else the children decide on.

DISPLAY THE "ZOO"

Put Your Zoo in the block area along with all types of zoo animals. Periodically add and subtract different animals and accessories to encourage the children's continued play.

EXTENSION:

Continue the zoo discussion. This time concentrate on what else the children saw besides animals on their zoo trip. Make a list of their ideas and hang it on your door for everyone to read.

BALLOON BOUQUETS

PREPARE FOR THE ACTIVITY

Gather The Materials

* Collect a variety of small paper bags.
* Cut thin dowel rods in a variety of lengths from 8″ to 12″.
* Put balls of soft clay in the bottoms of several flowerpots.
* Cut a large piece of flat styrofoam about an inch thick.
* Have: newspaper
 tempera paint
 brushes
 masking tape

Talk With The Children: Cut a bunch of colored balloons out of felt. Put them on the felt board and show them to the children. Pretend you are selling balloons. Say to a child, *"Toma, are you going to buy one of my balloons?"* If so, let her come up, pretend to give you money, and take a balloon. What color did Toma buy? Continue letting all of the children buy balloons.

Tell the children they are going to form balloons by stuffing small paper bags with newspaper. Once they are stuffed, the children can paint them a variety of colors.

ENJOY THE ACTIVITY

Put the newspaper, bags, dowel rods, tape, and paint on the art table. Have the children blow up their balloons by tearing the newspapers into small strips and stuffing it into the bags. When the balloons are stuffed, poke the dowel rods into the bags and then help the children tape the balloons closed. Paint the balloons. When the children finish painting, have them poke their balloons into the styrofoam to dry.

DISPLAY THE "BALLOONS"

After the Balloons have dried, have the children poke them into the flowerpots. Put the Balloon Bouquets around the room.

EXTENSION:

One day, just as the children are going home, blow up a bunch of balloons — at least one for each child. Have the cash register and pretend money by the door. As the children leave, ask them if they would like to buy a balloon. If so, sell them one to take home.

PICNIC TABLECLOTH

PREPARE FOR THE ACTIVITY

Gather The Materials
- Cut butcher paper long enough for all of the children to sit around.
- Have: sponges cut in balloon shapes
 zoo animal cookie cutters
 tempera paint poured in shallow containers
 thin markers

Talk With The Children: Show the children a variety of food pictures which would be appropriate for a picnic at the zoo. Then ask them what else they might like to eat at the zoo. If they have recently taken a trip to the zoo also discuss what they actually ate. Did they bring a picnic or buy their food?

Tell the children they are going to print a long tablecloth and use it outside for a picnic.

ENJOY THE ACTIVITY

Lay the butcher paper on the floor in the art area. Spread the tempera paint and cookie cutters around the edges of the paper. Have the children print the zoo animals on the paper. As they are printing their zoo, talk about all of the animals. Let it dry overnight.

The next day, lay the picnic tablecloth on the floor again and sponge paint balloons using the tempera paint and variety of cut sponges. The children can add strings to the balloons with the markers if they want. Let it dry.

DISPLAY THE *"TABLECLOTH"*

Soon after the Tablecloth is finished, take it outside, sit around it, and pretend you're all at the zoo. Enjoy eating your picnic lunch or snack.

EXTENSION:

Add pretend picnic foods and accessories to the housekeeping center. If a part of the Tablecloth is still clean, cut it out and let the children use it on the housekeeping table.

DOODLING AROUND

PREPARE FOR THE ACTIVITY

Gather The Materials

- Have: white bed sheet
 different width non-toxic red markers
 blue crayons
 yellow tempera paint
 green chalk
 black crayons

Talk With The Children: Doodling is lots of fun. Have the children sit down, pretend that there is a piece of paper in front of them, and that their index finger is a crayon. Say to them, *"Remember your finger is a crayon. Make a big doodle on your paper. (Let them pretend and then talk about it.) OK, now make a very tiny doodle. (Give them time.) Can you make a round doodle? (Wait.) Here's a hard type of doodle. Make a doodle while holding your elbow to your waist."* Continue having fun by making more doodles on your pretend paper.

Tell the children that at art they are going to doodle on a sheet. Each day of the week they are going to add a different color to the sheet, using a different writing utensil.

ENJOY THE ACTIVITY

Lay the sheet outside on the concrete. Put different width red markers around the edges. When the children want, encourage them to doodle on the sheet. As they are marking the sheet, talk with them about their lines and designs. Each day during the week, bring the sheet outside and let the children add a new color with a different type of writing device. As the days progress, note the different marks each type of writing utensil makes.

DISPLAY THE "SHEET"

Clip the Sheet to the playground fence. Whenever you are going to read a story to the children outside, unclip the Sheet, lay it on the ground, and let the children sit around it as you read. After the story, clip the Sheet back onto the fence.

EXTENSION:

Hang a large piece of white paper on one of your walls inside the clasroom. Put crayons, markers, chalk, and pencils nearby. Encourage the children to doodle inside.

CHALK DESIGNS

JUNE

PREPARE FOR THE ACTIVITY

Gather The Materials
- Have: colored chalk

Talk With The Children: Bring pieces of colored chalk, along with matching crayons and markers to show the children. Pass out the crayons and markers to the children. Let the children tell the others what colors they are holding. Now hold up a piece of chalk. Say *"I'm holding a piece of blue chalk. Who has a blue crayon? Bring it to me. (Let child do it.) Whoever has a blue marker bring it to me."* (Let the child do it.) Lay the blue chalk, crayon, and marker down on the floor. Continue the matching game with the other colors of chalk you brought and the crayons and markers the children are holding.

Tell the children that you are going to bring the chalk outside for them to use to color designs on the concrete.

ENJOY THE ACTIVITY
Bring the colored chalk outside. In a large designated area let the children create all sorts and sizes of designs on the concrete.

DISPLAY THE *"DESIGNS"*
When everyone has finished, draw a chalk line bordering the Designs. If possible everyone should walk around the Designs. If people must walk in the design area they should be careful to avoid the chalk.

EXTENSION:
Put pieces of sandpaper on the art table. Let the children use chalk, crayon, and marker on the sandpaper. How do they like marking on the rough surface. Is chalking on sandpaper the same as chalking on the concrete outside?

BARNYARD

Gather The Materials

- Cut butcher paper the size of your bulletin board.
- Draw a variety of simple farm animal shapes on different colors of construction paper.
- Make a barn from a large piece of posterboard. Cut windows and doors.
- Mix several bowls of sugar water.
- Have: several colors of tempera paint
 in shallow containers
 a variety of collage materials
 such as construction paper
 pieces, cotton balls,
 feathers, yarn, plastic
 movable eyes, etc.
 paste
 blunt-tipped scissors
 chalk
 stack of newspapers

Talk With The Children: Play *Farmer in the Dell* with the children. After playing, name all of the animals in the song, then add other farm animals the children can think of.

Show the children the barn you cut out. Tell them that they are going to print a background paper for the barnyard and then you are going to staple the barn to it. Hold up the animal shapes you've drawn and have the children call out the animal names and then make their noise. Tell the children that at art they can cut out the animals, color them with chalk, and add detail to them by pasting on materials from the collage box.

ENJOY THE ACTIVITY

First print the background. Lay the butcher paper in the art area. Put the stack of newspapers and the tempera paint around the edges of the paper. When the children come to art, have them tear pieces of newspaper (any size) and wad them up. Dip the paper wads into paint and print onto the butcher paper. Continue printing. When finished, let it dry and hang it on the bulletin board. Add the barn.

Put the animal shapes, scissors, sugar water, chalk, collage materials, and paste on the art table. Have the children choose what animals they would like to put in the barnyard and cut them out. Next the children can dip the chalk in the water and color their animals. When dry, they can collage any detail they would like.

DISPLAY THE "FARM ANIMALS"

When the children finish their Animals, have them put paste on the backside and put them in the barnyard. As they are adding their Animals to the yard, have them make the sound of their Animals.

EXTENSION:

Make a simple barnyard game. Get a piece of posterboard. Cut it into a large circle. Divide the circle into six or eight equal sections. Glue a picture of a different farm animal in each section. Poke a spinner in the middle of the board. Have a box full of matching farm animals. To play: Randomly distribute all of the farm animals to the players. Have the first player flick the spinner. What animal does the spinner point to? If any of the players have that animal they should put it near that section of the board. The next player spins. What animal does the spinner land on this time? Once again, have all of the children look at their animals and put the matching ones near that section of the board. Continue until all of the animals have been matched.

SUMMER TREE

PREPARE FOR THE ACTIVITY

Gather The Materials

- Cut butcher paper the size of your bulletin board.
- Pour thin layers of black, brown, and different shades of green tempera paint into shallow dishes.

Talk With The Children: Throughout the summer, trees grow many leaves. Each type of tree grows a different type of leaf. Talk with the children about all of the things they like about trees.

After the discussion, tell the children that at art they are going to handprint a beautiful tree with lots of green leaves.

ENJOY THE ACTIVITY

Lay the piece of butcher paper on the floor in the art area. First, have the children print the trunk and branches of the tree using brown and black tempera paint. (You may want to sketch a rough outline of a tree for them before they begin.) Have the children lay the palms of their hands in whichever color paint they choose and then begin handprinting the trunk of the tree. Encourage them to cluster their handprints so it is a wide, sturdy trunk. As the trunk is forming, let the children begin to branch out, again using brown and black handprints to create as many branches as they would like. Let it dry.

Add handprint leaves to the tree by letting the children lay the palms of their hands in the shades of green paint and then printing on all of the branches. If they want, add grass by printing with their knuckles along the bottom of the paper.

DISPLAY THE "SUMMER TREE"

When the Summer Tree has completely dried, carefully roll it up and carry it over to the bulletin board. Let the children help as you staple their tree to the board. When it is securely fastened, have them stand back and search the tree for light colored leaves, dark colored ones, ones that look a little torn, and so on.

EXTENSION:

After the tree has been up for several days, read your children THE GIVING TREE by Shel Silverstein.

THE FLAG

┌─ PREPARE FOR THE ACTIVITY ─

Gather The Materials

- Cut butcher paper the size of your bulletin board.
- Have: red, white, and blue tempera paint
 - brushes
 - red, white, and blue construction paper
 - three containers
 - glue in shallow containers
 - marker
 - box of gummed stars

Talk With The Children: Show the children a real United States flag. First discuss the three colors in it. Talk about the stripes, the red-white pattern, how many red stripes, white stripes, how many stripes all together, which color stripe is on top, etc. Do the children see any other shapes in the flag? What?

Tell the children that at art they are going to make a flag for the classroom. First they can flick red, white, and blue paint on the background and then glue red, white, and blue paper onto an outline of the flag.

ENJOY THE ACTIVITY

First let the children create the background. Take the butcher paper outside and lay it on the grass or concrete. Put the paint and brushes around the edges of the paper. Have the children dip their brushes into the paint and then flick the paint onto the paper. Let it dry. While it is drying, have the children tear the construction paper into small pieces and put the pieces into separate containers.

On the background, lightly draw the outline of a large United States flag complete with stripes and a square for the stars. Put the glue and containers of construction paper pieces around the edges of the paper. Have the children spread glue on the construction paper pieces and press them onto the Flag. After the Flag is full of color, add the stars.

DISPLAY THE "FLAG"

Carefully roll up the paper and carry it inside. Tack it up to the bulletin board. Display the real flag near the bulletin board. Talk about both flags during July.

EXTENSION:

Have a Fourth of July parade with the children. Decorate the riding toys, make simple hats, have streamers, horns, whistles, etc. March around the neighborhood.

BLAST OFF

Gather The Materials

- Cut a large, simple spaceship out of several pieces of posterboard. Tape the pieces together to make a long ship.
- Take each child's photograph.
- Have: crayons with the paper peeled off
 individual pencil sharpeners or potato peelers
 warming tray
 aluminum foil cupcake liners
 toothbrushes
 utility knife (for adult use only)
 cellophane tape
 heavy-duty tape

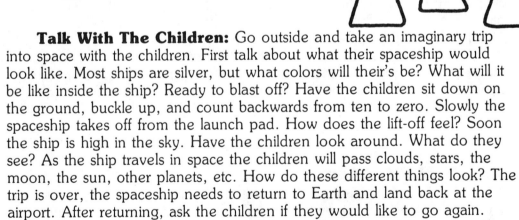

Talk With The Children: Go outside and take an imaginary trip into space with the children. First talk about what their spaceship would look like. Most ships are silver, but what colors will their's be? What will it be like inside the ship? Ready to blast off? Have the children sit down on the ground, buckle up, and count backwards from ten to zero. Slowly the spaceship takes off from the launch pad. How does the lift-off feel? Soon the ship is high in the sky. Have the children look around. What do they see? As the ship travels in space the children will pass clouds, stars, the moon, the sun, other planets, etc. How do these different things look? The trip is over, the spaceship needs to return to Earth and land back at the airport. After returning, ask the children if they would like to go again.

Tell the children that they are going to paint a spaceship at art and then cut windows in it for their photos.

ENJOY THE ACTIVITY

Collect all of the colors of crayons the children said their spaceship should be. Have the children shave the crayons, putting each color into a different cupcake liner.

Set up the warming tray on the art table. Turn it on a low setting. (Remember safety.) Put the cupcake liners with crayon shavings on the tray. Let the shavings melt. Lay the spaceship near the warming tray. When the crayons are melted, have the children use the toothbrushes to paint their ship. Let it dry.

Have the spaceship on a table with all of the children's photos. As the children find their photo, have them decide where they would like to sit in the spaceship. Using the utility knife, an adult can cut windows out of the ship and then let the children tape their photos on the back of the ship so their faces peek through.

DISPLAY THE *"BLAST-OFF"*

When all of the children are on board the ship, securely fasten it to the door, low enough so they can easily see each other's photos.

EXTENSIONS:

Encourage the children to take a walk with their parents at night. While they are walking have them think about being in space when it is dark. What would they see?

Read *MOONCAKE* by Frank Asch to the children.

SUMMERTIME WREATH

PREPARE FOR THE ACTIVITY

Gather The Materials

- Cut several large circles out of white posterboard or use large round pizza boards. Cut a small circle in the center of each one.
- Pour thin layers of all colors of tempera paint including green into shallow containers.
- Glue blocks of wood for handles to tongue depressors and popsicle sticks.
- Have: small paint brushes
 heavy-duty tape
 crepe paper

Talk With The Children: Summer is always a welcome time. Children and adults enjoy a wide variety of outside activities during the warm weather. Discuss different things the children like to do outdoors. Ask them if they have seen flowers blooming in the parks, preserves, and yards where they've been playing. What colors were the flowers?

Tell the children that at art they are going to paint a wreath full of summertime flowers. Show them a large circle. Tell them that when they come to art they are going to print the stems of the flowers with popsicle sticks and tongue depressors and then add the blossoms by dotting the tops of the stems with different colors of paint.

ENJOY THE ACTIVITY

Lay the circles, popsicle sticks, tongue depressors and green tempera paint on the art table. When the children come to art, have them use popsicle sticks or tongue depressors to print stems on the cardboard, then dip their fingertips into the tempera paint and form the blossoms on their stems. Continue adding flowers until all of the wreaths are blooming. Let them dry.

DISPLAY THE "WREATH"

Have the children carry the Wreaths to the door. Securely tape them at the children's eye level. Add a crepe paper bow to each Wreath.

EXTENSION:

The children and parents might want to add a border to the door by handprinting individual bouquets. Have the people making these bouquets dip the flats of their hands in green paint and make their handprints on white paper. Then add the blossoms to the five stems by dipping their fingertips into different colors of tempera paint and fingerprinting blossoms on the stems. Cut them out and tape them to the door.

216

SUMMER SUNCATCHER

PREPARE FOR THE ACTIVITY

Gather The Materials
- Collect all sizes of clear plastic lids.
- Have: all colors of tissue paper
 meat trays
 liquid starch in small bowls
 paint brushes
 paper punch
 ribbon

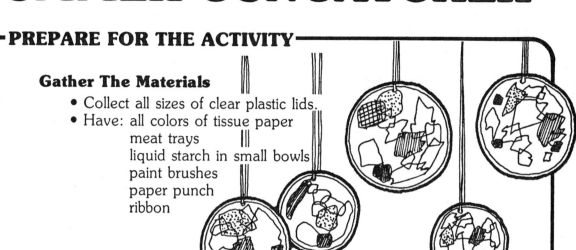

Talk With The Children: Show the children a piece of blue tissue paper. Talk about the color. Ask them if they see anything else in the room that is blue. Carry the piece of tissue paper over to the window. Hold it up in the sun. Does it look the same with the sun shining through it? How is it the same — different? Hold up several other colors and discuss them.

Tell the children that at art they are going to glue tissue paper to plastic lids to hang in the sunny windows.

ENJOY THE ACTIVITY

Have the first children who come to the art table tear the tissue paper into very small pieces. Put each color on a separate meat tray. Have the trays of tissue scraps and small bowls of starch on the art table. As the children come to art, have each of them choose a plastic lid, paint it with starch, and then layer the tissue paper pieces all over it. When finished layering, paint another coat of starch over the tissue paper. Let the Suncatchers dry overnight.

DISPLAY THE *"SUMMER SUNCATCHERS"*

When dry, punch a hole through the plastic lids, loop pieces of ribbon through them, and hang them in a sunny window.

EXTENSIONS:

When the sun is shining brightly, look carefully at the suncatchers. Do the children see any designs, objects, people, or animals in them?

Put kaleidoscopes on your window ledge. Do the children see any similarities between their suncatchers and the designs in the kaleidoscopes? What differences do they see?

SPACE CHART

Gather The Materials

- Cut butcher paper as long as the area on your wall.
- Cut sponges into circle and star shapes.
- Collect a variety of containers which can be used to print circles, such as fruit juice cans and plastic medicine bottles.
- Pour black, blue, and a variety of pastel tempera paint colors into shallow containers.
- Have: several feather dusters
 heavy-duty tape

Talk With The Children: Show the children a simple space chart (get from any science museum). Looking at the chart, show the children the pictures of the planets, stars, suns, etc. Explain to them that humans cannot see some of these objects because their eyes are not powerful enough. Space scientists use very powerful instruments called telescopes to help them see objects which are far into space. These telescopes are like very powerful eyes.

After discussing space, go outside. Ask the children to name all of the things they see in the sky. As they name the different objects, make a list on a large sheet of chart paper. When you go back inside, compare what you saw to the pictures on the chart.

Tell the children that at art they are going to print a large space chart of their own.

ENJOY THE ACTIVITY

Lay the butcher paper on the floor in the art area. First paint the space background. Have the black and blue paint and feather dusters around the edges of the paper. Have the children paint the space by dipping the feather dusters in the tempera paint and brushing it on the paper. Let it dry. Then put the pastel paints, sponge shapes, and circular containers around the edges of the paper. Have the children pretend they are looking through telescopes as they print a variety of objects which appear in space. As they are printing, talk about the different things which they have seen when they were outside or have seen pictured on a chart.

DISPLAY THE *"SPACE CHART"*

When the children's Space Chart has dried, hang it low on a wall. Talk about their stars and planets. Tack the actual chart of space near the children's. Continue talking about the planets. Teach children who are interested the names of the various planets.

EXTENSION:

Bring a pair of binoculars to school. Let the children use them. What do they see through the binoculars? Can they see as well without the binoculars?

HAPPY FOURTH

PREPARE FOR THE ACTIVITY

Gather The Materials
- Bring an old white sheet to school.
- Have: red, white, and blue tempera paint
 - markers
 - brushes
 - heavy-duty tape

Talk With The Children: Many towns celebrate the Fourth of July with parades. Have the children ever been to a parade? What did they see? Most parades have musical bands, marching soldiers, scout troops, and others walking in the parade. Leading all these groups is a person carrying a United States flag.

Tell the children that at art they are going to paint a flag on a large sheet.

ENJOY THE ACTIVITY

Spread the sheet on the floor in the art area. Place red and blue paint along with brushes around the edges. Mark off a square in the upper left-hand corner of the sheet for the stars and lines for the stripes. Beginning with the middle red stripe, paint every other stripe red, ending with the first and last stripe. Let them dry. Paint the area for the stars blue. Let it dry. After it has dried, use white paint to dot stars in the blue field. Let it dry again.

DISPLAY THE "FLAG"

Hang the Flag on a large wall. As the children pass their Flag, have them march and salute or put their right hand on their chest.

EXTENSION:

Read this rhyme to the children:

OUR FLAG
The Flag is coming. We see it now.
It's red and blue and white.
With stars and stripes, it's held so high.
It's such a wonderful sight.

We are proud to hold our faces up
And stand so straight and tall,
To place our hands upon our hearts
And pray for peace for all.

Dick Wilmes

LOOPDY-LOOPS

PREPARE FOR THE ACTIVITY

Gather The Materials
- Cut all colors of construction paper into various length and width strips. Put them on separate trays.
- Have: large pieces of construction paper
 paste
 heavy-duty tape

Talk With The Children: Put construction paper, blunt-tipped scissors, and meat trays on an empty table. Sit with groups of children and cut the strips for the activity. Put the strips on separate meat trays. As the children are cutting, talk about the different colors, widths, and lengths of their strips. Tell them that at art they can make loops, bridges, hills, and mountains with the strips and paste them on large pieces of construction paper.

ENJOY THE ACTIVITY

Put the construction paper strips, large pieces of construction paper, and paste on the art table. When a child comes to art have him choose a piece of construction paper and one paper strip. He should dab paste on each end of the strip, put one end of it down on the paper, loop the strip and paste the other end down. Now have him choose another strip, add paste to it, loop or bridge it, and paste it down. Continue until he has used as many strips as he would like. Let it dry.

DISPLAY THE *"LOOPDY-LOOPS"*

Hang all of the Loopdy-Loops in a patchwork fashion low on one of the walls in the hallway. When the children are in the hall, encourage them to stop and look at the art. Find bridges that go over and under other ones, find wide blue loops, and narrow yellow ones. Look for high loops and low ones. Have fun!

EXTENSIONS:

Celebrate the Fourth of July by only using red, white, and blue construction paper strips for this activity.

Repeat this activity using different materials. Have pieces of styrofoam for the bases and different colored wires and pipe cleaners to make the loops. Instead of pasting the ends of the paper loops, the children can stick the wires into the styrofoam.

POPCORN MOBILE

PREPARE FOR THE ACTIVITY

Gather The Materials

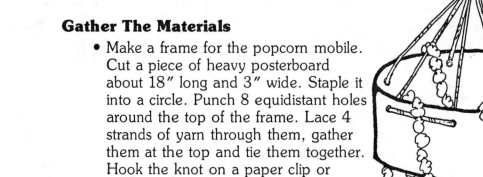

- Make a frame for the popcorn mobile. Cut a piece of heavy posterboard about 18″ long and 3″ wide. Staple it into a circle. Punch 8 equidistant holes around the top of the frame. Lace 4 strands of yarn through them, gather them at the top and tie them together. Hook the knot on a paper clip or hook in the ceiling.
- Pop the popcorn the children are going to use to string, a day or so before the activity. (Aged popcorn strings best.)
- Have: sewing needles
 thread
 watercolors

Talk With The Children: Pop popcorn with the children. Show all of the ingredients to the children, talk about the ingredients, and then pop the kernels. Listen carefully as the kernels pop. How do the kernels sound as they are beginning to pop? Then what begins to happen? How do the children know when the popcorn is finished? Pour the popcorn in a bowl and save it to eat during the art activity.

Show the children the popcorn you popped several days ago. Tell them that when they come to the art table they are going to string it for a mobile.

ENJOY THE ACTIVITY

Have the popcorn for stringing on the table along with a bowl of fresh popcorn for the children to eat. Begin stringing three or four strands of popcorn. As the children come to art they can continue stringing more popcorn on the strands. Let them enjoy stringing throughout their free play time.

When the popcorn has been strung, let the children use watercolor paint to dot the popcorn with color.

DISPLAY THE *"POPCORN"*

Hang the frame very low from the ceiling. Have the children carefully hang the popcorn strands from the frame or loop the strands over, under, and through the frame. When the strands are attached, pull the frame higher so the mobile floats in the air.

EXTENSIONS:

Make popcorn again just before the children go home. Give the children paper napkins. Let them put a handful of popcorn in their napkins, tie them shut with a twistem, and take them home for snacks.

Read this rhyme to your children.

E-Z POPPER

Take a little oil.
Take a little seed.
Put them in a popper,
And heat is all you need.
Dick Wilmes

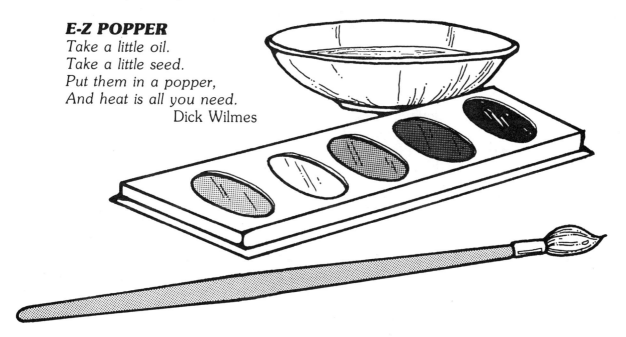

SATELLITE MOBILES

PREPARE FOR THE ACTIVITY

Gather The Materials

- Collect different picks which can be stuck into styrofoam, such as toothpicks, coffee stirrers, short plastic straws, and so on.
- Have: a variety of sizes of styrofoam balls
 a variety of other styrofoam such as peanuts, flat pieces, packing forms, etc.
 string
 blunt-tipped scissors

Talk With The Children: There are many reasons why people want to travel far into space. Some people want to see if they could live on other planets, some want to see if people already live on the other planets, others want to see if they could build towns in space, and so on. Another reason is to launch special machines called satellites. Some satellites are carried by spaceship into space. When the ship gets to the right place in the sky, astronauts launch the satellite off of the ship into space. These special satellites have equipment such as high powered telescopes and televisions built on them which help people back on earth. The equipment helps weather forecasters predict weather and helps people in the world see what is happening in far away places.

Tell the children that they can construct a variety of satellites at the art table.

ENJOY THE ACTIVITY

Put the styrofoam pieces and the picks on the art table. Let the children build their own satellites by attaching the styrofoam balls and pieces together with the different picks. As the children are building their satellites talk about the different telescopes, televisions, and radar that are on them.

DISPLAY THE "SATELLITES"

Cut strings and poke them into the Satellites with toothpicks. Loop the other end of the strings and hang Satellites from the ceiling.

EXTENSION:

On different days encourage the children to pretend their satellites are specific types and have certain equipment on board. For example, one day they can be weather satellites and the children can predict what kind of weather is coming. Another day they can be communication satellites. Add telephones and talk to people far away. The children can also pretend there are high powered telescopes on the satellites. Have wrapping paper tubes for children to look around the sky. What do they see?

YELLOW SUN

PREPARE FOR THE ACTIVITY

Gather The Materials

- Cut a large sun shape from yellow posterboard.
- Pour yellow corn meal in salt shakers.
- Make yellow glue by mixing yellow food coloring with white glue.
- Have: brushes for the glue
 heavy-duty tape

Talk With The Children: Play *I See Yellow.* Have the children carefully look for yellow in the room, on each other's clothes, out of the window, on the different toys, and so on. As they find yellow things, have them tell the others.

Show them the large circle you cut out of posterboard. Talk about different things a circle reminds them of. Tell them that at art they are going to pretend the circle is a sun and sprinkle yellow corn meal all over it.

ENJOY THE ACTIVITY

Put the posterboard sun, yellow glue, brushes, and corn meal on the art table. Have the children brush glue onto a small section of the sun and then shake corn meal over the glue. Continue until the sun is covered with corn meal. Let it dry and then carefully shake off the excess corn meal.

DISPLAY THE "YELLOW SUN"

Tape the Yellow Sun low on a classroom wall. Throughout July encourage the children to bring in yellow things that they can glue to the large sun. Each day a child brings in something yellow, have him share it and then glue it to the sun. At the end of July have the children help you tape their Yellow Sun to the Wall of Colors.

EXTENSIONS:

Let the children make telescopes. Using watered-down glue or liquid starch have them glue yellow pieces of tissue paper to paper towel rolls. Punch two holes at the top of the telescopes. Loop pieces of yarn through the holes. When the telescopes have dried, have the children drape them around their necks and go for a *yellow walk* around the neighborhood. As they walk, encourage the children to use their telescopes as they search for yellow things.

Let the children mix a dab of blue into some yellow tempera paint. What happened? Now try red in yellow paint. What happens when you mix the two new colors together?

TO THE MOON

Gather The Materials

- Get a large appliance box, such as for an oven.
- Have: pieces of metallic wallpaper
 - wallpaper paste (or watered down white glue)
 - brushes for paste
 - blunt-tipped scissors
 - utility knife (for adult use only)
 - stack of newspapers
 - heavy-duty tape

Talk With The Children: Make very simple space helmets for the children to use on their spaceship. Get several large ice cream tubs from the local ice cream parlor. Cut a hole in one side of each tub the size of the children's faces. (During free time they can paint their helmets and add any other detail they might want to, such as pipe cleaner antennae.) Give the children the space helmets and let them wear them as you read *WHAT NEXT, BABY BEAR* by Jill Murphy.

After reading the story show the children the large appliance box. Tell them that at art they are going to build a spaceship just like baby bear flew in. Have two children carry the box to the art area.

ENJOY THE ACTIVITY

Spread the newspapers on the floor in the art area or outside in the play area. Put the large box, wallpaper, brushes, scissors, and wallpaper paste on the newspapers. Brush the paste on the pieces of wallpaper and apply them to the box. Continue wallpapering the entire spaceship. As the children are wallpapering, talk about where they would like to travel in space. When the spaceship is dry, ask the children where they would like you to cut the doors and windows in their spaceship. Cut the openings with the utility knife.

DISPLAY THE "SPACESHIP"

Put the Spaceship on the playground, along with the helmets and other props such as walkie-talkies, boots, gloves, and binoculars. As the children play, talk about where they are traveling, what they see, and when they will return.

EXTENSIONS:

Enjoy this rhyme with the children:

MOON RIDE
Do you want to go with me up to the
* Moon?*
We'll get in our rocket ship and blast off
* soon!*
Faster and faster we reach to the sky.
Isn't it fun to be able to fly?
We'll orbit the Moon until we get tired,
Then streak back to Earth, when our
* rockets are fired!*

Read the book *MOONGAME* by Frank Asch to the children.

FARMER'S PLACEMAT

PREPARE FOR THE ACTIVITY

Gather The Materials
- Cut simple farm animal shapes out of thin corkboard. Glue a thread spool to each animal shape to use as a handle.
- Pour very thin layers of all colors of tempera paint into shallow containers.
- Have: construction paper
 roll of clear adhesive paper

Talk With The Children: Bring pictures of farm animals and the animal cork shapes you cut out. Pass out the cork shapes to the children. Have each child name the animal shape he is holding. Show the children the first picture and say, *"I'm holding a picture of a pig. Whoever has the pig shape put it on the art table and then come back."* Continue until all of the cork shapes are on the table.

Tell the children that at art they are going to use the cork shapes to print placemats for snacktime.

ENJOY THE ACTIVITY

Have the construction paper, tempera paint, and animal shapes on the art table. When children come to art, have them first choose a color of construction paper for their placemat, then print farm animals on it by using the cork shapes and tempera paint. When it has dried, cover both sides of the placemat with clear adhesive, leaving a half inch border.

DISPLAY THE *"PLACEMATS"*

Put the Farmer's Placemats near the snack table. Use them each day.

EXTENSIONS:

Serve snacks that farm animals might also eat, such as raw vegetables. Have snacks that come from farm animals such as milk and eggs.

Add plastic farm animals and equipment to the sand area.

I'M BACK AGAIN

PREPARE FOR THE ACTIVITY

Gather The Materials
- Have: pieces of charcoal
 colored chalk

Talk With The Children: Read *BEAR'S SHADOW* by Frank Asch to the children. After reading the story, shine a flashlight on a wall and let the children create their own shadows.

Tell the children that when they go outside they should look for all types of shadows — maybe they can even find their own shadow. If they do, you will trace around their shadow for them.

ENJOY THE ACTIVITY

Take the chalk and several pieces of charcoal outside. Encourage the children to look for shadows. Which ones do they find? How big are the shadows? When they find their own shadow, have them stand still and you quickly trace around it with the charcoal. After tracing, have them look at their shadow and then lie down next to it. With colored chalk, trace around the child's body. When finished tracing, the child can add detail to his body with the colored chalk and color his shadow black with the charcoal. Compare the shape of the shadow to the outline of the body.

DISPLAY THE *"SHADOW TRACINGS"*

Over the next several days encourage the children to avoid stepping on each other's tracings. When a child wants to wash his tracing away, give him a bucket of water and a scrub brush. He should be careful to scrub only his tracing.

EXTENSIONS:

Update the growth chart. Measure each child's height and weight and/or measure his shadow's height.

Play shadow tag outside. Instead of tagging a person on his shoulder, you tag him by stepping on his shadow.

TOOLS

Gather The Materials
- Cut butcher paper the size of your bulletin board.
- Have: several wide markers of different colors

 5-6 small garden tools in a box — clippers, sprinkling can, digger, shovel, pail, etc.

 5-6 building tools in a box — hammer, paint brush, screw driver, pliers, ruler, etc.

 5-6 cooking tools in a box — spatula, spoon, pancake turner, tongs, baster, etc.

 5-6 office tools in a box — pencil, scissors, eraser, rubber band, paper clips, etc.

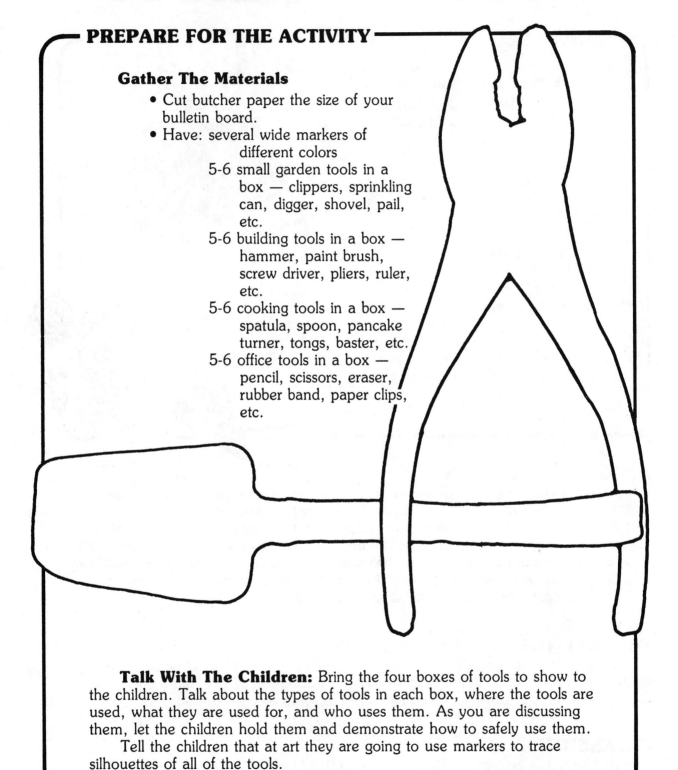

Talk With The Children: Bring the four boxes of tools to show to the children. Talk about the types of tools in each box, where the tools are used, what they are used for, and who uses them. As you are discussing them, let the children hold them and demonstrate how to safely use them.

Tell the children that at art they are going to use markers to trace silhouettes of all of the tools.

ENJOY THE ACTIVITY

Lay the piece of butcher paper on the floor in the art area. Divide the paper into four sections. Put one box of tools and several markers in each section. When the children come to the art area, they can choose what tools they would like to trace, lay them on the paper, and draw around them with the markers. If they want, they can add detail and/or color to the tools.

DISPLAY THE "TOOLS"

Hang the Tools on the bulletin board. Put the boxes of tools on a table near the board. Have the children look at the tracings and find the real tools in the boxes. Name the tool each time.

EXTENSION:

Before Labor Day, talk about the work that adults do when they go to their jobs. Start the discussion by talking about different community helpers and the tools they use while working. Invite a community helper, such as a firefighter to talk to your children. Have him/her show the children his/her tools. If s/he drives over in one of the fire vehicles have the children walk outside and see it.

OCEAN MURAL

Gather The Materials

- Cut pastel colored butcher paper the size of your bulletin board.
- Get several dish sponges which have the attached handles for the liquid detergent. Fill the handles with green, blue, and black tempera paint.
- Cut several shapes of fish from textured styrofoam meat trays. Glue a wooden handle to each shape.
- Pour thin layers of pastel tempera paints into shallow containers.
- Collect different materials found near water such as sand, sea shells, pebbles, seaweed, etc. Put them in separate containers.
- Have: glue
 brushes for glue
 green construction paper
 blunt-tipped scissors

Talk With The Children: Play *What's in the Sand.* Have a tray of small items and a bucket full of sand to show the children. Hold up each object and have the children call out its name. As they name each one, give it to a child and have him bury it in the bucket of sand. When all of the items have been buried, reach in the sand, find an object, and describe it to the children. Let the children guess what it is. Pull it out. What is it? Continue until all of the objects have been found. After the game ask the children if they have ever found any treasures in the sand at the beach. What were they?

Tell the children that at art they are going to paint a large ocean scene on mural paper. They will use special sponges to color the water and then glue the sand and all types of beach items to the mural.

ENJOY THE ACTIVITY

Lay the butcher paper on the floor in the art area. Put the sponges filled with paint around the paper. Have the children sponge paint the ocean. Let it dry.

Put the glue, scissors, construction paper, ocean items, fish, and paint around the mural. Have the children cut wiggly strips for seaweed, brush glue along the bottom part of the mural and sprinkle the sand for the beach area. Now glue the shells, pebbles, seaweed, etc. Add fish to the scene by dipping the styrofoam fish shapes into the pastel paints and printing them throughout the ocean waters. Let the scene dry.

DISPLAY THE "OCEAN MURAL"

Hang the mural on the bulletin board. Throughout the month encourage the children to bring in magazine pictures of people at the shore or photos of themselves enjoying an afternoon at the beach. Hang the pictures and photos around the bulletin board.

EXTENSIONS:

Place a variety of water animals, sea shells, rocks, seaweed, and colored gravel in the water play table. Encourage the children to create their own ocean scenes.

Read *SANDCAKE* by Frank Asch to the children.

DRIZZLE PAINTING

PREPARE FOR THE ACTIVITY

Gather The Materials
- Cut butcher paper the size of your bulletin board.
- Get eight to ten styrofoam cups with flat bottoms. Using pencils, poke several holes in the bottom of each one.
- Pour eight to ten colors of tempera paint into small pitchers.
- Get several meat trays for the cups to sit on.

Talk With The Children: Bring different kitchen utensils which have holes in them such as a colander, sifter, and slotted spoon to show the children. Have some washed lettuce leaves to drain, some powdered sugar to sift, and noodles ready to strain. Talk about each one of the utensils, what each is used for, and how it is used. As you're talking, demonstrate each one to the children. When finished, add these utensils to your housekeeping area.

Tell the children that at art they are going to use cups with small holes punched in them for Drizzle Painting.

ENJOY THE ACTIVITY
If it is a nice day have the children help you carry the butcher paper, paint, meat trays, and styrofoam cups outside. Lay the paper on the ground. When the children come to art have them carefully pour a little paint into one of the cups. The paint will begin to slowly drizzle out through the holes. Encourage the children to move the cup all over the paper as they create their designs. If they run out of paint, they can pour more of the same color or try another color in a different cup. When everyone has finished Drizzle Painting carefully carry the paper off to the side to dry.

DISPLAY THE *"DRIZZLE PAINTING"*
When the Drizzle Painting has dried, carry it inside and hang it on your bulletin board. Enjoy looking at all of the designs, colors, shapes, and lines. Look for places where two lines cross. Are the lines the same color? Is there a place where the lines come very close, but do not quite touch?

EXTENSION:
Encourage the children to be on the lookout for things in their environment which look like their Drizzle Painting — string designs, spider webs, evergreen branches, etc. This may be a little difficult in the beginning, but once they start, they'll find more and more things.

SAILBOATS

PREPARE FOR THE ACTIVITY

Gather The Materials

- Cut the base of a sailboat out of posterboard as wide as your door.
- Cut a wide fabric sail for the sailboat.
- Pour shallow layers of tempera paint into separate containers.
- Have: paints
 brushes
 metal forks
 narrow dowel rod for the sail
 double-sided cellophane tape
 heavy-duty tape

Talk With The Children: There are many types of boats. They are powered in different ways. A motorboat is powered by a motor, a row boat, canoe, or raft by people, an ocean liner by giant engines, and a sailboat by wind. The stronger the wind, the faster the sailboat will move.

Give the children small pieces of tissue paper. Have them lay the papers on their open hands and pretend the papers are sails. Have the children blow very gentle breezes onto their sails. How much did the sail move? The wind is picking up and getting a little stronger. Now how much did the sail move? A sailboat works in basically the same way. People who sail, learn how to move the sails and their boat to take advantage of the winds. Show the children the fabric sail and the base. Tell them that at art they can paint the base and use forks to print a design on the sail.

ENJOY THE ACTIVITY

Lay the fabric sail in the middle of the table with the forks and tempera paints around it. When the children come to art they should dip the tines of the forks into the paint and print the design on the cloth. As the cloth sail is drying, paint the base. Maybe the children would like to name their sailboat. If so, when the base is dry, write the name on it.

DISPLAY THE "SAILBOATS"

Tape the sailboat base low on the classroom door. Add the dowel rod and the have the children carry the sail to the door and help you tape it in place. Now your sailboat is ready. Where do you want to go?

EXTENSION:

Get several types of the styrofoam boxes used for sandwiches at fast food restaurants. Cut the lid and base apart. Glue sails to colored toothpicks and stick them into both halves of the styrofoam boxes. Add these sailboats and a variety of other boats to your waterplay.

OUCH!

PREPARE FOR THE ACTIVITY

Gather The Materials

- Cut butcher paper the size of your door.
- Cut the shapes of tools — hammer, saw, screwdriver, drill, and others — out of posterboard.
- Peel the paper off of crayons. (The children can do this.)
- Gather all types of supplies used for minor injuries such as adhesive bandages, gauze, adhesive tape, cotton, boxes from different first aid creams, sprays, ointments, and so on.
- Have: blunt-tipped scissors
 glue
 double-sided cellophane tape
 heavy-duty tape

Talk With The Children: Ask the children if they have ever had an accident while helping their moms or dads work with tools. Have any of them ever banged a finger with a hammer or gotten a small cut with a nail or saw? Talk about the accidents. Show the children the variety of first aid supplies. When they got hurt, did they use any of these? Which ones?

Tell them that at art they are going to make a display of all of the first aid supplies.

ENJOY THE ACTIVITY

Have all of the tool shapes on the art table. When the first children come to art have them spread the tool shapes on the table and use the double-stick tape to fasten them in place. Lay the piece of butcher paper over the shapes. Put the crayons on the table. Have the children feel the paper for a shape and then, using the side of a crayon, make a rubbing of it. Continue, making rubbings of all of the tools.

After the children have finished their rubbings, add the first aid supplies. Let them unwrap bandages and put them on, cut strips of adhesive tape and stick them to the paper, glue cotton wads and pads, empty supply boxes, and so on.

DISPLAY THE *"OUCH MURAL"*

When the mural has dried, have the children help you hang it on the door.

EXTENSIONS:

Take a trip to a local pharmacy. Have the pharmacist show the children the different types of bandages and explain how each type is used.

Have a nurse visit the classroom and talk with the children about how to take care of minor cuts and injuries.

CRAYON BOX

Gather The Materials

- Cut a large crayon box out of posterboard large enough to hold up to 11 crayons.
- Draw 11 large crayon shapes on white paper.
- Have: red, green, blue, yellow, purple, brown, black, white, pink, gray, and orange crayons
 heavy-duty tape

Talk With The Children: Take a walk over to the Wall of Colors. Starting with the first color, name all of the colors being displayed. How many colors are there? Give the children the opportunity to talk about and admire all of their work. Show them the empty Crayon Box. Let them help you tape it to the wall, leaving the top side untaped. Tell the children they are going to color different crayons at art and add them to the Crayon Box. There will be one crayon for each color on the Wall of Colors.

ENJOY THE ACTIVITY

Lay as many crayon shapes on the art table as the children have colors displayed. Have the matching crayons available. Have the first children at art cut the crayons out. Let the children scribble each crayon a different color.

DISPLAY THE "CRAYON BOX"

As each crayon is finished tape it low on a wall in the classroom. Throughout August, encourage the children to bring in objects which can be glued to the different colored crayons. Each day have the children glue their items to the appropriate crayon. At the end of August put the crayons in the Crayon Box hanging on the Wall of Colors.

EXTENSIONS:

Put a kaleidoscope on the window ledge. Encourage the children to twist it slowly and enjoy all of the colors.

Enjoy this color rhyme with your children.

THE COLOR GARDEN

Red is the apple,
Up in the tree,
Hiding behind a green leaf,
Winking at me.

Blue is the little bird,
Sitting in her nest,
Who just caught a big brown worm,
And is now taking a rest.

Orange is the butterfly,
Floating near the brook,
Amid the purple violets,
Think I'll take a look.

Gray is the bunny rabbit,
Hopping on the ground.
With his nose a twitching,
Moist and pink and round.

Yellow is the sun up high,
Warming up the day.
With colors all around me,
I'm a lucky boy (girl) I'd say.

Black is the little animal,
Who isn't far away.
The stripe of white upon his back,
Tells me not to stay.

Dick Wilmes

MOVING ON

Gather The Materials

- Cut butcher paper as long as your wall.
- Cut a very large bus, car, garbage truck, and semi-trailer truck out of tagboard.
- Have: yellow tissue paper
 - gray and yellow tempera paint in wide containers
 - bottle caps
 - different width paint rollers
 - aluminum foil
 - different colors of tempera paint
 - 6" styrofoam bowls
 - black marker
 - blunt-tipped scissors
 - magazines
 - glue in shallow dishes
 - black construction paper
 - heavy-duty tape

Talk With The Children: Tell the children to put on their *thinking caps*. Now they should think of all of the vehicles that can travel on a road. Write them down as they think of them. When done, read the list back to the children. Can they think of any more? Count how many different vehicles they have thought of.

Show them the car, semi-trailer truck, garbage truck, and bus shapes you have cut out. Tell them that at the art table they can glue different collage materials to each of the transportation vehicles.

ENJOY THE ACTIVITY

Lay the butcher paper on the floor in the art area. Put the gray paint and rollers around the edges of the paper. Using the rollers, paint the paper gray and let it dry. Add a yellow strip down the middle of the road. Hang it on the wall.

Put the bus on the art table. Have the yellow tissue paper, glue, styrofoam bowls, and magazines on the table. Before adding color to the bus, discuss where the windows, doors, lights, and so on are located. Using a black marker, draw them in for the children. Encourage the children to tear fairly large pieces of yellow tissue paper (4" by 4" or so), pinch them in the middle, dip the pinched part of the tissue into the glue, and stick it to the bus. After each child has added as much yellow tissue as he wants, ask him if he'd like to find a person's face in a magazine and glue it to one of the windows. Let him do it. Also let several children glue styrofoam bowls to the bus for the wheels.

Each day the children can enjoy gluing different materials to one of the transportation shapes. For example, the children can glue bottle caps to the car, black construction paper pieces to the garbage truck, and aluminum foil bits to the semi-trailer truck. In addition the children can paint and add other collage materials to each vehicle.

DISPLAY THE "VEHICLES"

As each vehicle has dried, have the children tape it to the road on the wall. While you are taping, talk with the children about where they see cars, different types of trucks, and buses. Add clouds, sun, and other detail if the children would like.

EXTENSIONS:

Use similar activities to highlight air, water, and rail transportation vehicles.

Put Richard Scary's book, *CARS AND TRUCKS AND THINGS THAT GO,* on the book shelf. Encourage the children to 'read' it.

OCEAN OF FISH

┌─ PREPARE FOR THE ACTIVITY ─

Gather The Materials

- Cut several sizes and shapes of fish out of lightweight cardboard.
- Have: Ivory Snow®
 - water
 - dry blue tempera
 - large bowl
 - several small containers
 - double-stick cellophane tape
 - several sturdy stools children can use (if necessary) to reach the windows

Talk With The Children: Show the children the fish you cut out. Pass them around. Have one child hold up his fish for others to see. Ask the others to look at their fish. Do any of them have the same size or shape fish as the one the child is holding up? If so, have them bring their fish over to the first one and see if they are alike in size and shape. Put the ones that are alike in a pile. Continue until all of the fish are sorted.

Tell the children that at art they are going to change their windows into an ocean full of fish. You are going to put the fish shapes on the window ledge along with several containers of whipped Ivory Snow® and rolls of tape. When they want to paint the ocean, you'll help them tape fish to the window and then they can fingerpaint with the soap mixture all around the fish.

ENJOY THE ACTIVITY

When the first children come to art, have them mix the dry tempera paint, water, and Ivory Snow® to a fingerpaint consistency. Scoop the mixture into several smaller containers and distribute them, the fish shapes, and tape along the window ledge.

When the children come to art, have them put tape on the fish and stick them to the window. Then they should scoop a little of the soap mixture onto one hand and fingerpaint all around their taped fish. Leave all of the fish taped to the window.

DISPLAY THE *"FISH"*

When the windows have thoroughly dried, have the children help you carefully take the fish off. When they are off of the window, stand back and look at your Ocean of Fish. Where are the largest fish swimming?

EXTENSION:

Read *SWIMMY* by Leo Lionni to the children.

FISH MOBILES

PREPARE FOR THE ACTIVITY

Gather The Materials

- Cut 5-6 large fish out of posterboard as the tops for the mobiles. Punch holes along the bottom of each one.
- Mark off sheets of construction paper into 2" widths.
- Have: blunt-tipped scissors
 heavy thread
 sewing needles
 watercolors

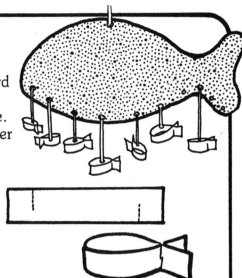

Talk With The Children: Have the children think of all of the things that fish do throughout the day — swim, dive, eat. What else? Write them down on chart paper. Have the children pretend to be fish by folding their hands like fish and doing all of the actions they thought of. As they're doing the actions they may think of more.

Tell the children that at art table they are going to make fish mobiles by cutting strips of paper and twisting the paper into fish shapes.

ENJOY THE ACTIVITY

Put the construction paper, scissors, and watercolors on the art table. Have the children cut strips of construction paper along the marked lines. Paint them with watercolors. When the paint is dry, the children should take each strip and make one cut about two inches from each end going halfway through the strip on opposite sides. Twist the ends together and insert the two slits. Let the children cut, paint, and twist as many fish as they want.

DISPLAY THE *"FISH"*

Using a needle, string a piece of thread through each construction paper fish. Hang the little fish from the base. When each large fish is full of small fish, punch a hole in the top of the big fish and hang it from the ceiling.

EXTENSION:

Start an aquarium for the classroom. If possible, take a trip with the children to a nearby pet store. Buy the fish and all of the supplies. When everyone is back at the school, look at the supplies and put the aquarium together. Make a job calendar so the children know which day they feed the fish.

CAR PARTS

PREPARE FOR THE ACTIVITY

Gather The Materials

- Cut a piece of corrugated cardboard from a large box about 18" by 36".
- Collect clean, used car parts such as window wipers, spark plugs, gaskets, license plates, fan belts, fuses, etc.
- Have: glue
 several large plastic trays

Talk With The Children: Take a walk to a nearby gas station or car dealer which services cars and trucks. Have the service manager give the children a tour of the facility. (Be sure to call ahead and have an adequate number of chaperones.) Ask him to show the children the parts department, where cars are repaired, and where cars are washed and cleaned up. If you have arranged ahead of time, have him show the children the used car parts he has cleaned and saved. After he has explained each one, put them in a box and bring them back to the school.

Show the children the car parts once again. Put them onto several trays. Tell them that at art they can glue the parts to a piece of corrugated cardboard.

ENJOY THE ACTIVITY

Lay the piece of cardboard in the middle of the art table. Put the trays of car parts and glue on each side of the cardboard. When the children come to art have them glue the variety of parts to one side of the cardboard base. When it is dry, turn it over and glue the remaining parts on the other side. As they are gluing, talk about the parts — their names, designs, functions, etc. Discuss times when they have watched or helped adults fix cars.

DISPLAY THE "CAR PARTS"

When all of the parts are securely attached to the board, fasten a piece of heavy-duty twine to the top of the board and hang it from the ceiling in the block area.

EXTENSIONS:

Make a set of car puzzles for the children to use. Cut out large pictures of cars. Using rubber cement, glue them to lightweight cardboard. When the glue has dried, cut the cars into as many pieces as is appropriate for your children's abilities.

Get an old steering wheel from a used parts dealer. Put it in the block area for the children to use when they build cars.

BOX HANGING

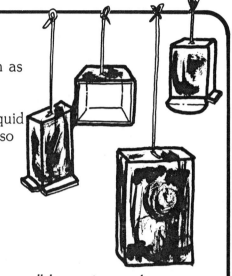

PREPARE FOR THE ACTIVITY

Gather The Materials

- Have: a variety of small boxes such as cake mix, toothpaste, jewelry, and cereal
 - tempera paint (add a little liquid detergent to your paint so it adheres better to the boxes)
 - brushes
 - waxed paper
 - string
 - stapler
 - dowel rod

Talk With The Children: Put all of the small boxes in one large box. Close it so the children cannot see what is inside. Bring it to circle time. Tell the children that you have brought a secret box to show them. Pass the big box around. Let the children shake it. After everyone has had an opportunity to shake the box, let the children guess what they think is inside. After the discussion, open the box and show the children the different boxes. Talk about what each one is for.

Tell the children that at art they can paint the boxes and then hang them from the ceiling.

ENJOY THE ACTIVITY

Have several children carry all of the boxes to the art table. Put them in the center. Spread the paint and brushes around the table. Lay a long sheet of waxed paper on the floor near the table. When the children come to art they can choose boxes and paint them. When they are finished painting, have them carefully lay their boxes on the waxed paper to dry.

DISPLAY THE *"BOX HANGING"*

After the boxes have dried, have each child cut a piece of string, staple one end to his box top, and tie the other end to the rod. When all of the boxes have been fastened, hang the dowel rod from the ceiling. Have fun watching the boxes swing and twirl.

EXTENSION:

Encourage the children to bring boxes they have found at home. Let each child tell the others what his box was used for. Put all of the boxes on the Discovery Table so the children can examine them more closely. You might make an ongoing list of all of the types of boxes and tape it to a wall near the table.

STYROFOAM HANGING

PREPARE FOR THE ACTIVITY

Gather The Materials

- Collect all sizes and shapes of styrofoam pieces such as egg cartons, packing pieces, peanuts, meat trays, and so on.
- Have: 2 corrugated box tops about the size of a soda case
 all colors of tempera paint
 — add a little liquid detergent to each color
 glue
 several large trays
 heavy-duty twine
 brushes

Talk With The Children: Bring a large bag with some of the styrofoam pieces in it to show the children. Pass the pieces to the children so they each get at least one. Have the children examine their pieces. Talk about what each piece could be used for. Ask the children if they have any styrofoam around their house. What do they use it for? Have several trays in the middle of the circle. Ask the children who have small pieces of styrofoam to put theirs on the first tray, those with middle-size pieces on the second tray, and those with the largest pieces on the third tray. Have three children carry the trays over to the art table.

Tell the children that at art they are going to glue the different types of styrofoam onto large box tops and then hang them from the ceiling.

ENJOY THE ACTIVITY

Put the trays of styrofoam, the two cardboard boxes, and the glue on the art table. When the children come to art have them glue the styrofoam pieces into and on the sides of the boxes. Let it dry thoroughly. If the children would like, they can paint the hanging after it has dried.

DISPLAY THE "STYROFOAM HANGING"

Attach the two corrugated boxes by punching two sets of holes through one side of each box. Loosely string a piece of twine through each set of holes. Loop a long piece of twine between the two holes to hang from the ceiling. Hang the Styrofoam Hanging low over a table, so the children can easily see the variety of styrofoam in their hanging, yet it is not in their way.

EXTENSION:

Cut a large piece of flat corrugated cardboard. Encourage the children to bring in styrofoam pieces from home and glue them onto the board. When it is full, hang it on your door with heavy-duty tape. Just look at the variety of pieces!

COMMUTER TRAIN

─ PREPARE FOR THE ACTIVITY ─

Gather The Materials
- Collect several boxes large enough for at least one child to sit in.
- Have: tempera paint
 wide brushes
 6" paper plates
 construction paper
 glue
 blunt-tipped scissors
 stapler

Talk With The Children: Using your local commuter railroad system, take the children on a train ride. Plan to get on the train at your local station and ride to the next stop. When you arrive, walk over to a nearby park, play for awhile, eat a picnic lunch or snack, and then take the train back home. If you are able to arrange it, have one of the train officials give the children a tour of the station and maybe the train engine. Ask the conductor in your train car to explain his job to the children.

Tell the children that in the art area they can build a train from cardboard boxes. First they will paint the cars and then link them together with paper chains.

ENJOY THE ACTIVITY
Have the children help you carry the boxes to the art table. Put the paint and brushes near the boxes. Encourage the children to paint the cars whatever colors they choose. Let the train cars dry. Glue paper plate wheels to each car. Cut strips of construction paper and link them together in fairly long chains. When the chains are complete and the cars are dry, staple the chains between the cars.

DISPLAY THE *"TRAIN"*
Drive the Train over to the block area. Have several accessories there for the children to use while playing — tickets, train schedules, conductor and engineer hats, and several magazines to 'read' while riding on the train.

EXTENSION:
Get study prints of different types of train cars from your local library. Show them to the children and talk about what each type of car is used for. Hang them low on a wall so the children can easily see them.

VACATION TABLECLOTH

─PREPARE FOR THE ACTIVITY─

Gather The Materials

- Cut butcher paper the size of your snack table.
- Cut different transportation shapes — cars, trucks, airplanes, boats, buses, and trains — out of posterboard.
- Fill empty shoe polish bottles (with sponge or brush applicator) with different colors of tempera paint.

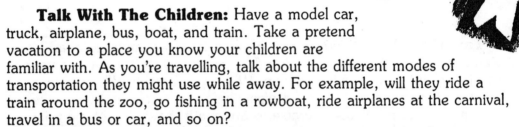

Talk With The Children: Have a model car, truck, airplane, bus, boat, and train. Take a pretend vacation to a place you know your children are familiar with. As you're travelling, talk about the different modes of transportation they might use while away. For example, will they ride a train around the zoo, go fishing in a rowboat, ride airplanes at the carnival, travel in a bus or car, and so on?

Show the children the transportation shapes you cut out of posterboard. Tell them they are going to use these shapes, along with shoe polish bottles filled with different colors, to paint a tablecloth for snack time.

ENJOY THE ACTIVITY

Put the piece of butcher paper on the floor in the art area with the shapes and shoe polish bottles around the edges. When children come to art, have them choose a transportation shape, lay it on the paper, and pick a color of paint. Holding the shape firmly with one hand, have them paint all around the edges of their shape with the applicator on the shoe polish bottle. When finished, carefully lift the shape. What's on the paper? Continue by filling the tablecloth with a variety of vehicles. Let it dry.

DISPLAY THE *"VACATION TABLECLOTH"*

Use the Vacation Tablecloth at snack time. As you eat, talk about the different ways people can travel.

EXTENSION:

Make a transportation game to add to your other manipulatives. Cut a duplicate set of transportation shapes out of posterboard. Get a variety of small cars, boats, buses, trains, trucks, and planes and put them along with the new shapes in a box. To play: Have the children lay the posterboard shapes on the floor and pass all of the model vehicles to the players. Taking turns, let each child match one of his vehicles to a posterboard shape.

WATER DESIGNS

PREPARE FOR THE ACTIVITY

Gather The Materials
- Have: several plastic buckets filled with water
 - several widths of paint brushes
 - several spray bottles
 - several empty liquid detergent bottles
 - gravy baster
 - plastic ketchup squeeze bottle

Talk With The Children: Show the children a glass of water. Say to them, *"See this glass of water. I want you to think of all of the places in your house where you would find water."* As they name each place, discuss how that water is used, for example, washing clothes in a washing machine. After they have thought of different places, talk about places they could find water outside their home. What is that water used for?

Show them the empty plastic bucket. Tell them that when they go outside you are going to fill several of these buckets with water and they can paint Water Designs all over the concrete.

ENJOY THE ACTIVITY

On a warm day, take out the buckets and water painting devices. As the children choose, let them paint the concrete using the different devices. Encourage them to watch their designs. What happens to them? Do the different devices produce different designs? Why?

DISPLAY THE *"WATER DESIGNS"*

As parents pick up their children have them go outside on the playground. Let each child choose his favorite device and create another Water Design on the concrete.

EXTENSION:

Attach a hose on the playground. Turn it on so water slowly flows out. Have the children wear bathing suits and have fun playing in the trickling water. Later in the day, set up a car wash and clean all of the riding toys.

Appendix

For Your Lesson Planning

Turkeys

Valentine's Day

Winter

For Your Displays

For Your Supply Cabinet

Equipment

ballpoint pens
baskets
bowls
brads
brayers
brushes - wide
 easel
 scrub
broom
buckets
camera
chairs
cloths
containers - small w/lids
deodorant bottles
dish pan
dish sponges w/handle
electric iron
egg beaters
feather dusters
film
flower pots
fly swatters
funnels
gravy baster
hammer
ice trays
ink pads
knife - sharp
 utility
magnifying glass
medicine droppers
mirror - full length
muffin tins
nails
needles - sewing
 yarn
paint rollers
paint stirrers
pans - cake
 shallow
paper punches
pencil sharpeners
pie tins
pinking shears
pitchers

plastic bottles - assorted
pot holders
potato mashers
potato peelers
record player
records
roller-type bottles
rolling pins
salt shakers
sandpaper
sawhorse
scale
scissors - blunt tipped
 sharp
scoops
shoe polish bottles w/applicator
spoons
spray bottles
staplers
stools
tennis balls
toothbrushes
towels
tubs - margarine
 plastic
warming tray
wire cutters

Materials

acorns
apples
balloons
bed sheets
birdseed
bolts
bottlecaps
boxes - cylinder
 small
 large
 appliance
 clothes
bread
broomstraw
buttermilk
car parts

catalogs
cattails
chalk
charcoal
Cheerios®
chicken wire
clay
clothespins - regular
 spring-loaded
coffee filters
coffee stirrers
construction paper - all colors
cord
corkboard
corks
corn husks
cornmeal
corn stalks
cotton - balls
 batting
 swabs
crayons - regular
 iridescent
crepe paper streamers
cupcake liners - paper
 aluminum
cups - paper
 styrofoam
dowel rods
dried beans
dried flowers
Easter grass
egg cartons - paper
 styrofoam
egg shells
elastic
erasers
evergreen sprigs
fabric - all textures
 and colors
feathers
fingerpaint - all colors
food coloring
gauze
Glass Wax®
glitter
gourds
grasses
greeting cards
grocery bags
ground coffee

ground tea leaves
gummed stars
hairspray
hose pieces
Ivory Snow®
juice cans
leaves
liquid starch
lumber - 2 × 4's
lumber scraps
lunch bags
magazines
marbles
markers - fine
 wide
meat trays
mesh bags
moveable eyes
nuts
oranges
paper doilies
paper egg cartons
paper plates
paper towel rolls
paste - wheat
 white
pebbles
pinecones
pipecleaners
pizza box/board
plastic medicine bottles
plywood
popcorn
popsicle sticks
posterboard
pumpkins
punch ball
ribbon - wide
 narrow
rice
rubber bands
rope
salt
sand
sandpaper
sawdust
scouring pads
seashells
sponges
staples
sticks

stones
straw
straws
streamers
string
styrofoam - sheets
 meat trays
 peanuts
suet
tagboard
tape - cellophane
 double-stick
 masking
 heavy-duty
tempera paint - dry
 liquid
thread
tinsel
toilet paper rolls
tongue depressors
tools - assorted
toothpicks - plastic
 wood
travel brochures
twine
twistems
vegetable oil
vinegar
wallpaper
washers
watercolor paints
weeds w/stems
white glue
willow branches
wire - telephone
 floral
yarn - heavy-weight
 light-weight
 rug

Papers

aluminum foil
bags - lunch
 grocery
bond
butcher
cardboard
cellophane
chart
clear adhesive

construction
corrugated cardboard - single wall
 double wall
 triple wall
doilies
facial tissue
fingerpaint
freezer wrap
mailing
napkins
newspaper
newsprint
onion skin
paper towels
pizza boards
posterboard
sandpaper
shelf
tablecloth
tagboard
tissue
wallpaper
wrapping
waxed

Printing Devices

bark
cookie cutters
corkboard
corn husks
empty thread spools
erasers
flowerpots
forks
funnels
Indian corn
juice cans
leaves
lumber scraps
medicine bottles
paper doilies
popsicle sticks
potato mashers
sponges
styrofoam
thread spools
tongue depressors
wood chunks (blocks)

Building Blocks Library

The Circle Time Series

by Liz and Dick Wilmes. Hundreds of activities for large and small groups of children. Each book is filled with Language and Active games, Fingerplays, Songs, Stories, Snacks, and more. A great resource for every library shelf.

Circle Time Book
Captures the spirit of 39 holidays and seasons.
ISBN 0-943452-00-7 **$ 9.95**

Everyday Circle Times
Over 900 ideas. Choose from 48 topics divided into 7 sections: self-concept, basic concepts, animals, foods, science, occupations, and recreation.
ISBN 0-943452-01-5 **$14.95**

More Everyday Circle Times
Divided into the same 7 sections as EVERYDAY. Features new topics such as Birds and Pizza, plus all new ideas for some familiar topics contained in EVERYDAY.
ISBN 0-943452-14-7 **$14.95**

Yearful of Circle Times
52 different topics to use weekly, by seasons, or mixed throughout the year. New Friends, Signs of Fall, Snowfolk Fun, and much more.
ISBN 0-943452-10-4 **$14.95**

Paint Without Brushes

by Liz and Dick Wilmes. Use common materials which you already have to discover the painting possibilities in your classroom! PAINT WITHOUT BRUSHES gives your children open-ended art activities to explore paint in lots of creative ways. A valuable art resource. One you'll want to use daily.
ISBN 0-943452-15-5 **$12.95**

Gifts, Cards, and Wraps

by Wilmes and Zavodsky. Help the children sparkle with the excitement of gift giving. Filled with thoughtful gifts, unique wraps, and special cards which the children can make and give. They're sure to bring smiles.
ISBN 0-943452-06-6 **$ 7.95**

Everyday Bulletin Boards

by Wilmes and Moehling. Features borders, murals, backgrounds, and other open-ended art to display on your bulletin boards. Plus board ideas with patterns, which teachers can make and use to enhance their curriculum.
ISBN 0-943452-09-0 **$ 8.95**

Exploring Art

by Liz and Dick Wilmes. EXPLORING ART is divided by months. Over 250 art ideas for paint, chalk, doughs, scissors, and more. Easy to set-up in your classroom.
ISBN 0-943452-05-8 **$16.95**

Parachute Play

by Liz and Dick Wilmes. A year 'round approach to one of the most versatile pieces of large muscle equipment. Starting with basic techniques, PARACHUTE PLAY provides over 100 activities to use with your parachute.
ISBN 0-943452-03-1 **$ 7.95**

Classroom Parties

by Susan Spaete. Each party plan suggests decorations, trimmings, and snacks which the children can easily make to set a festive mood. Choose from games, songs, art activities, stories, and related experiences which will add to the spirit and fun.
ISBN 0-943452-07-4 **$ 8.95**

Imagination Stretchers

by Liz and Dick Wilmes. Perfect for whole language. Over 400 conversation starters for creative discussions, simple lists, and beginning dictation and writing.
ISBN 0-943452-04-X **$ 6.95**

Parent Programs and Open Houses

by Susan Spaete. Filled with a wide variety of year 'round presentations, pre-registration ideas, open houses, and end-of-the-year gatherings. All involve the children from the planning stages through the programs.
ISBN 0-943452-08-2 **$ 9.95**

Learning Centers

by Liz and Dick Wilmes. Hundreds of open-ended activities to quickly involve and excite your children. You'll use it every time you plan and whenever you need a quick, additional activity. A must for every teacher's bookshelf.
ISBN 0-943452-13-9 **$16.95**

Felt Board Fun

by Liz and Dick Wilmes. Make your felt board come alive. Discover how versatile it is as the children become involved with a wide range of activities. This unique book has over 150 ideas with accompanying patterns.
ISBN 0-943452-02-3 **$14.95**

Table & Floor Games

by Liz and Dick Wilmes. 32 easy-to-make, fun-to-play table/floor games with accompanying patterns ready to trace or photocopy. Teach beginning concepts such as matching, counting, colors, alphabet recognition, sorting and so on.
ISBN 0-943452-16-3 **$16.95**

Activities Unlimited

by Adler, Caton, and Cleveland. Create an enthusiasm for learning! Hundreds of innovative activities to help your children develop fine and gross motor skills, increase their language, become self-reliant, and play cooperatively. Whether you're a beginning teacher or a veteran, this book will quickly become one of your favorites.
ISBN 0-943452-17-1 **$16.95**

2'S Experience Series

by Liz and Dick Wilmes. An exciting series developed especially for toddlers and twos!

2's Experience - Felt Board Fun

Make your felt board come alive. Enjoy stories, activities, and rhymes developed just for very young children. Hundreds of extra large patterns feature teddy bears, birthdays, farm animals, and much, much more.
ISBN0-943452-19-8 **$12.95**

2's Experience - Fingerplays

A wonderful collection of easy fingerplays with accompanying games and large FINGERPLAY CARDS. Put each CARD together so that your children can look at the picture on one side, while you look at the words and actions on the other. Build a CARD file to use everyday.
ISBN 0-943452-18-X **$9.95**

Watch for more titles in the 2's Experience series.

All books available from teacher stores, school supply catalogs or directly from:

Thank you for your order.

38W567 Brindlewood
Elgin, Illinois 60123
800-233-2448 708-742-1054 (FAX)

	Each	Total
BUILDING BLOCKS Subscription	20.00	_____
2's EXPERIENCE Series		
2'S EXPERIENCE FELTBOARD FUN	12.95	_____
2'S EXPERIENCE FINGERPLAYS	9.95	_____
CIRCLE TIME Series		
CIRCLE TIME BOOK	9.95	_____
EVERYDAY CIRCLE TIMES	14.95	_____
MORE EVERYDAY CIRCLE TIMES	14.95	_____
YEARFUL OF CIRCLE TIMES	14.95	_____
ART		
PAINT WITHOUT BRUSHES	12.95	_____
EXPLORING ART	16.95	_____
EVERYDAY BULLETIN BOARDS	8.95	_____
GIFTS, CARDS, AND WRAPS	7.95	_____
LEARNING GAMES		
ACTIVITIES UNLIMITED	14.95	_____
FELT BOARD FUN	14.95	_____
TABLE & FLOOR GAMES	16.95	_____
LEARNING CENTERS	16.95	_____
ASSORTED TITLES		
CLASSROOM PARTIES	8.95	_____
IMAGINATION STRETCHERS	6.95	_____
PARACHUTE PLAY	7.95	_____
PARENT PROGRAMS/OPEN HOUSE	9.95	_____
TOTAL		_____

Name_____

Address_____

City_____

State_____ Zip _____

QUALITY
BUILDING BLOCKS
SINCE 1977